Designing
for children

Designing for children

Steven Heller & Steven Guarnaccia

designed by Teresa Fernandes

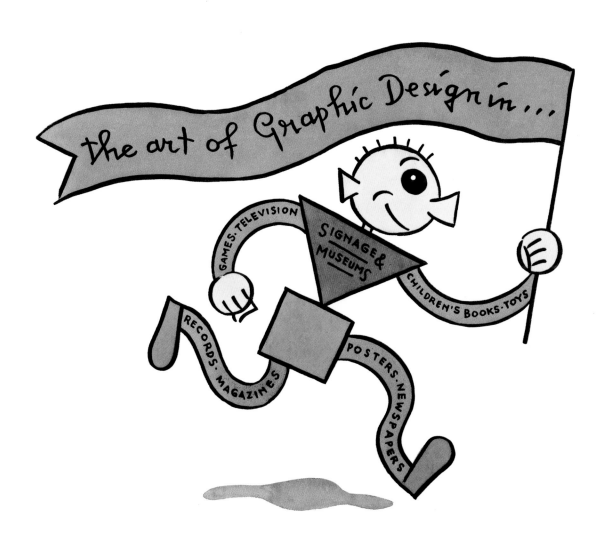

Watson-Guptill Publications / New York

acknowledgments

for Nick and Jasper

We express heartfelt gratitude to Teresa Fernandes, our book designer, chief researcher, and overall collaborator; without her this book would have been impossible to produce. For their support and encouragement thanks also go to Candace Raney, our editor; Marian Appellof, our project editor; and Mary Suffudy, our publisher at Watson-Guptill.

For their invaluable contributions, thanks to James Fraser, Mary Beth Jordan, Andrea Blaine, David Voegler, and Michael Malouf of Right Brain/Left Brain for offering ideas and suggestions; John Hassan, Jo Schiano, John Summerford, Karen Mynatt and Courtenay Clinton for research assistance; Dany Drennan for computer expertise; Edward Spiro for additional photography; and Sarah Jane Freymann, our agent.

© 1994 by Steven Heller and Steven Guarnaccia

First published in 1994 by Watson-Guptill Publications, a division of BPI Communications, Inc., 1515 Broadway, New York, N.Y. 10036

Library of Congress Cataloging-in-Publication Data

Heller, Steven. Designing for children / Steven Heller & Steven Guarnaccia ; designed by Teresa Fernandes.
p. cm.
"The art of graphic design in children's books, toys, games, television, records, magazines, posters, newspapers, signage & museums."
Includes index.
ISBN 0-8230-1304-9 (pbk.)
1. Advertising—Children's paraphernalia—United States. 2. Children's paraphernalia—Design. 3. Commercial art—United States. I. Guarnaccia, Steven.

II. Title. NC1002.C46H45 1994
741.6'08083—dc20 93-49723 CIP

Manufactured in Singapore

First printing, 1994

1 2 3 4 5 / 98 97 96 95 94

Illustrations on pages 3, 4, 5, 7, 17, 33, 57, 65, 87, 99, 107, 113 by Steven Guarnaccia.

Page 6: *Jumping Jacks game, 1920s.* Page 16: *Illustration by Henrik Drescher from "The Fool and the Flying Ship" video for Rabbit Ear s Productions Inc., Rowayton, Connecticut.* Page 32: *Signage designed by Michael Manwaring for Children's Discovery Museum, San Jose, California.* Page 56: *Paper sample designed by Linda Finnell and Julie Cohn for Two Women Boxing, Inc., Dallas, Texas.* Page 64: *Kitty Kat Kit, designed by David Kirk for Hoobert, Inc., Jamaica Plain, Massachusetts.* Page 86: *Club Kidsoft magazine, designed by Woods + Woods for Kidsoft, Los Gatos, California.* Page 98: *Illustration from Rodney's Funscreen, designed by Rodney Alan Greenblat for Activision, Los Angeles, California.* Page 106: *The Paper Bag Players, photographed by Ken Howard.* Page 112: *Illustration from Chicken Soup, Boots by Maira Kalman. © 1993 by Maira Kalman. Used by permission of Viking Penguin, a division of Penguin Books USA Inc.*

The text of *Designing for Children* is set in New Baskerville 12/19 and 9/16; captions are set in New Baskerville italic and roman small caps 8/11. All titles are set in Franklin Gothic Condensed in various sizes.

ART DIRECTION AND DESIGN: *Teresa Fernandes*
RESEARCH: *Teresa Fernandes*
ELECTRONIC PRODUCTION: *Dany Drennan*
GRAPHIC PRODUCTION: *Hector Campbell*
RESEARCH ASSISTANCE: *Karen Mynatt, John Summerford, Jo Schiano, John Hassan, Courtenay Clinton*
TESTERS: *Nicolas Heller and Jasper Guarnaccia*

contents

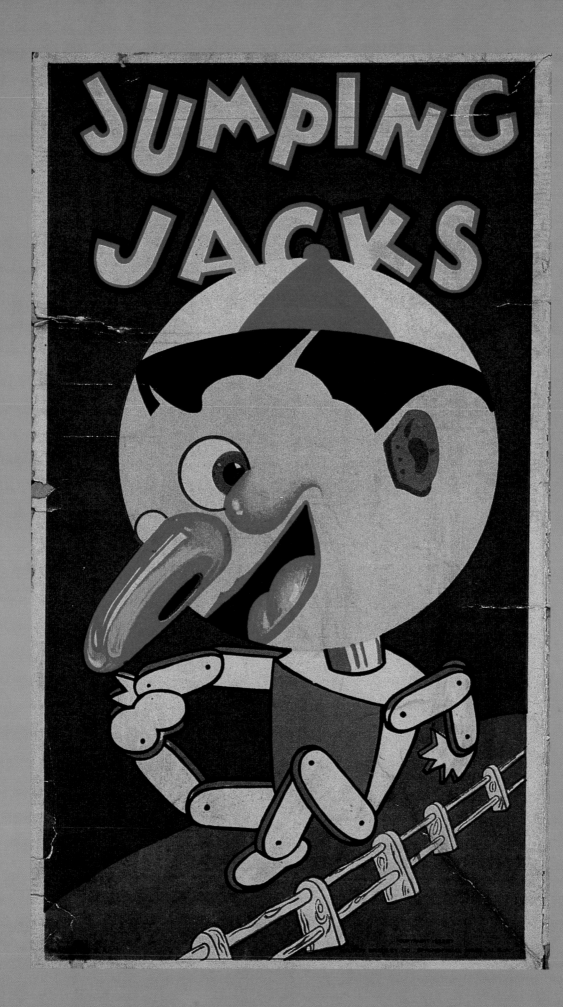

the new golden age

Never before have children been as cared for and respected, coddled and indulged—even worshiped—as now, particularly in the United States. Until recently the concept of children's rights was moot; children were the property of adults and inmates of school. Twenty years ago who could have imagined that a child would attempt, no less be in a position, to divorce her parents? Approaches toward child rearing have radically changed since the early 1950s, when Dr. Benjamin Spock first promoted his progressive theories. Depending, of course, on the class, race, and economic status that one is born into, by and large children have become the beneficiaries of munificence.

The progressive attitude toward children is paralleled by an upsurge in the production of merchandise for them. Since the 1950s industries focusing on children, including clothing, food, entertainment, and education, have been mainsprings for many businesses and wellsprings of fortunes. Each year thousands of manufacturers, distributors, and retailers jam the Toy Center in New York City to buy and sell state-of-the-art merchandise. In a frenzy resembling that of the New York Stock Exchange, toys, games, and books of all technological ranges are tenaciously hawked in showrooms without a child in sight (except those hired as models). Children have become more visible in society, and the adult-driven marketing machine revs to a fevered pitch as new products are released seasonally to capitalize on the ever-shifting and constantly increasing market. Businesses vying for a piece of that market trade on trends, fads, and fashions with all the intensity of the auto and clothing industries as they search desperately for the miracle that will prove itself to be the next season's Cabbage Patch or Jurassic Park blockbuster. 7

introduction

adults buy **the merchandise** that children consume in such prodigious quantities, and are thus in a position to exercise certain controls on what children consume. Yet adults are nonetheless at the mercy of manufacturers, promoters, and designers. In this equation the designer has become ever more critical, for as the conceiver or interpreter of ideas, he or she is the link between the adult's and child's imagination, and perhaps one of the most significant influences on childrens' lives after parents and teachers.

In recent years designers have taken a more dominant role in the creation of children's products. The number of designers of toys, fashions, and furniture for major companies has been steadily increasing, and those who design for independent and cottage businesses

Spoof card game, *Milton Bradley, c. 1918*

have made a considerable impact on the field. Graphic designers have also become more active as both creators and packagers of children's materials, branching out beyond the province of books and posters that has traditionally been theirs to develop such diverse products as stationery, videos, and games. In fact, the quantity of "well-designed" products for children indicates that a new aesthetic has been evolving of late. Stores and boutiques catering to children now offer products that range widely in design quality, from mass market to premium.

"Well-designed" is, of course, a relative term. What an adult might savor a child might shun. Many mass-produced goods in which the subtleties of design are unimportant have great visceral appeal for children. Yet the vulgar qualities that can be so appealing to kids are often anathema to adults. Although not entirely repudiating those qualities, the criteria for selecting the work that appears in *Designing for Children* were based on ideas that transcend convention (in other words, a mainstream marketer's belief of what *kids really want*) and

Shape sorter with holes making a face, *Brio, perhaps 1960s*

exhibit an intelligent design scheme that bypasses the rules and taboos imposed by timeworn tradition. Innumerable materials fit this bill—hundreds more than can possibly be examined here. So in the final analysis, what is included in the book is the result of subjective criteria that take into account not only the rightness of form but a profound wish on the authors' parts that future children's materials follow these models.

It may be foolish to presume that these are truly appropriate designs for children. Perhaps they are merely an adult's vision of what the child's world ought to be. Good design may be just another tool for controlling children. Therefore, before accepting the virtues of what is shown in *Designing for Children*, the reader should ask, What is the purpose of design for children—to challenge or to divert? How is success measured—by an adult's satisfaction or a child's joy? Do the aesthetics proposed by the examples shown here truly enhance the child's experience? Most importantly, what qualifications are needed to design for children?

In addition to certain talents and acquired skills, having been a child is a reasonable requirement for such an occupation, yet it hardly means that one has the ability to relate to children through art or design. Comparatively few artists and designers have what it takes to effectively communicate with kids. So what *is* the key? Must the successful designer for children have to be a child at heart? Or simply keep his or her heart open to children? If adults do not stay on speaking terms with children, writes John Updike, they cease to be people "and become machines for eating and for earning money."

Over a century ago designing for children was not a major concern. Adults did not cater to children as they do today. To be seen and not heard was the child's lot. "Children are all foreigners. [And] we treat them as such,"

cautioned Ralph Waldo Emerson in his *Journals* of 1836. Indeed, children were often considered encumbrances whose cuteness just scarcely excused their disagreeable habits. Childhood was viewed

Machine Age pencil box, *c. 1930*

as an intolerable stage, and as Emerson stated, "There never was a child so lovely but his mother was glad to get him asleep." Many parents maintained a customary distance between themselves and their offspring; obedience was placed before most familial prerequisites practiced today. Many a childhood was cut short as children were required to leave their innocence at the barn or factory door so as to hasten the process of adulthood. With death rates high, particularly in America during the nineteenth century, replacement grownups were in fierce demand—and what use has a grownup, regardless of age, for the accouterments of childhood?

Not all matters concerning children were so Dickensian. It might be argued that for every adult who decried childhood, there was another who viewed its fleeting state as something to be preserved like metallized baby shoes. "To be an adult," wrote Selma Lanes in *Down the Rabbit Hole* (Atheneum, 1976), "is to view childhood at a great distance through the wide end of the telescope, and pos-

Plastic numbers on chain, *perhaps 1940s*

sibly to invest the state with idealized abstractions." This perspective gives rise to the idea, as expressed by the French romantic writer Paul Hazard, that "childhood [is] a fortunate island where happiness must be protected." Of course, all who have children, or who remember the many difficult times when being a child was like being on Planet Hell, realize that happiness is not the child's only state of being. Nevertheless, most of us would do anything we could to make it so—or at least to perpetuate the myth.

Few adults would willingly return to the daily grind of being a child, but many would gladly replay its more halcyon moments. Selma Lanes writes in *Down the Rabbit*

Hole that consciously or not, adults try to return to less pressured times through activities with their children: "One of the little-acknowledged joys of young children's books is that they allow us [as adults] momentarily to escape from failures and inadequacies, from spilled milk and harsh scolding, into a more tranquil world where any problem posed generally has a satisfactory answer."

Those of us born into the relative security of the postwar baby boom want to bestow as many of the benefits we received on our own offspring. We were the first generation to reap the rewards of a better life in the richest nation on earth. Our grandparents had struggled to give our parents, children of the Depression, a few of childhood's perks. In turn our parents felt compelled to lavish a bounty of goods and services on us. Materially and emotionally speaking, ours was the best period to be a child. We were not burdens on family and society, we were real people with birthrights.

We were also something else that our parents were not: a market. A profit center for the manufacturers of thousands of products, from cereal to knitwear. We were not passive consumers for whom a few essential commodities were produced, but active targets. Our needs were not just taken more seriously than ever before, they were pandered to on television, radio, and in advertisements. Barrages of overt and subliminal messages greeted us daily in media devoted to our pleasures. Today, despite a few laws defining the limits of advertising targeted at children on Saturday mornings, the kids' television ghetto—which now includes two dedicated cable networks—remains a global village of materialism.

Children's developmental and recreational interests were given comparatively short shrift in nineteenth-century America, with the exception of efforts by progressives who

created a small number of unique books, magazines, and toys. In the twentieth century, particularly following World War II, children emerged as a nexus of economic attention. "The statement has been made, and with some justification, that the child is a modern discovery," wrote Bess Porter Adams in *About Books and Children* (Henry Holt and Company, 1953). "It is true, at least, that the modern child holds a position of respect and security unique in the history of civilization."

The modern child did not develop overnight. Around the turn of the century a few visionary artists and thinkers seriously addressed children as an integral social group. Among the great American pioneers was Mary Mapes Dodge, the author of *Hans Brinker, or the Silver Skates* and an editor who began publishing the children's magazine *St. Nicholas* as early as 1873 (thirty-five years before Macmillan opened the first American juvenile book department). Her goal was to supplement the standard classroom primers of the day while providing an alternative to rote

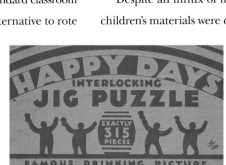

B.Z.L. baby talcum,
Wesley Company Inc., probably 1930s

tration was her mission, and *St. Nicholas*, which continued until 1940, influenced other efforts, notably *Chatterbox* magazine, which was also an antecedent to such later titles as *Child*, *Highlights*, and *My Weekly Reader*. Dodge's lasting contribution was her ability to influence popular authors and illustrators who had never considered children a viable audience to tap into their own imaginations. Contributions by Joel Chandler Harris, Bret Harte, and William Cullen Bryant became classics. Dodge also encouraged the magazine's young readers to contribute letters, text, and drawings, which were published on a regular basis; among the notable neophytes were Edna St. Vincent Millay, Ring Lardner, and E. B. White. Dodge insisted that the enlightened editor for children must "give just what the child demands, and to do this is a matter of instinct." This began a standard by which the writing, art, and, by extension, design for children could be judged.

Despite an influx of immigrants, nineteenth-century children's materials were designed for the dominant middle- and upper-class Anglo-Saxon child and reflected the popular prejudices of the day. Though the structures and styles of many books and toys were inventive at the time, they ossified into strict and exclusionary conventions of form and

10

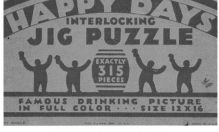

The ABCs to Draw and Color,
Big Little Set, probably 1930s

Happy Days puzzle,
Ullman Mfg. Co., perhaps 1930s

learning practices. "We edit for the approval of fathers and mothers and endeavor to make the child's monthly a milk and water variety of the adult's periodical," wrote Dodge in an editorial. "But in fact, the child's magazine needs to be stronger, truer, bolder, more uncompromising than the other. Its cheer must be the cheer of the bird song, not of condescending editorial babble…no sermonizing either, no wearisome spinning out of facts, nor rattling of the dry bones of history…the ideal child's magazine is a pleasure ground."

To stimulate children through good writing and illus-

content over the years. Meanwhile, in Europe more radical ideas of family life, rooted in socialism and Marxism, were influencing attitudes toward child rearing and ultimately affected children's design. As early as 1901 exhibitions of art for children, such as Die Kunst im Leben des Kindes (Art in the Child's Life), sponsored by the Berlin Secession, explored new approaches to children's lives. In 1903 a conference called Children's World, held in St. Petersburg, Russia, proposed standards that influenced the programs of socialist groups in Sweden and Germany and, much later, in America. In addition to the

radical notion of day-care, progressives sought to build a truly child-oriented environment in which educational tools and playthings were based on the child's experience rather than on imposed standards. The creators of furniture, textiles, and toys looked at what images, colors, and shapes children preferred and then interpreted their requirements, often in handcrafted products. The mission was to keep the commercial world at bay, and to protect the innocence of children.

Attempts were also made in America to proffer a kind of naturalism in children's products, and in the realm of books and toys this was carried out in limited ways. When laws prohibiting child labor were enacted in the early twentieth century, which in effect legislated that a fixed period of childhood be set aside, a potentially rich market for children's products beckoned businessmen with more interest in entrepreneurial schemes than in children. Many of the new items developed for children were designed merely to divert, not challenge. During the 1920s and 30s a great many toys, games, and trinkets were created as movie and radio tie-ins and cereal premiums. Although popular, they did not reinforce the innocence of or provide tasks for children. Some classics were, however, produced, such as diminutive versions of streamlined trains, sleek dirigibles, and airflow cars, which were prized then as they are now. But in the final analysis these and other artifacts were not deliberately or exclusively designed, but rather were miniaturized, for children, who themselves were still viewed as miniature adults. Even comic strips and comic books, both indigenous American popular art forms, were not originally intended for children alone.

During the 1930s and 40s children were perceptibly developing their own identity. Their health, education,

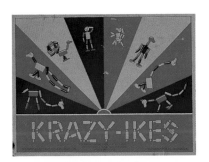

Original Krazy Ikes box, *Knapp Electric Corp., 1930*

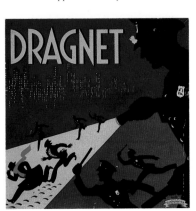

Dragnet game, *Selchow & Righter Co., 1930s (predates the TV show of the same name)*

and welfare were major concerns addressed by government and other institutions. But design with the child in mind was still not a priority, owing partly to the austerity imposed by the Depression and World War II. Not till after the war did serious designing for children begin.

Those of us who grew up in the postwar era have vivid memories of the bountiful merchandise dedicated to our enjoyment. It was a period when the great toy firms Mattel, Hasbro, and Marx began fighting for shares of the new market. One can still recall that the introduction of a remarkable new battery-operated toy made our collective mouths water with Pavlovian predictability. Yet it was also a time when progressive designers, many originally from Europe and some who were previously involved with avant-garde schools and workshops of the German Bauhaus or Dutch de Stijl, began to proffer alternatives to the aggressively commercial products on the market. Such graphic and industrial designers as Charles and Ray Eames, Ladislav Sutnar, and Raymond Loewy developed materials that fundamentally diverged from the hyperrealistic dolls, weapons, and other conventional fare that proliferated. The "well-designed" toys, such as Charles Eames's House of Cards, were created to help develop cognitive and intuitive skills. In reaction to the plethora of disposable gimmicks and gadgets that, frankly, made being a kid in the postwar years materially quite satisfying, a need for higher standards was recognized—a need not just for products that wouldn't break within minutes of being removed from the box, but for ideas that would both please and challenge children.

Still, what kid would opt for a Creative Plaything, one of those handsomely designed yet static wooden "educational" toys so popular with adults in the 1960s, over the

11

plastic Rock-em-Sock-em Robots or other commercial action toys of the same period? Despite the push among enlightened adults for alternatives and the efforts of progressive thinkers to enhance life through effective design, even by the 1960s and 70s the resistance to good design was still strong among marketers—and children bombarded with mesmerizing advertising.

Actually, children had other, perhaps intuitive, reasons to prefer the mass-market aesthetics. In 1963 an issue of *Design Quarterly* (#57; Walker Art Center, Minneapolis) was devoted to children's furniture and showed stunning reproductions of elegantly proportioned modern forms from Denmark, Great Britain, and Sweden. These were promoted as paradigms of a new sensibility. In one photograph two children play with an Erector Set, which they've obviously taken out of a handsomely designed, very functional modular storage crate. The sterility of this ideal scene overwhelms even one sympathetic to modern design. For in trying to create a perfectly designed environment—one that an adult would surely accept—the childhood aesthetic was lost.

The modern dictum "Form follows function" led to a belief in the rightness of simplified form, which in theory should apply to everyone regardless of age. Yet mature adults have different aesthetics than children do, and children have different preferences even among themselves. The problem with designing for children in the 1960s and early 70s was that many innovative designers were reacting to chaos and imposing a sense of order that was not instinctively in tune with children. Despite efforts to mold children into our own image, the most effective design is based not on sophisticated avant-gardisms but on qualities that somehow respond to the child within and without.

Only recently has a generation come of age that fully

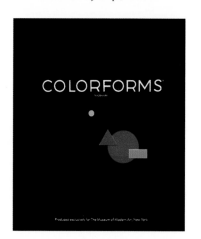

Puzzle Package dexterity puzzles,
Pressman Toy Corp., 1950s

Colorforms design toy,
The Museum of Modern Art, 1980s
reproduction of original

embraces a "Peter Pan Principle"—the idea that a childlike state of mind can and should be perpetuated, in this case through art and design. While this statement may seem to invalidate a long heritage of remarkable efforts in behalf of children, and appears to be biased in favor of our own generation, it can be argued that baby boomers have been more intensely involved in children's culture than previous generations, who had to slog through the muck of the Depression and mire of war, and that we are now continually bombarded with this culture through media that didn't exist for preceding generations. Rather than reinvent the child's environment through sophisticated methodologies that often owe more to some theory of functionalism than to childhood, many artists and designers today—baby boomers mostly—are revisiting their own experiences, reprising, assimilating, and synthesizing images and icons of the past three decades into a contemporary children's culture.

One example of this is "Pee-wee's Playhouse," the defunct Saturday-morning kids' TV show celebrated not only for the madcap antics of its star and creator, Paul Reubens, but for its extraordinarily imaginative sets and props by "alternative-culture" cartoonists and "comix" artists. Without a doubt it is a paradigm of the postmodern aesthetic that now informs children's culture. Pee-wee's environment was a polygamy of Depression-era heirlooms, 50s-style relics, 60s iconography, and high-tech madness. Its principal creators, Gary Panter and Wayne White, drew inspiration from the once-contraband stimulants of their childhood and adolescence—*Mad* magazine, underground comix, and rock and roll. Pee-wee's playthings, like Pee-wee himself, exhibited the controlled anarchy that flourishes in all healthy children. Compared to previous children's

12

shows like "Howdy Dowdy," "Pinky Lee," "Soupy Sales," and the Muppets' "Fraggle Rock," "Pee-wee's Playhouse" was very concerned with the effects of visual stimulation through design on a generation born into a multimedia vortex.

"Pee-wee's Playhouse" was more than a children's show. It was a doorway through which adults of the baby-boom generation (and perhaps others) could again experience their own childhood

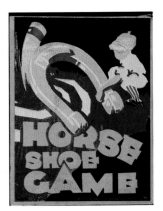

Horse Shoe Game, *Milton Bradley, perhaps late teens, early 20s*

antics—and at the same time forge a unique bond with their children. As such the program was the quintessence of what constitutes design for children. So, to finally answer the question, "What qualifications are needed to design for children?", one has only to look at examples that are in tune with, mediate, and respect a child's wants.

As theatrics, "Pee-wee" maintained a fast pace that excited children on a primal level; as design his playthings busted conventions while establishing new models. Some critics argued that "Pee-wee's Playhouse" was too frenetic and radical, but compared to the inexpressive, manipulative cartoons and commercials that sandwiched the show on Saturday mornings, it was a model of restraint.

The "Pee-wee" aesthetic is only one part of a larger children's culture that has been developing since the early 1980s. Another aspect evolved more directly from the underground comix of the 1960s, the rebellion that arose against establishment-imposed strictures that forced comic books to decline into a state of mediocrity. Underground cartoonists used parody and satire, inspired by *Mad* magazine, to criticize the sad state of the art as well as to develop new forms that broke with tradition. During the late 70s and into the 80s this was manifested in Topps Bubble Gum Company's toys and cards, which were designed by first-generation

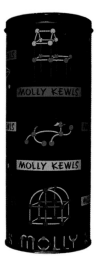

Molly Kewls construction toy, *Paul Bon Hop, Inc., 1950s*

underground artists like Art Spiegelman, R. Crumb, and Bill Griffiths. These irreverent parodies of popular products and trends unleashed and legitimized the primal grossness that most kids (particularly boys) love to express. While grossness is a dubious part of the current art and design aesthetic, this sensibility must be reckoned with, as it has been tapped for a variety of premium and toy designs for cable TV's Nickelodeon network and for cartoons like "Ren & Stimpy."

Another characteristic of contemporary aesthetics is an artful primitivism that eschews timeworn conventions of hyperrealism and magic realism so as to achieve a pure visual expression. Artists such as Maira Kalman, Henrik Drescher, and Lane Smith exemplify this sensibility in their iconoclastic children's books, which reject sentimentalism and reflect the child's primal essence. In addition, their works are benchmarks of a postmodern graphic aesthetic exhibited through a respectful play with typography, an element of children's literature that has long been more or less rooted in conservative principles.

Maira Kalman's images are charmingly primitive yet mightily expressive. What underlies the success of her books, including her popular "Max" series, is the convincing way she identifies with both her characters and her audience, and how design serves to bind that relationship. Her images set the stage and are complemented by a typography that, inspired by the Italian Futurist poets' "words in freedom" movement, uses fluctuations in point size and letterspacing to give resonance to the words. Like stage directions, this mannerism tells the adult reader to emphasize or downplay words and phrases.

Henrik Drescher's *art brut* achieves a similar result and also lures readers young and old by tapping into the primitive sensibility in us all. In his recent *Pat the Beastie,* "a pull-and-poke book," as its cover copy describes it, he sardonically parodies Dorothy Kunhardt's classic toddler's book *Pat the Bunny.* Drescher's deliberately raw style, which synthesizes tribal art with modern European art, is a wry

13

counterpoint to the guileless sketches of the original. *Pat the Beastie* also enjoys its own integrity apart from the parody: The typography is appropriately raucous, which allows the text a distinctive voice.

In the same mold is Lane Smith's *Stinky Cheese Man*, a collection of twisted retellings of classic fairy tales and rhymes by Jon Scuieska that not only puts a spin on children's literature but skewers the conventions of the book itself. While Smith's drawings are artfully primitive, and thus consistent with contemporary styles of illustration, it is the book design by Molly Leach that is the *brut*est of all. Here, too, the type varies in weight, size, and leading, but there are other witty tricks: for instance, where there

necessarily consider themselves devoted exclusively to children's materials could apply those talents they were unable sell in an adult market. Seymour Chwast is one who made a reputation as an editorial and advertising illustrator working in styles that on the surface suggest juvenile rather than adult sensibilities, but in fact are appropriate to all. Yet he finds considerably more constraints in the adult arena. "I do what I do," he once said, "and I'll do it for whoever allows me the freedom." The children's field has provided that license.

Chwast says that the actual process of designing for children is no different from his other commercial efforts. Yet within his body of successful children's work lies a

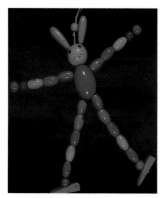

Wooden rabbit crib toy,
1930s–1950s

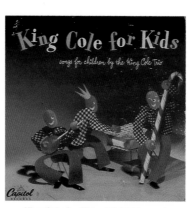

King Cole for Kids, *78 RPM record album, Capitol Records, 1948*

Wooden articulated horse,
perhaps 1940s

isn't enough text to fill a page it is repeated, and when the character Chicken Licken is introduced the type, not the sky, falls on her head. The most ironic touch is that an endpaper is bound into the middle of the book to fool The Giant, a character in one of the twisted tales, into thinking that the story is over.

In all three books it is clear that primitivism is a tool imposed by design, not by accident or innocence. The radical structures of each book, which have developed in a manner coinciding with broader-based graphic design experimentation, are at once defying conventional children's book design and, in light of the challenges posed by the current multimedia explosion, offering new ways for children and adults to enjoy a book together.

Actually, children's book publishing has for decades been a testing ground for form and content. It has also been an area where artists and designers who would not

clue to why not all designers, even those with the best motives, can succeed with children. *Paper Pets*, a cut-out book of quirky animals that combines Chwast's love of toys and art deco styling, exemplifies the problems with designing for children and at the same time satisfying one's muse. A square the size of an old record album, it is a real eye-catcher. Inside, the drawings of foldable animals—witty characterizations of, among others, a dog, cat, and parrot—are beautifully printed. However, in reality, the animals were designed not for the child to construct but the adult. The folding and attaching mechanisms are easy enough, but the decorative shapes are too complicated for a child's level of dexterity. Here is a case where design with the child in mind is not necessarily good design for children.

What, then, is good design for children? The key, but not the entire answer, lies in appropriateness. Is the idea

or product, whatever its target age group, going to let the child experience the material pleasurably, either by allowing participation or by posing a reasonable challenge? Children's design doesn't have to conform to strict rules, but it should neither underestimate nor undermine its audience.

Design for children can be educational or entertaining, but the best design often incorporates aspects of both. Drescher's *Pat the Beastie* is not just a witty sendup and exciting book-as-toy; after a few readings it also reveals a beguilingly simple animal-rights message that beseeches the reader not to torment his and her pets. That this is seamlessly included, by design, within the more overt silliness of the work is exemplary of the ethical heritage of children's materials. But whether overtly or subliminally educational, the most effective design for children is still whatever piques their interest first and the adult's second.

Many designers stumbled into the field of children's design by accident. Decades before creating his first children's book, Leo Lionni was an art director, photographer, and painter. To entertain his grandchildren he began cutting out bits of paper, forming them into mice and fish and developing ad hoc tales as accompaniment. Not till he saw his creations' potential for a broader audience did he launch a second career, which has resulted in over thirty books.

David Kirk used to make exquisite hand-painted wooden toys that recalled a bygone age of handicrafts, yet were decidedly modern in form and style. Like Lionni, Kirk was following his muse without regard for a commercial audience; in fact, most of his one-of-a-kinds were purchased by adults for their own pleasure. Over time, however, he began to accept that a market existed for low-tech toys that not only harked back to less complicated times but also prized an artisan's individual vision over mass-produced stereotypes.

Then there are other designers like

Hi Pop! game, *Advance Games Co., 1946*

Penny Comeback Bank, *Line Mar Toys, 1950s*

Richard McGuire, an editorial illustrator who always knew he wanted to apply himself to creating things for kids. His designs for children include a book and three toys, each deliberately aimed at the young while offering equal enjoyment to adults. Grownups can appreciate his version of the popular card game Go Fish as an artifact for the amusing renderings that grace each card and enhance the experience for all players by transcending the typical witless figurations on the common deck.

Regardless of how one has become a designer for children, many requisites for this occupation apply. *Designing for Children* shows that not the least of these is staying in tune with and understanding the intended audience.

"A child's world changes but the adult's remembrance of his own childhood stays static," wrote the publisher William R. Scott in his catalog of 1948, referring to the need he saw to update certain classics. "Perhaps this changing world accounts for the cold shoulder which greets many of our childhood favorites when we read them to the child of today."

Today's products and packages must appeal to both kids and parents, and therein is a tension that must be reconciled. As William Scott stated, "When a promising young manuscript comes in we take it to school with us for children's editorial criticism. Children, especially younger children, think differently than grown-ups." Perhaps the real issue is not what qualifications are needed to design for children—the creators are invariably distanced from children by their age—but how the designer's skills and talents are put into practice. In today's multimedia environment, the challenge is to be what Raymond Loewy called MAYA: Most Advanced Yet Acceptable. This should not suggest that artists and designers only follow their rebellious muses, or blindly follow outmoded conventions—or the orders of marketers who follow conventions—but rather, that they listen to children, interpret their needs, and respect their wisdom.

15

television and videos (and radio, too) Television

has been called a one-eyed monster, a thief of time, a vast wasteland. It has also been accused of exploiting and romanticizing some of the worst human instincts, notably violence. Yet television is so much a fixture of American life that the image of children sitting transfixed in front of a set is as emblematic as a Norman Rockwell painting. In 1959, when the medium was still more or less in its infancy, the novelist Marya Mannes wrote, "It is television's primary damage that it provides ten million children with the same fantasy, ready-made and on a platter." Those were the days before educational television became widespread, and children were exposed to a relentless barrage of cartoons and advertisements—yet there were also a few genuinely entertaining, and sometimes challenging, morning shows geared toward a young audience. In fact, television has never been a total wasteland as far as children are concerned, as long as viewer discretion is observed. Today's options for programming are even greater; though some might argue that the ratio between high-quality and low-quality fare remains constant, there is a reasonably good range and balance between education and entertainment.

With more channels on cable TV (and a small renaissance on radio, too) children now have greater options. With the advent of home video they currently enjoy access to visual stimuli that did not exist even a decade ago. Graphic design plays an important role in the process of attracting a child's (and a parent's) attention to these programs. While there is a tendency to follow safe, often crass, marketing formulas, there is also a trend (and one that's all to the good) toward increasing the quality of graphics through sophisticated treatments that are neither above nor below the child's level of perception. 17

chapter one

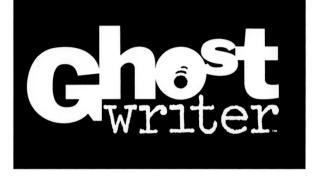

intelligent identity Ghost

Writer With a huge number of television shows aimed at
children of various ages, the challenge broadcasters face
is to guide children and parents toward the best one pos-
sible. Of course, the reputation of the show itself is a good
draw. But what about the new show with great potential
that has yet to carve out its special niche?

One way to attract an audience is through an identity
campaign directed at schools, perhaps including promo-
tions and a logo. While only a teaser, an appealing adver-
tisement or poster linked with a distinctive graphic style
can at least cause the potential viewer to take notice. The
graphics for "Ghost Writer," a series devoted to books and
reading that is aimed at elementary school children, are

lively and contemporary, and suggest that this show far
transcends a staid library science course.

Although there are no rules governing what typefaces
are "kids'" faces, the size variations in the word *ghost* clear-
ly imply fun, while the typewriter style used for *writer*
emphasizes the theme of this show. Moreover, the kinetic
dot over the *i* becomes a logo for a program that combines
entertaining activities with the pleasures of reading.

18

Ghost Writer
CLIENT: *Children's*
Television Workshop,
New York
DESIGN FIRM: *Pentagram*
Design Inc.
DESIGNER: *Paula Scher*

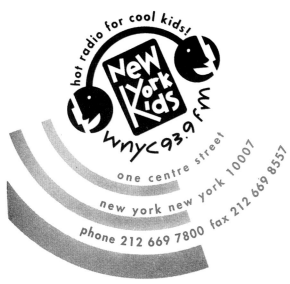

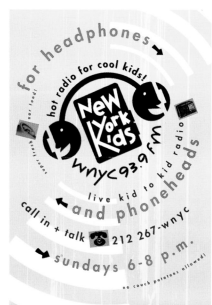

raucous radio New York Kids Per-

haps it is not so strange that some graphics designed to
appeal to kids are close in look and spirit to certain of the
hothouse or cutting-edge approaches to contemporary
graphic design—the kind of anarchic typography that
mainstream designers often vehemently object to as being
too trendy, or even illegible. But because kids are unhin-
dered by the "correct" rules of design, they are able to
respond freely to new stimuli. Unconventional imagery
and symbols can work brilliantly when aimed at a young
audience, because they are a kid's own.

"New York Kids" is a live, weekly call-in program on
New York's public radio station WNYC-FM that invites ele-
mentary school children to interact with guests on the air
on a variety of levels. The identity for the program employs
contemporary graphic styles to advertise itself. As a way
of both promoting and involving its audience, the show
created striking posters with the slogan "hot radio for cool
kids" and posted them in New York public schools to
encourage the target audience to take part. The subtly col-
ored poster, which uses lowercase, letterspaced Futura
Bold set in the arcs of concentric circles, also includes the
show's logo, a stylized version of a Walkman with earphones
in the shape of heads talking on a telephone. The gender-
nonspecific icon, which also appears on stickers, postcards,
and letterhead, is a wonderful use of the *art brut* style for
symbolic efficiency. The graphics, as stylish as they are rau-
cous, are perfectly comprehensible.

19

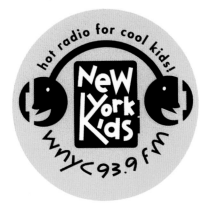

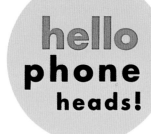

New York Kids CLIENT: *WNYC-FM, New York*
DESIGN FIRM: *Hello Studio* DESIGNER: *K.C. Wetherall*

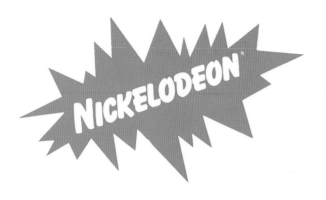

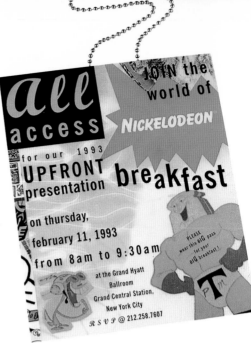

groove tube **Nickelodeon**

In the beginning cable TV was promoted as a panacea for imperfect reception in urban canyons where broadcast signals were easily impeded. Who would have imagined that in a little over a decade cable would become a major threat to network television, and spawn networks of its own, including those devoted to women, American families, African Americans, hard-rock freaks, classic-rock aficionados, country music mavens, humor lovers, movie buffs, and even children? Long ago the publishing industry began catering to special interests, as did radio in the wake of its decline as the main mass medium in the 1950s—so why not TV?

Given the huge audience for Saturday-morning children's television, it should come as no surprise that a network appealing to youngsters—and the nostalgic adult—would be a big hit. This is the story of Nickelodeon, which throughout the day devotes its programming to kids of various ages and at night (Nick at Nite) gives itself over to baby boomers who have a fondness for vintage sitcoms and melodramas.

Nickelodeon is an offshoot of MTV (a division of MTV Networks) and so has adapted MTV's graphic sensibility for its younger audience. Like those of its parent, Nick's graphics are bold and witty, but with a distinctly different focus. While the MTV imagery is often in the vanguard, in keeping with the more artfully adventurous music videos it airs, Nick gives the traditional imagery of childhood an au courant twist. For example, Nickelodeon's logo, set in a variant of Trafton's Cartoon Bold, is dropped out of a series of playful

20

Nickelodeon
CLIENT: *Nickelodeon, New York*
DESIGNERS: *David Vogler, Laurie Kelliher, Michelle Willems, Kenna Kay, Julie Wilson, Cheri Dor, Lisa Judson, Tim Blankley, Scott Webb, Steve Thomas*

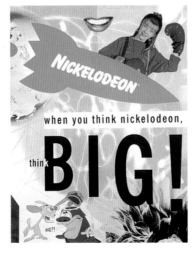

monitor

Nickelodeon's research device plugs in to kids' lives

How often do you watch TV together with your friends at your house or at theirs?
33 percent of kids claim they watch Nickelodeon at a friend's house

Some kids have told us they fix their own breakfast, lunch, dinner, and snacks. Do you?
79 percent of kids say they do

Where do you find out about news and current events?
79 percent of kids' report that television is their source for news and current events

How do you decide what to wear to school?
72 percent of all kids say they choose the clothes they wear to school

kids aged 6-17)
urce: Nickelodeon/Yankelovich
th Monitor, 1991

the NICKELODEON promises

place hand here!

In 1985, Nickelodeon introduced its new pro-kid attitude and style. To keep this new Nickelodeon on track and on target, we drafted a list of six rules by which to run the channel. These rules serve as a checklist against which we measure shows, contests, products, and promotions. We call them the Promises. These are the promises we make to kids, the goals we set for the network, and the claims we make in Nick promotion. Everything we do at Nick has to have a purpose—to fulfill one of our Promises.

Nickelodeon

CLIENT: *Nickelodeon, New York*
DESIGNERS: *David Vogler, Laurie
Kelliher, Michelle Willems,
Kenna Kay, Julie Wilson, Cheri
Dor, Lisa Judson, Tim Blankley,
Scott Webb, Steve Thomas*

shapes, including its signature cartoon splat. "At the heart of the Nickelodeon logo is an unusual, flexible design concept that allows for play and innovation," says the Nick design standards manual. "The logo is all about shapes, lots of shapes. The logo does not appear on an orange shape, it *is* an orange shape...." In contrast to most children's products, whose logos are designed with adult recognition in mind, the Nickelodeon logo actually appeals to the child—and so is a virtual primer in the science of logos.

Many of Nick's on-air and promotion designers are young enough to remember their own favorite childhood stimuli, yet old enough to appreciate and follow the current trends in graphic design. Therefore Nickelodeon's design style is a seamless blend of kids' minutiae and cutting-edge conceits, particularly typographic ones. The design for on-air identities and print promotions are consistent with the retro and deconstructionist graphic design fashions. Moreover, a self-mocking sense of camp pervades the Nick aesthetic. *Nick Elementary,* for example, a Nickelodeon annual report, is a hilarious lampoon of the grade school notebook. While not all of Nick's graphic materials are directed at children—most of the promotions are aimed at media buyers and sponsors—the overall aesthetic is one that has the kid in mind, and the kid at heart.

23

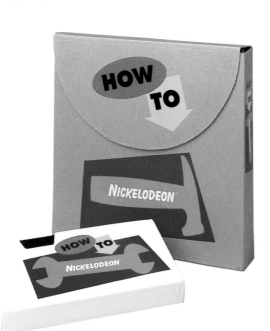

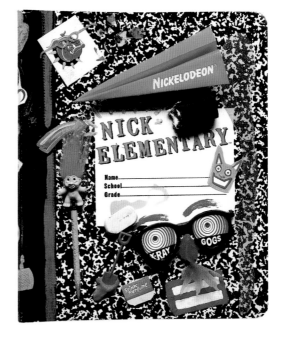

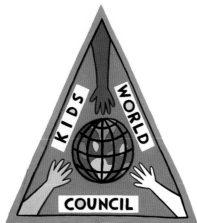

Nickelodeon

CLIENT: *Nickelodeon, New York*
DESIGNERS: *David Vogler, Laurie Kelliher, Michelle Willems, Kenna Kay, Julie Wilson, Cheri Dor, Lisa Judson, Tim Blankley, Scott Webb, Steve Thomas*

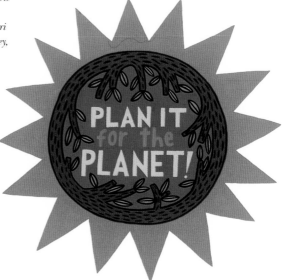

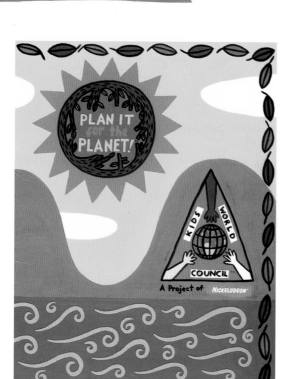

Two key examples, the logo and information materials for the Kids World Council and Plan It for the Planet public service campaigns, use imagery accessible to children, while at the same time providing a strong identity that appeals to their parents. The simple, colorful rendering of hands and globe set against a handlettered title at once suggests that this is a project dedicated to children but should be taken seriously by adults.

Nickelodeon also maintains its own cast of cartoon characters, stars of the animated "Doug," "Ren & Stimpy," and "Rugrats" programs. Licensed and spun off into

24

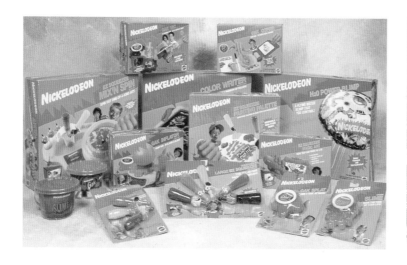

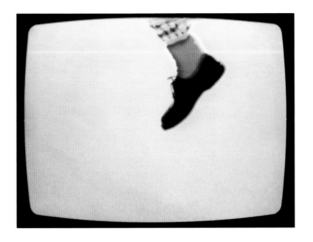

products, these characters have their own graphic identities and, though cut from traditional cartoon molds, extend the formal conventions. The mass-market packaging of these graphic personae in books, trading cards, puzzles, and games is refreshing largely by virtue of the characters' amusingly off-center design.

Graphics for Nickelodeon's identity and product line appropriate the old and introduce new ideas. The designs are programmatically consistent yet different enough to make each graphic idea new. Design purists might argue that Nick's output is too anarchic. But that would be like saying they are having too much *fun*. In the end, Nickelodeon's design aesthetic is very much rooted in fun and cut with a healthy respect for its audience.

adventurous advertising

Esprit/Kids Given its sophisticated concept—showing only closeup details of a child jumping or running out of the image frame—Esprit's television commercial is equally appealing to adults and children. Unlike most fashion advertisements, which use hard-sell approaches and show the clothes on prim models, the Esprit campaign opts for an imaginative subtlety that hints at the special qualities of the company, not the clothes. Esprit is selling not just its line but its ethos, which is that clothes are to be enjoyed by everyone. An MTV sensibility is guaranteed to grab the eye of the young parent, as well as that of the child who has become used to quick takes and poetic imagery and is entranced by moving figures and patterns.

25

Esprit/Kids CLIENT: *Esprit, San Francisco, California* DESIGN FIRM: *April Greiman Inc.* DESIGNER: *April Greiman*

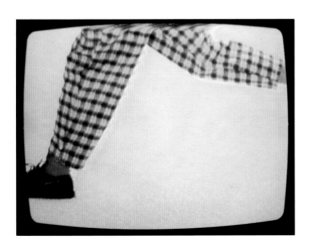

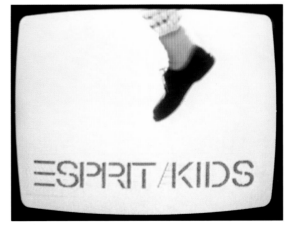

Rabbit Ears
CLIENT: *Rabbit Ears
Productions Inc.,
Rowayton, Connecticut*
ART DIRECTOR: *Paul Elliott*
DESIGNER: *Motoko Inoue*
ILLUSTRATORS: *Clockwise
on spread: "Puss in
Boots," Pierre Le-Tan;
"John Henry," Barry
Jackson; "Johnny
Appleseed," Stan Olson*

vanguard videos Rabbit Ears

A decade ago all eyes were on the video industry in anticipation of how the new home entertainment technology would affect children. Would their viewing habits be altered? Would broadcast television take a backseat? We are well into the video era and these and other questions have not been definitively answered. However, it is not news that a plethora of videos have been marketed with children in mind. While many of the products on the market are old, sometimes rare, movie and television retreads, a few producers have introduced original material. The most prolific is Rabbit Ears Productions, a multimedia production company that has created a series of superb reinterpretations of classic tales, including "Jack and the Beanstalk," "Puss in Boots," "Rumpelstiltskin," "King Midas," and the lesser-known "Anansi," "Koe and the Kola Nuts," and "The Boy Who Drew Cats."

Each production is the seamless collaboration of an artist, writer, composer, and reader. The video *Puss in Boots*, for example, was adapted by Eric Metaxas, drawn by Pierre Le-Tan, has music composed and performed by Jean-Luc Ponty, and is narrated by Tracey Ullman. Though some Rabbit Ears artists have experience in the children's book field—Karen Barbour, Peter Sis, and Henrik Drescher

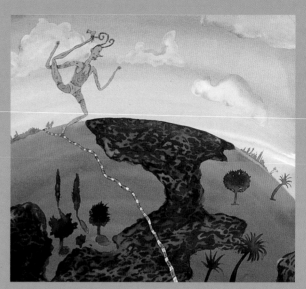
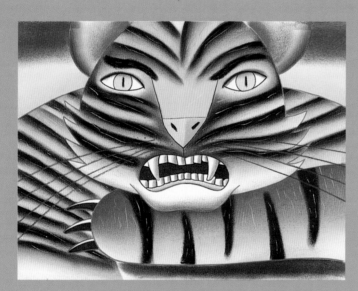
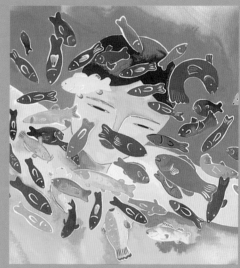
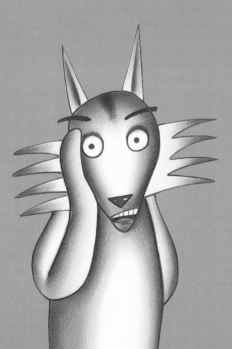
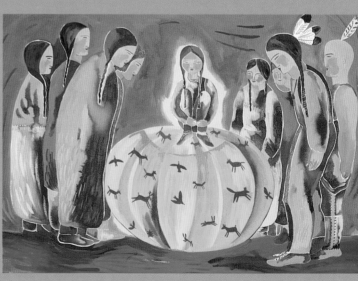

Rabbit Ears
CLIENT: *Rabbit Ears
Productions Inc.,
Rowayton, Connecticut*
ART DIRECTOR: *Paul Elliott*
DESIGNER: *Motoko Inoue*
PACKAGE DESIGNER:
Peter Millen
ILLUSTRATORS: *Opposite page,
clockwise: "The Fool and the
Flying Ship," Henrik Drescher;
"Princess Scargo and the
Birthday Pumpkin," Karen
Barbour; "The Tiger and the
Brahmin," Kurt Vargö; this
page, below: "Anansi,"
Steven Guarnaccia*

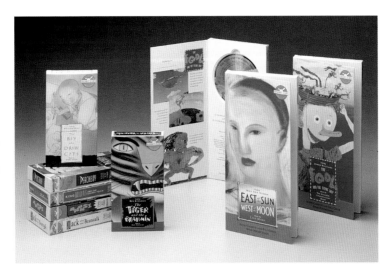

among them—they are largely drawn from the front ranks of editorial and advertising illustration and include Vivienne Flesher, Peter de Sève, David Johnson, Ed Sorel, and Rick Meyerowitz. Among the composers are those not known for their efforts in the children's field, such as Ellis Marsalis, Yo-Yo Ma, Herbie Hancock, UB40, and Ravi Shankar. And the readers include well-known film actors, such as Max von Sydow, Robin Williams, Ben Kingsley, Denzel Washington, and Kathleen Turner.

Each video requires hundreds of original drawings, which are then animated in a limited way using camera zooms and pans. Unlike the fluid cel animation of large-budget films, these videos have a slower, more contemplative pace that showcases both art and writing; viewing them is more like

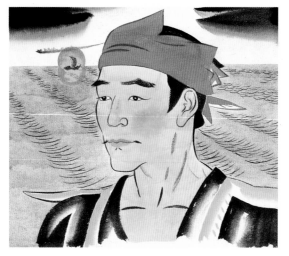

Rabbit Ears CLIENT: *Rabbit Ears Productions Inc., Rowayton, Connecticut* ART DIRECTOR: *Paul Elliott*
DESIGNER: *Motoko Inoue* ILLUSTRATORS: *"Peach Boy," Jeffrey Smith; "East of the Sun, West of the Moon," Vivienne Flesher*

being read to aloud than watching a film or tape. In addition to the video itself, attention is given to the package design. The typography and lettering are sophisticated and avoid the clichéd excesses often used to attract the child's attention. While each product is individually distinctive, all conform to a basically consistent identity.

Further setting Rabbit Ears apart from the conventional video producer is that it is a totally integrated multimedia company. Each production includes a videotape, audio CD or audiotape, and picture book (packaged either separately or as an ensemble). Rabbit Ears has proven that with the coordinated employ of extraordinary talent, fine children's programming can be created within this influential and exciting new medium.

ear today **I Love What I Hear!** This video guide to the wonders of sound is designed to appeal to teachers who must interpret the material for their young students (grades three to six). Yet the package and study guide are rendered with images that are visually compelling to both teacher and student alike.

A deliberately crude, brightly colored die-cut illustration of a huge ear serves as the opening flap. Rendered in a woodcut style, it is surrounded by smaller images of the musical instruments, animals, vehicles, and tools that are recorded on the tape. *I Love What I Hear!* offers one simple idea—that we live in a world filled with countless different, often remarkable sounds—and the package superbly and directly expresses the kit's mission.

30

I Love What I Hear!
CLIENT: *The National Institute on Deafness and Other Communications Disorders, Washington, D.C.*
DESIGN FIRM: *Grafik Communications Inc.*
CREATIVE DIRECTOR: *Judy F. Kirpich* DESIGNER: *Gregg Glaviano*
ILLUSTRATOR: *Richard Hamilton*

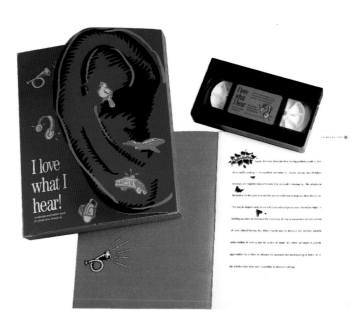

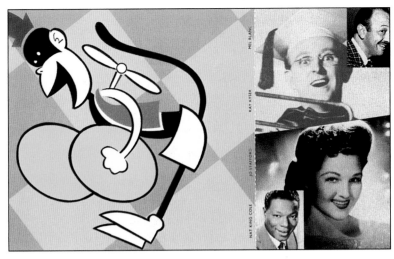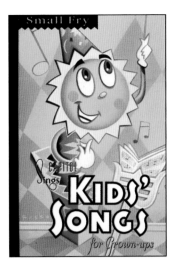

Capitol Sings Kids' Songs for Grown-ups CLIENT: *Capitol Records, Hollywood, California* DESIGN FIRM: *Murphy & Company*
ART DIRECTOR: *Tommy Steele* DESIGNER: *Bill Murphy* ILLUSTRATOR: *Robert Risko* PHOTOGRAPHERS: *Various* ARCHIVIST: *Brad Benedict*

eye songs Capitol Sings Kids' Songs for Grown-ups and Zip-A-Dee Doo-Dah Next to postage stamps and matchbooks, the tape cassette is the smallest surface for graphic design, with all the constrictions and limitations that implies. Even the best type and design can get lost on this surface. Therefore, to analyze the effectiveness of cassette graphics one must consider the inherent problems of legibility and display.

The two examples shown here represent two sides of the coin. *Capitol Sings Kids' Songs for Grown-ups* includes delightful individual elements—a witty characterization of a jack-in-the-box painted in eye-catching colors and an appealing novelty type treatment—yet together they clash, resulting in a cacophony of unresolved design, from the sawtooth-ruled "Small Fry" banner to the lightline art deco typefaces set against a complex background. On the other hand, the *Zip-A-Dee Doo-Dah* cassette design has almost the same number of graphic elements, though they are separated and set against a white background. The former example is aggressive, the latter one subdued.

31

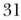

Zip-A-Dee Doo-Dah
CLIENT: *Legacy Recordings/Sony Music Entertainment Inc., New York*
DESIGNER: *Mark Brudett*
ILLUSTRATOR: *David Sheldon*

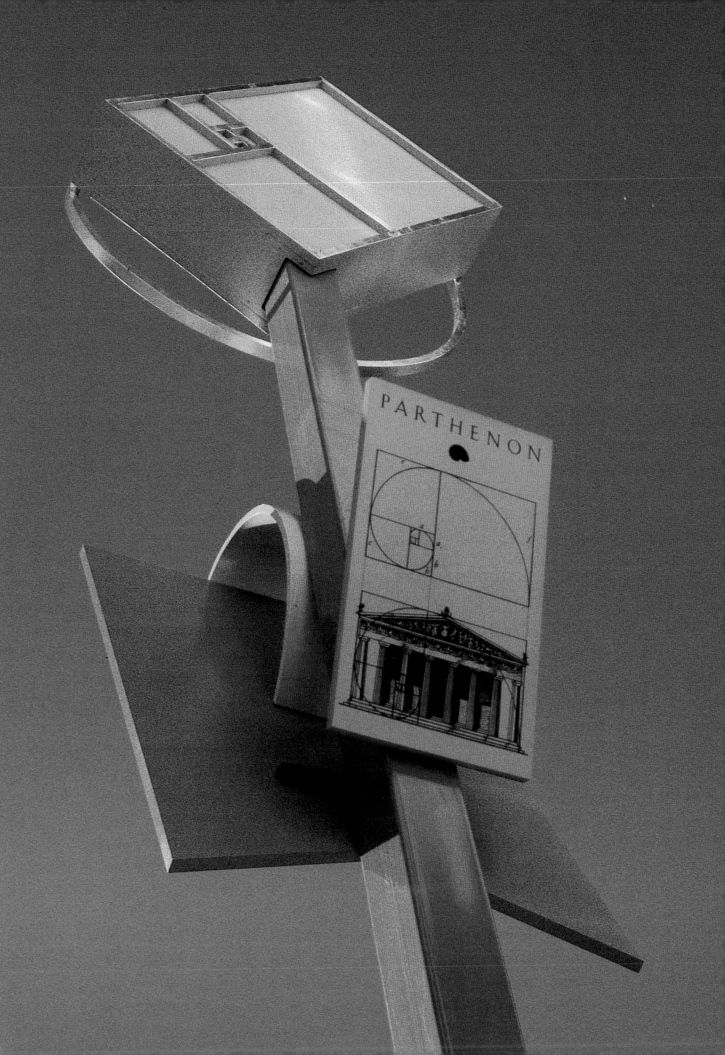

PARTHENON

museums and environments

Only a generation ago museums came in one size fits all. With the exception of special attractions, adults and children shared the same museum and exhibits. While children could always find something to engage them (a dinosaur room, for instance), a large percentage of the great halls and galleries were designed with adults in mind. But just as children already had their own books, movies, and theater, so too did they deserve, in the eyes of designers, at least, museums dedicated to their particular interests. Such museums were not to be miniaturizations of the adult genre, but specially designed spaces and buildings that were at once extensions of both the classroom and the playroom. Gradually, in most major cities warehouses, storefronts, and office buildings were reclaimed and renovated to house museums for the young.

In an adult museum the exhibits are often aimed at a general population with various levels of comprehension. In a children's museum it is necessary to target specific age groups with separate attractions that at once draw the broadest range, yet are comprehensible at fairly well defined levels. Many of the best-designed children's museums provide a variety of entry points for distinct stages of experience.

Museums, zoos, and other environments designed to challenge, inform, and entertain children have become more "user-friendly" in recent years due to an increasing awareness of how graphic design can be used effectively. Sophisticated print materials—such as catalogs, study guides, and the like—can inspire and assist in the learning process. Imaginative sign systems help in identifying, locating, and educating. A humorous diagram or witty icon can both attract the museum visitor's attention and facilitate having a good time. 33

chapter two

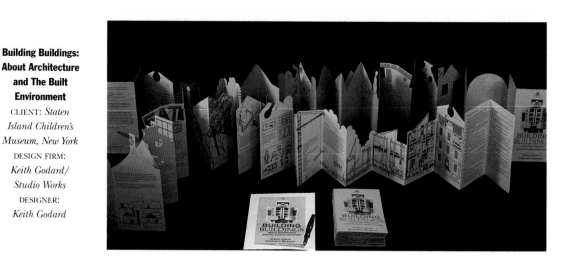

fabulous folder Building Buildings: About Architecture and the Built Environment

For an exhibition on how buildings are constructed, the Staten Island Children's Museum commissioned sculptor and illustrator James Grashow to develop a centerpiece exhibit, an anthropomorphic skyscraper that opens to reveal the inner workings of a massive office tower. To further humanize and provide a context for the various facts presented in the exhibit, an accordion-fold catalog was produced; printed on chipboard, it features didactic drawings and text about how a variety of structures were built and with what materials. The top of each page is die-cut in the shape of a pediment that relates to the building example shown on that page. The catalog provides useful information, and what might have been a dry study guide has been transformed by design into an intriguing object that is intended to be played with and saved.

loquacious logo Staten Island Children's Museum

Designing a logo for a children's museum may sound easy, but in reality it is not—which is why the logo for the Staten Island Children's Museum deserves praise. Given its basic element—a silhouette of the museum's impressive building—it should defy even the faintest possibility of being exuberant, and yet it is.

While the basic logo format and the materials on which it is presented are subdued (Helvetica type, formal Swiss grid), the building itself is given magical properties. On

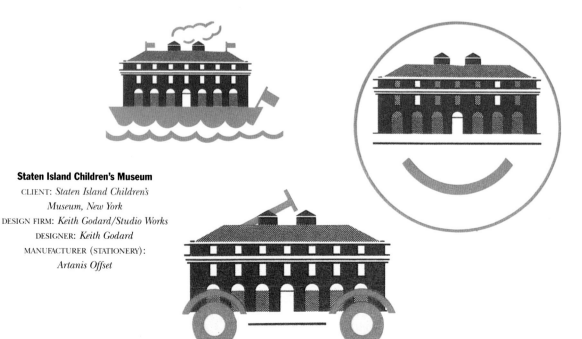

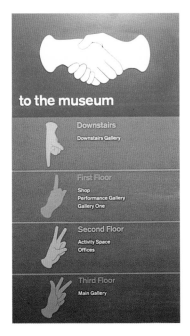
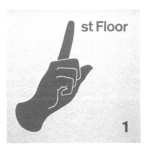
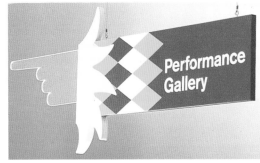

the letterhead it is a boat, car, airplane, and happy face. For the introductory brochure it blows its top, out of which explode festive fireworks. This multipurpose mark suggests the seriousness and joy to be found in Staten Island.

high signs Directionals at the Staten Island Children's Museum

Getting around a museum can be a challenge for both child and adult. A good wayfinding system can facilitate and enliven the museum experience. The directional signs for the Staten Island Children's Museum are models of clarity (the type is Helvetica), yet they also stimulate the imagination.

The classic pointing finger on the directional to the Performance Gallery becomes the hand of a clown or jester. Continuing this motif, the hand points downward to direct visitors to the Downstairs Gallery and upward to indicate upper floors; it holds up one finger to designate the first floor, two fingers for the second floor, and so on. Waving and extended hands also greet visitors at the entrance, beckoning them into the museum. This simple "sign-language" enables children to find their way easily, and contributes to the notion that this institution dedicated to their interests is not in any way a daunting place.

Staten Island Children's Museum
CLIENT: *Staten Island Children's Museum, New York*
DESIGN FIRM: *Keith Godard/Studio Works*
DESIGNER: *Keith Godard*
PHOTOGRAPHER: *Robert Lisak*
MANUFACTURER: *Faro/Walker*

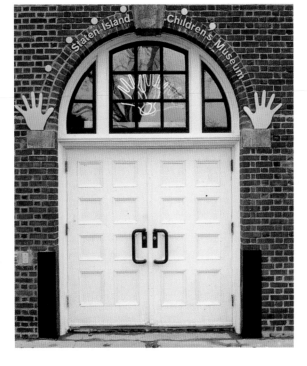
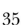

35

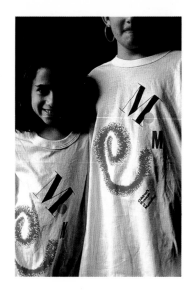

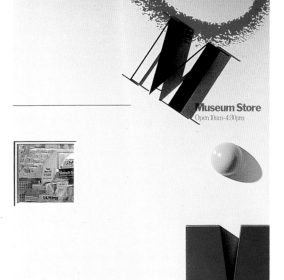

eye-catching identity

Children's Museum of Manhattan The Children's Museum of Manhattan is an excellent example of a well-balanced program. It is a playground, activity center, and exhibit hall appealing to young and older children through various arts, science, and cultural projects that challenge and entertain. The institution's graphic identity emphasizes its commitment to intelligent programming, while suggesting the essential funhouse nature of the place.

The logo, a combination of traditional and modern letters, is pleasing to the eye, immediately legible, and a symbolic interpretation of the scope of the museum's activities. A collection of jumbled letters, it is a puzzle to be deciphered and a rebus to be read. When used as a three-dimensional display (such as the entry shingle for the museum's store), it has the quality of a toy. With this playful amalgam of letters as a focal point, the brochures, posters, and other announcements issued by the museum can be more prosaically designed for legibility and accessibility. The Helvetica type is bold and eye-catching when printed against fields of primary color.

36

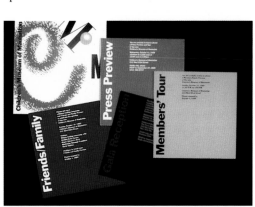

Children's Museum of Manhattan
CLIENT: *Children's Museum of Manhattan, New York*
DESIGN FIRM: *Pentagram Design Inc.*
DESIGNERS: *Michael Bierut, Alan Hopfensperger*
SIGNAGE DESIGNERS: *(Right) Michael Bierut, Tracy Cameron*

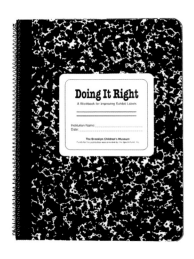

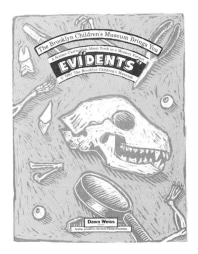

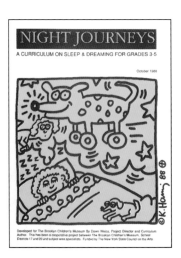

custom curriculum

The Brooklyn Children's Museum This is the oldest children's museum in the United States, the first to understand that children require special attention. The colorful robot mascot of The Brooklyn Children's Museum, designed by Seymour Chwast, suggests that there is more to this institution than meets the eye. Here, the challenging permanent exhibits and programmed activities address the mind, body, and senses. All of this is made clear in the museum's printed materials, which present the various extracurricular events aimed at schoolchildren and their teachers.

Doing It Right: A Workbook for Improving Exhibit Labels, featuring a marbleized notebook cover, is an activity book that allows children to develop their own exhibit descrip-

tions. *Night Journeys: A Curriculum on Sleep & Dreaming for Grades 3-5* and *Night Journeys: A Family Activity Book About Bedtime, Sleep and Dreams,* designed with covers by Keith Haring, invite children into the world of REM sleep. In both cases the graphics are low-key but witty, so as to support the sophistication of the projects themselves.

Evi"dents": A Science Curriculum About Teeth in a Mystery Format is designed with a little more style, using stark woodcut illustrations and printed in two rich colors, to add an air of mystery to an otherwise mundane subject. *The Brooklyn Children's Museum Activity Kit* is also appealing for its subdued typography accented by clever figural letterforms, such as the button that dots an *i* and the finger holes of the scissors that form the two *o*s in *Brooklyn*.

37

The Brooklyn Children's Museum
CLIENT: *The Brooklyn Children's Museum, New York*
ART DIRECTOR: Night Journeys, *Marcello Araujo*
DESIGNERS: Night Journeys, *Denise Fraifeld, Fernando Azevedo;* Activity Kit, *Agnes Sexty;* Doing It Right, *Susan M. Stern;* Evi"dents", *Jan Milstead*
ILLUSTRATORS: Night Journeys, *Fernando Azevedo;* Activity Kit, *Agnes Sexty;* Doing It Right, *Susan M. Stern;* Evi"dents", *Susan Greenstein, Jan Milstead*
LOGO: *Designed and illustrated by Seymour Chwast, The Pushpin Group Inc.*

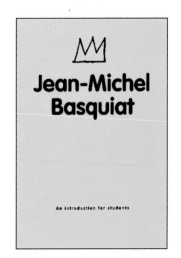

Jean-Michel Basquiat

CLIENT: *Whitney Museum of American Art, New York*

DESIGNER: *Nathan Garland*

SPONSORS: *Larry Warsh, The Art of Knowledge Corporation*

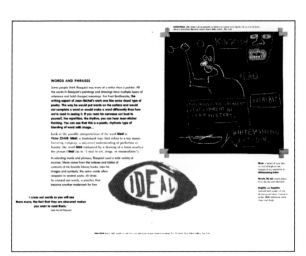

articulate art Jean-Michel Basquiat:
An Introduction for Students

For an exhibition of the neo-expressionist art of the late Jean-Michel Basquiat, the Whitney Museum of American Art developed an ambitious catalog that is directed at high school students but appropriate to museumgoers of all ages and educational backgrounds.

Basquiat's paintings incorporate the kind of graffiti and street art that children are familiar with. Expressive scrawls, anatomically incorrect figures, and interpretations of commercial logos and other icons are composed of what seem to be random scribblings. In fact, Basquiat borrowed much of his vocabulary from the urban environment—specifically New York City—and converted it, much as a child would do, into narratives of the real and imagined world.

To encourage inner-city schoolchildren to appreciate and understand the motives behind Basquiat's work, the Whitney Museum catalog features illustrations and footnote images that relate to the works, didactic captions that explain details, and an accessibly worded text that unlocks the mysteries of the artist's paintings. The design enhances the learning experience by clearly and economically presenting the various levels of information on a comfortable, approachable grid that allows even those with reading problems to navigate freely and enjoyably.

38

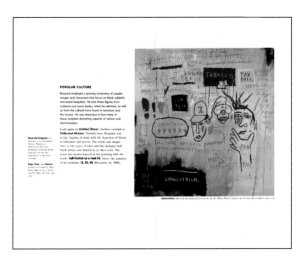

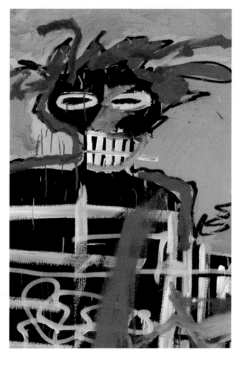

All Basquiat Works © 1992 The Estate of Jean-Michel Basquiat. Used by permission. All rights reserved. Courtesy of Whitney Museum of American Art and The Art of Knowledge Corporation.

munificent museum

The Children's Museum "Touch things. Talk out loud. Learn a lot." Isn't that what museums should offer as a rule? Certainly those designed to open children's minds and unleash their imaginations. Yet not all museums offer that kind of free access in their exhibits or printed materials.

Children demand more interactivity, and so museums devoted exclusively to children are a relatively recent phenomenon, but since their proliferation a generation ago almost every major American metropolis has one. The Children's Museum of Boston is among the most celebrated for its variety of sophisticated yet accessible programs and exhibitions, which are supported by an intelligent array of study aids, kits, and other complementary graphic matter.

39

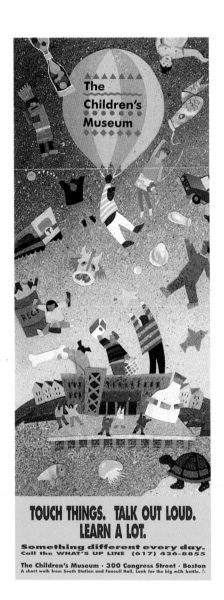

TOUCH THINGS. TALK OUT LOUD. LEARN A LOT.
Something different every day.
Call the WHAT'S UP LINE (617) 426-8855
The Children's Museum · 300 Congress Street · Boston
A short walk from South Station and Faneuil Hall. Look for the big milk bottle.

The Children's Museum
CLIENT: *The Children's Museum, Boston, Massachusetts*
DESIGN FIRM: *The Children's Museum*
PHOTOGRAPHER: *"Mind Your Own Business," Donna Paul*

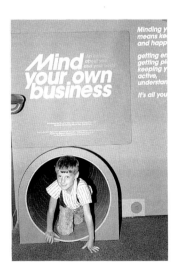

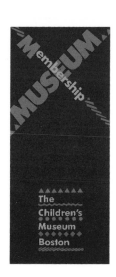

Set against carnival colors and shapes (wavy patterns, squiggly rules, dotty decorations, and swerving type), The Children's Museum graphics owe their style to contemporary illustration mannerisms found in collage, scratch-board, and woodcut. The concepts echo the current preference for graphics with Matisse-like simplicity, a style that engages the young viewer viscerally while defining the tenor of the museum's activities. The raucous imagery directly appeals to the target audience, and yet the typography used for both print materials and exhibition signage does not undermine legibility. For the show Mind Your Own Business: An Exhibit About You and Your Body, the type treatment is boldly contemporary yet intentionally conservative compared to the attractions themselves, like The Giant Intestine, through which children take a fantastic simulated voyage through the human body. This balance of carnival and subdued graphics is an effective means for engaging and teaching children.

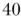

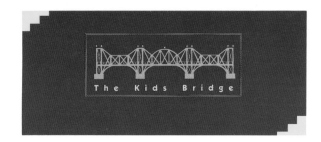

The Children's Museum
CLIENT: *The Children's Museum, Boston, Massachusetts*
DESIGN FIRM: *The Children's Museum*
PHOTOGRAPHER: *Top left: "The Kids Bridge," Don West*

40

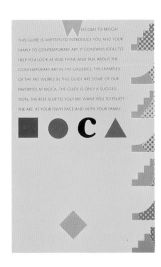

MOCA Guide
CLIENT: *Museum of
Contemporary Art,
Los Angeles, California*
DESIGN FIRM:
Pentagram Design Inc.
DESIGNER:
Belle How

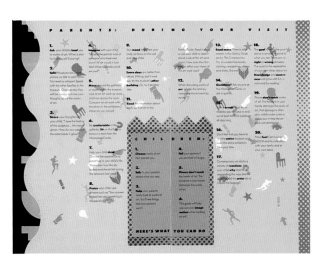

delightful docent MOCA Guide

Art museums can be intimidating places for adults, no less children. So to welcome visitors, the Museum of Contemporary Art (MOCA) in Los Angeles prepared a brochure "to introduce you and your family to contemporary art." Replete with postmodern ornaments, dingbats, and colors, the brochure is purposely designed to be as friendly as possible, as if it were a guidebook to a fair or theme park. While primarily aimed at parents (there is a section with the heading "Parents: During Your Visit"), a specially marked section is directed at kids ("Children: Here's What You Can Do"). The brochure's main intent is to foster inquisitiveness, imagination, and fun, all of which are effectively underscored by its unconventional, carnival-like appearance.

mobile museum Go Van Gogh

Van Who wouldn't be curious at seeing the Go Van Gogh van making its rounds throughout Dallas? Piquing interest in the local cultural institution was the idea behind the orange van, whose windows are covered with reproductions of faces found in some of the Dallas Museum of Art's best-loved paintings.

Designed to appeal to all ages, the van is a pleasing invitation to the museum that owes its creation to the desire to attract more children. Indeed, this moving advertisement, which routinely traverses the city's streets and avenues, captured the attention and imagination of many passersby and helped increase youthful attendance at the museum by a significant amount.

41

Go Van Gogh Van CLIENT: *Dallas Museum of Art, Dallas, Texas* DESIGN FIRM: *Sibley Peteet Design* ART DIRECTOR: *Rex Peteet*
DESIGNER: *Rex Peteet* ILLUSTRATOR: *Sibley Peteet Design* PHOTOGRAPHERS: *Various*

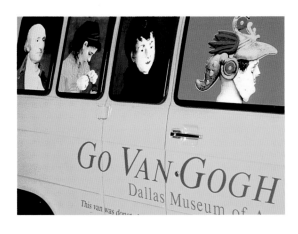

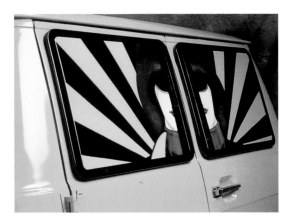

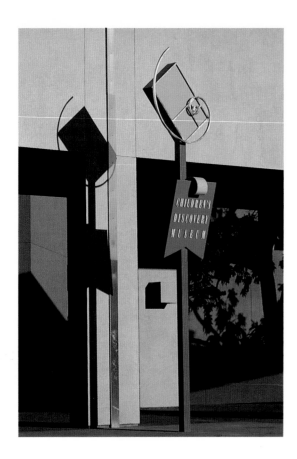

Children's
Discovery Museum
CLIENT: *Children's
Discovery Museum,
San Jose, California*
DESIGN FIRM: *The office
of Michael Manwaring*
DESIGNER: *Michael
Manwaring*

exciting signs Children's Discovery
Museum Should a children's museum look like a children's museum? In Houston the answer is yes (see page 44). In other cities the answers vary, and are dictated by the availability of space, zoning regulations, and other factors. The Children's Discovery Museum in San Jose, California, is a typically unadorned modern edifice that on the outside reveals hardly a hint of what's to be found inside. Therefore much of the weight of identification is placed on its signage. The colorful post to which the museum's entry sign and additional graphic elements are attached is not merely a stylized way finder, but a means to inform the viewer that the building is constructed on the principle of the golden section, as exemplified by the Parthenon.

42

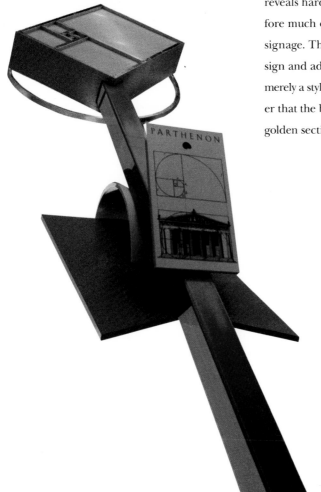

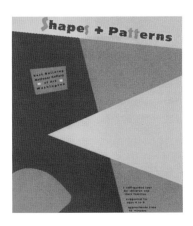

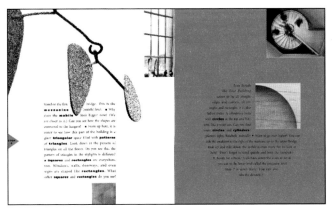

artful escorts Shapes + Patterns

and **Portraits + Personalities** Just the title "National Gallery of Art" has an imposing ring. Yet America's premier art museum wants to be as inclusive as possible, especially for children. To that end its activity booklet *Shapes + Patterns* (suggested for 4- to 8-year-olds) is designed as "a self-guided tour for children and their families." Although this publication is ostensibly for adults to use in guiding children through the collection, its bold patterns and colors signal that it is indeed for children. Moreover, the booklet serves as a model, for as more adult-oriented museums welcome children, the need grows for materials like this that will appeal to and challenge the child.

Portraits + Personalities (suggested for ages 8 to 10) provides a similar guide to the museum's portrait and figure paintings. It offers insights into the composition of portraits, including what the details—clock, candles, sword, maps, and papers—found in a nineteenth-century portrait of Napoleon Bonaparte indicate about his personality. Many of these details are highlighted in blowups that punctuate the pages, allowing the reader to make the necessary observations. Also shown are the materials used to make portraits, such as paints, a palette, and brushes. While the design is not raucous, neither is it so subdued that the young reader could mistake this for a boring textbook.

43

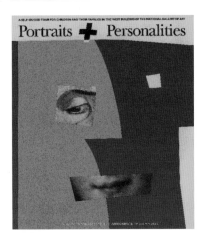

**Shapes + Patterns,
Portraits + Personalities**
CLIENT: *National Gallery of Art, Washington, D.C.* DESIGN FIRM: *Grafik Communications Inc.*
DESIGNERS: *Richard Hamilton, Susan English*
ILLUSTRATORS: *Richard Hamilton, Susan English*
PHOTOGRAPHERS: *National Gallery staff*
WRITERS: *National Gallery staff*

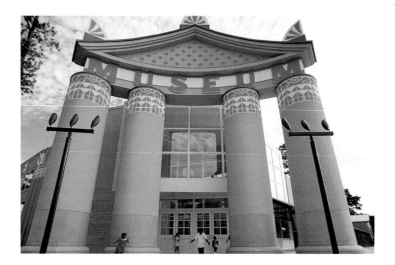

The Children's Museum of Houston
CLIENT: *The Children's Museum of
Houston, Houston, Texas*
DESIGN ARCHITECT: *Robert Venturi,
Venturi, Scott Brown & Associates*
ARCHITECT: *Jackson + Ryan*
PHOTOGRAPHER: *Nash Baker*
LOGO: *Designed by Craig Minor,
Minor Design Group*

educational environs

The Children's Museum of Houston To enter The Children's Museum of Houston, one must first walk through the swollen yellow columns that hold up a faux neoclassical pediment on which the word *museum* is carved and painted in bright red letters. This entry has become the virtual logo for America's most ambitious children's museum, and identifies Houston the way the Arc de Triomphe and Brandenburg Gate signal, respectively, Paris and Berlin. This delightfully imposing, cartoonlike parody of classical architecture—and in particular, of museums built in the Beaux-Arts style—is just one of the many environmental extravaganzas offered at this model institution. Though many of the young visitors may not understand the humor behind the entryway, or the other architectural puns that are sprinkled around the exterior, they cannot help but know that this highly animated structure is made especially for them.

In addition to its *architecture parlant* and exhibitions, The Children's Museum of Houston offers printed materials designed at once to convey its child orientation and the seriousness of its activities. The logo, a simplified paper cutout interpretation of the entryway, suggests the playful and educational nature of the institution. Brochures, fliers, and the newsletter used to announce classes and other events are adorned with similarly styled decorations, but are designed more simply and conservatively than the building itself to ensure ease of comprehension.

44

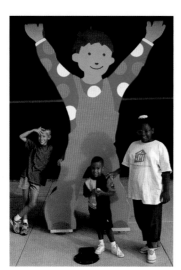

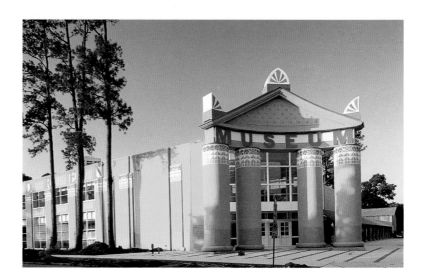

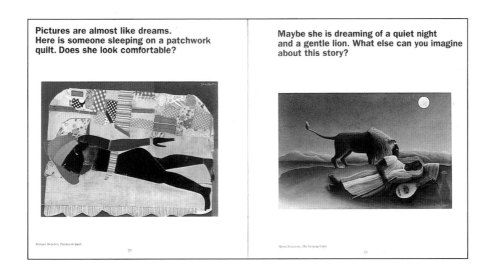

Pictures are almost like dreams. Here is someone sleeping on a patchwork quilt. Does she look comfortable?

Maybe she is dreaming of a quiet night and a gentle lion. What else can you imagine about this story?

Romare Bearden, *Patchwork Quilt*

Henri Rousseau, *The Sleeping Gypsy*

The Children's Museum of Houston is part of a trend in educational environments that are designed as active learning labs, where children can be taught not only about life's phenomena but also about how to use a museum.

cocoa table books Stories

The Museum of Modern Art in New York has welcomed children virtually since its inception. Saturday art classes are one of many programs that encourage the making and understanding of art. *Stories* by Philip Yenawine is another way of extending the museum experience beyond the confines and constraints of the building itself.

A compilation of well-known paintings from MoMA's permanent collection, *Stories* reveals meanings hidden within the images and urges children to make up and interpret stories about the people, places, and things represented. "Pictures are almost like dreams," reads the text over Romare Bearden's *Patchwork Quilt*. It then prompts readers to speculate about the figure in the painting.

The book is handsomely designed to show single images or up to four details per page. The questions are set in Franklin Gothic in a point size that is large enough to draw attention without being overpowering. Below each picture a caption indicates the artist and title of the work.

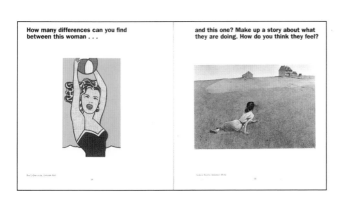

How many differences can you find between this woman . . .

and this one? Make up a story about what they are doing. How do you think they feel?

Stories
Philip Yenawine

The Museum of Modern Art, New York/Delacorte Press

Stories CLIENT: *The Museum of Modern Art, New York/Delacorte Press* DESIGN FIRM: *M + M Inc.* AUTHOR: *Philip Yenawine*

How Things Fly! CLIENT: *National Air and Space Museum, Washington, D.C.* DESIGN FIRM: *Grafik Communications Inc.*
DESIGNERS: *Susan English, David Collins, Judy F. Kirpich* ILLUSTRATOR: *Elwood Smith* GALLERY DRAWINGS: *National Gallery staff*

quizzical questions **How**

Things Fly! The Smithsonian Institution's National Air and Space Museum is not just for kids, but who better to enjoy and be inspired by all the wonders it has to offer, from the *Spirit of St. Louis* to Project Apollo spacecraft? Of course, merely displaying these historical artifacts is not enough to help a child learn. Explanation and comparison with other vehicles and inventions is required, which is why the museum offers study guides for children of various ages.

One of the most enlightening of these (even for adults) is an introduction to the phenomenon of flight produced to accompany an exhibition on flying machines. It begins by posing what might seem like a silly question, but it's one most visitors to the museum probably don't know the

answer to: "How <u>do</u> things really fly?" Illuminated with comic drawings by Elwood H. Smith, this spiral-bound, four-color (red, blue, yellow, and black) booklet is peppered with information and with questions from a variety of visitors. Sam, age 41, asks, "A 747 is bigger than my Uncle Melvin's barn. How does it ever get off the ground?" And Jody, age 26, asks, "If there's gravity in space, why don't the scales work?" These and other pressing queries are tackled in an easy-to-understand, delightful-to-experience keepsake that is at once a catalog and storybook.

46

If there's gravity in space, why don't the scales work?

Jody, age 26
Aerobics instructor

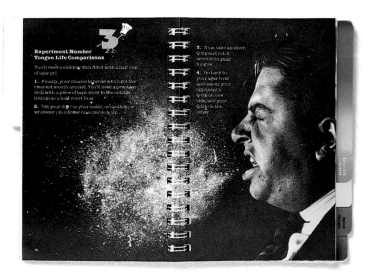

Explorabook: A Kids'
Science Museum
in a Book
CLIENTS: *Klutz Press,
Palo Alto, California, and
Exploratorium, San
Francisco* DESIGNER:
Mary Ellen Podgorski
CONCEPT: *John Cassidy and
Paul Doherty* ILLUSTRATOR:
Elwood H. Smith
PHOTOGRAPHERS: *Top, NASA;
bottom, UPI/ Bettman Archive;
licensed by the Roger Richman
Agency, Inc., Beverly
Hills, California*

handheld museum Explor-
abook: A Kids' Science Museum in a Book What

does a sneeze look like if you don't cover your nose and
mouth? One would be surprised to see the galaxy of mat-
ter that is released into the atmosphere with the initial
"achoo!" And what is a bacterium? According to a picture
in *Explorabook,* it looks suspiciously like a rabbit's foot with
tails. There are more insights and observations made in
this collection of weird but enjoyable experiments.

Unlike other science textbooks, *Explorabook* is designed
to be part game, part guide to the physical sciences. It
employs what might be called the "Mr. Wizard" (the ven-
erable syndicated TV science show) approach to teaching
science through everyday objects.

The book is efficiently and humorously designed in a
spiral-bound format that combines striking photographs,
lucid diagrams, and witty drawings by Elwood H. Smith.
It is organized into sections using colorful divider tabs that
allow the reader to jump easily from one topic to anoth-
er—from "Magnetism" to "Bacterial Stories," "Homemade
Science," and "Optical Illusions." Given its decidedly irrev-
erent tone, *Explorabook* could persuade even the most resis-
tant student that science might actually be fun.

47

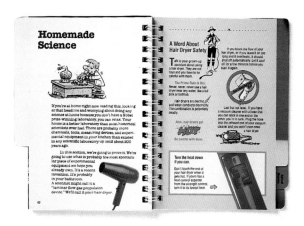

mighty mall **Imaginarium** Toy stores

come in a number of varieties. There are the warehouses of excess in the manner of Toys "R" Us, where merchandise is unimaginatively stacked to the ceiling. And there are the theaters of joy, like F.A.O. Schwarz, where exhibits are carefully designed as if they were figurations of a child's fantasy. Both are commercial environments, the former a supermarket, the latter a specialty store. Imaginarium is a toy store that is part theater, part carnival, and part museum. It is also artfully designed.

From the miniature doorway for children to the starlit logo to the T-shirts, shopping bags, and even to the receipts and invoices, Imaginarium is a totally designed environment—a confluence of children's imagery and sophisticated aesthetics. While the toys take center stage, Imaginarium's identity is a key factor in the store's appeal. The avoidance of child-oriented clichés suggests that this establishment does not pander to its customers, and that its merchandise will not be substandard.

With the increasing awareness among designers that children have higher tolerances for unusual forms and colors, more companies are creating sophisticated designs without totally rejecting children's basic interests. Imaginarium's elegance caters but does not speak down to children and serves as a model for other thoughtful approaches.

48

Imaginarium
CLIENT: *Imaginarium, Inc.,*
San Francisco, California
DESIGN FIRM:
Michael Mabry Design
CREATIVE DIRECTOR:
Sydney Cameron
DESIGNERS: *Michael*
Mabry, Margie Chu
ILLUSTRATOR:
Michael Mabry

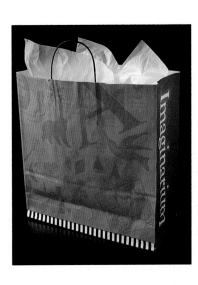

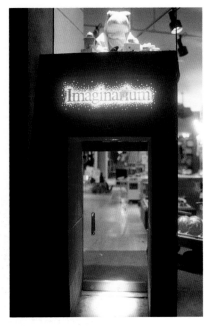

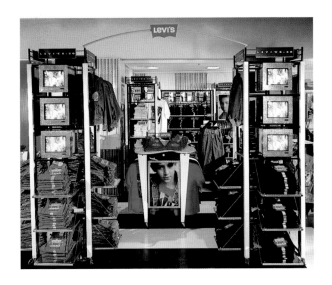

**Levi's Kids' Jean Shop
and Fixture Design**
CLIENT: *Levi
Strauss & Co., San
Francisco, California*
DESIGN FIRM:
Morla Design
DESIGNERS:
*Jennifer Morla,
Scott Drummond*
PHOTOGRAPHER:
Kit Morris

merchandise metallica

Levi's Kids' Store One might describe Jennifer Morla's design for Levi's Kids' Store as a cross between a warehouse and the starship *Enterprise*. Banks of small televisions housed in stainless-steel boxes playing Levi's commercials are mounted on movable metal racks. The walls are made of corrugated metal and the shelves are brushed steel. Upon entering this environment, a child cannot help but be overwhelmed by the density of denim, with jeans and jackets sitting on and hanging from the various metallic displays. The space is punctuated by metal-framed color photographs of child models decked out in Levi's finest, and is further enlivened by the strong graphics of Levi's labels and hangtags.

super shingle

Heffalump When Michael Manwaring was commissioned to design a logo and sign for one of San Francisco's most successful toy stores, the problem he faced was how to do justice to the wonderful name Heffalump, borrowed from an imaginary character in Winnie-the-Pooh stories. Manwaring decided to use his imagination and go with a typographic solution.

Using classic roman letters and fleurons (printer's ornaments), Manwaring developed a marriage of word and image. At once traditional and modern, the logo is also both functional and mysterious. The word *Heffalump* forms the body of a mascot: an abstracted child. Since its basic form is so well defined, the logo can be used large, as on an outdoor shingle, or small, as on stationery, bags, and wrapping.

49

Heffalump
CLIENT: *Heffalump Children's Store,
San Francisco, California*
DESIGN FIRM: *The office of Michael Manwaring*
DESIGNER: *Michael Manwaring*

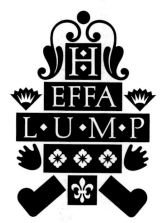

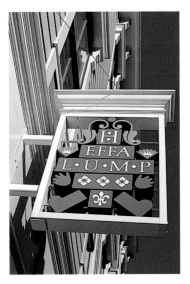

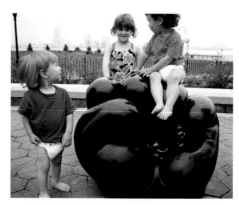

The Real World CLIENT: *Hudson River Park, New York* ARTIST: *Tom Otterness*
COURTESY: *Brooke Alexander Gallery, New York* PHOTOGRAPHER: *Tom Otterness*

lilliput on the hudson

The Real World New York City abounds with exciting places for children to explore, but none of them is more full of fantasy than the park adjacent to the children's playground at Battery Park City. Here the most improbable oasis is populated by a tribe of tiny beings who, though they don't move a muscle, can be observed rolling massive coins, hog-tying angry cats, ambushing innocent birds, bamboozling oversize frogs, and frolicking on the toes of gigantic feet and the fingers of a mammoth fist. These are not the petrified remains of some long lost civilization unearthed during the city's reclamation of this once arid riverfront area, but a new garden of mysterious—and very earthly—delights.

The lilliputian characters are actually brass and steel castings created by the sculptor Tom Otterness, whose imagination was turned loose on this otherwise ordinary city park, resulting in a bizarre and whimsical world filled with Bosch-like characters and their unsuspecting victims. The sculptures, which are of various sizes, are literally embedded in the walkways and sit on the benches and at the chess tables that punctuate the park.

Otterness's highly amusing sculptures invite passersby to touch, feel, pet, and even climb them. Children are enticed to follow a path of enormous pennies into the park, where they can get caught up in the gleeful pandemonium and take joy in finding the small change hidden under benches and tables.

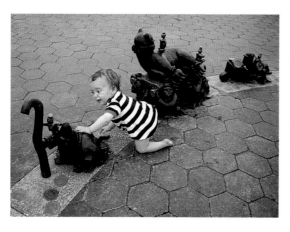
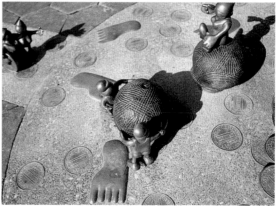

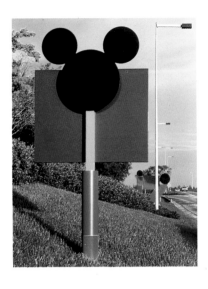

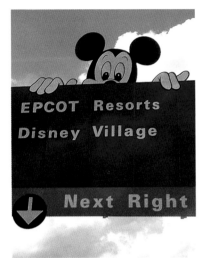

mouse signs **Walt Disney World**

Walt Disney World in Orlando, Florida, comprising theme parks, resorts, and other attractions, is as large as a medium-size city and is linked by roadways. A clear way-finding system enabling visitors to navigate the region was called for. Sussman/Prezja developed a plan that distinguished Disney World's signs from the Department of Transportation's typical brown-and-white ones by employing variations on an unmistakable motif: Mickey Mouse.

Although the system was not designed exclusively for the benefit of children, its creators have used a child's aesthetic in the overall plan by integrating a favorite cartoon character with vibrant postmodern colors and shapes. The design calls for traditional Mickey colors (red and black)

in combination with brilliant purples, oranges, and ultramarine suggesting Florida's tropical climate. Complementing the angular signposts are Mickey's perfectly round ears, which provide the surface for directional arrows.

Of the scores of signposts, the most impressive are those found on the highway approach to the Magic Kingdom. There, with each passing sign, Mickey's ears slowly rise over the information panel, until his entire face eventually appears in what is a tasteful and very clever marriage of tradition and functional contemporary design.

51

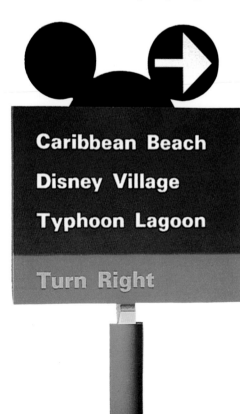

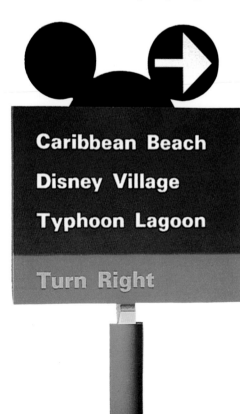

Walt Disney World CLIENT: *Walt Disney Inc., Orlando, Florida* DESIGN FIRM: *Sussman/Prezja* PHOTOGRAPHERS: *Timothy Hursley, Debi Harbin*

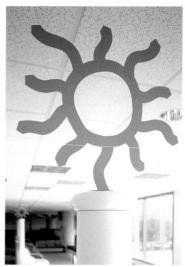

order in the court Edmund D.
Edelman Children's Court It's not fun for anyone to
have to appear in children's court, especially children.
Adding to an inherently uncomfortable experience, most
courthouses are not well designed, and frequently ignore
a child's basic need to feel unthreatened and secure. Such
is not the case at the Edmund D. Edelman Children's Court
in Los Angeles, where every attempt is made to humanize
the signage, directionals, and waiting areas with graphics
designed with children in mind.

Each of the building's six floors is color-coded with a
pleasing pastel or primary hue, and is signified by a simple
icon (for example, a star, a snowflake, a cloud) rendered
in a loose, childlike manner. Restrooms are indicated by

tasteful supergraphics and waiting areas are denoted by
three-dimensional versions of the floor's specific icon. Graph-
ic elements are complemented by soothing wall and door
color combinations and well-lighted hallways that don't hide
the building's function, but do take the edge off it.

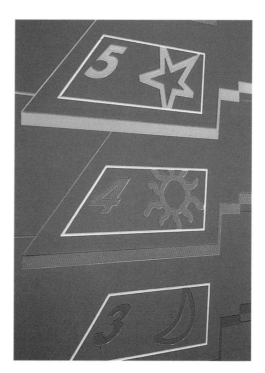

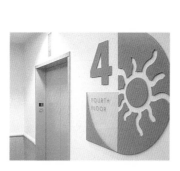

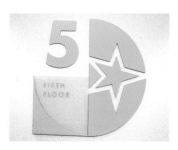

Edmund D. Edelman Children's Court
CLIENT: *Edmund D. Edelman Children's Court,*
Los Angeles, California
DESIGN FIRM: *Wayne Hunt Design, Inc.*
DESIGNERS: *Wayne Hunt, John Temple,*
Sharrie Lee, Kathryn Go
PHOTOGRAPHER: *Charles Allen*

52

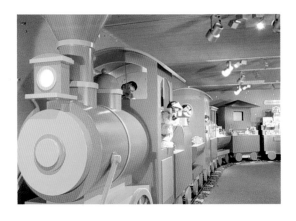

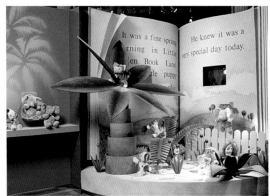

kid conscious

Hasbro Before children and parents can be merchandised to, the merchandise must be sold to retailers. It's here that a well-designed showroom display can mean the difference between success and failure. Yet not all toy displays do justice to the products. Sussman/Prezja's showrooms for Hasbro, one of America's leading toy manufacturers, are designed as ideal playrooms.

In one showroom a life-size storybook train painted in "carnival modern" colors—various complementary shades of orange, purple, and green—carries the current inventory of dolls, toys, and games. In another, an illustration in a large book comes alive with trees and ferns that frame Hasbro's plush animals. And in another, a cutaway of a lake reveals a faux aquarium with exotic toy fish, framing the introductory display of a child's first fishing rod and tackle.

In addition to the showrooms, the facade of the corporate headquarters signals a world of play. The windows on the front of Hasbro/Playskool's New York office, located in a landmark cast-iron building, feature large, impressionistic paintings on paper of children at play.

53

Hasbro
CLIENT: *Hasbro Toys Inc., New York*
DESIGN FIRM: *Sussman/Prezja* PHOTOGRAPHERS:
*Top left: Annette Del Zoppo; top right, bottom
left: Len Gittleman; center right, bottom right: Bo Parker*

the right foot **Stride Rite** Once upon

a time catering to children's tastes or aesthetics was not a priority, and the majority of children's clothes were smaller versions of adult styles. This is no longer the case. Indeed, more than ever children's clothes and accessories are designed and marketed expressly for young consumers. Young children have become bewilderingly clothes conscious.

Sneakers are currently a boom industry; they come in hundreds of styles for every mood and taste, and in a wide variety of colors and patterns. Stride Rite, one of America's foremost shoe manufacturers, has employed Big Blue Dot to create window displays that appeal specifically to children. The three-dimensional sets, including comic flying TVs, a dinosaur taking a bath, and an orange octopus,

Stride Rite
CLIENT: *Stride Rite Corporation, Cambridge, Massachusetts*
DESIGN FIRM: *Big Blue Dot*
DESIGNER: *Scott Nash*
ILLUSTRATORS: *Scott Nash, Tim Nihoff*
OTHER: *Walter Trinkle, Stride Rite*

Meet the Keeper

CLIENT: *Philadelphia Zoo,*
Philadelphia, Pennsylvania
DESIGN FIRM: *Cloud and*
Gehshan Associates, Inc.
PROJECT PRINCIPAL:
Virginia Gehshan
DESIGNER: *Jerome Cloud*
ILLUSTRATORS: *Jerome*
Cloud, Annette Vander
PHOTOGRAPHER:
Tom Crane
DETAILING: *Gary Lowe*

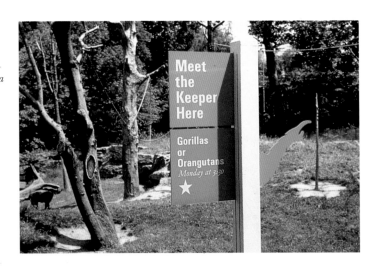

are among the options for Stride Rite retailers. Each set is made of simple materials and features bright colors and strong typography that evoke a delightful fantasy world.

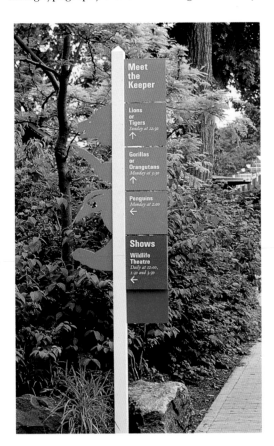

animal acts **Meet the Keeper**

Every zoo has a way-finding system, but how many are as engaging as the attractions? Cloud and Gehshan's system for the Philadelphia Zoo was designed to support a unique feature called "Meet the Keeper," tours by the experts in different areas and attractions held at various times during the week. The signposts situated throughout the zoo have color-coded guide panels on one side of the pole and silhouettes of the animals on the other, and inform visitors of the various meeting places and tour times. The information panels are handsome and functional, while the silhouettes, including a lion's head, eagle's wing, elephant's trunk, and gorilla's arm, are unmistakable eye-catchers that add humor to the overall environment.

55

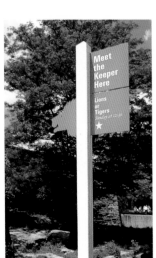

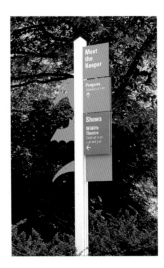

novelties and gifts

Two kinds of child-oriented gifts and novelties are surveyed here. One is "stuff" directly marketed to children, like stationery and supplies, and the other comprises the accessories designed with children's motifs for parents to use, like scrapbooks and notecards.

The first category has been a boom industry for decades. Toward the end of every August mountains of "Back to School" supplies—notebooks, lunchboxes, and the like—fill the variety and stationery stores. Even as these items signal an end to summer, they contribute to the fun of preparing for that inevitable day with spanking-new materials. By no means has there been a shortage of novelty supplies emblazoned with popular children's characters or heroes, but in recent years a noticeable change in aesthetics has taken place. In addition to designs featuring licensed characters (e.g., Mickey Mouse, Bart Simpson, Hulk Hogan), original designs are finding their way onto, among other products, pens and pencils. Companies are borrowing or commissioning design motifs from nonmainstream sources (such as cartoonists) and adapting them for commercial use. While this is not a new phenomenon—the avant-garde is often raided for its most advanced yet acceptable veneers—the recent crop of materials reveals a more adventurous side.

Accessories for parents—scrapbooks, notecards, and so forth—have recently changed in appearance: Conventional child-based colors and motifs have given way to subtler hues and more refined images. Presuming that many adults would like alternatives to clichéd merchandise, the designers whose work is shown here have both reprised the past and invented the present. Soothing colors, unique bindings, and modern graphics have made common baby gifts and supplies more appealing, if not more functional.

57

chapter three

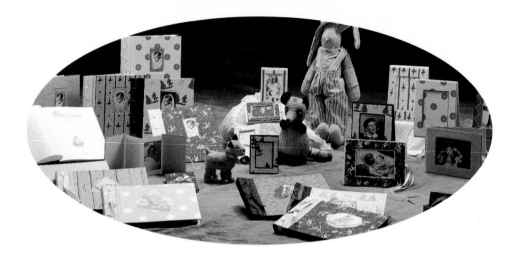

Baby Collection (including paper samples, below) CLIENT: *Two Women Boxing, Inc., Dallas, Texas* DESIGNERS: *Linda Finnell, Julie Cohn*

elegant accessories **Baby Collection**

Not all design with children in mind is specifically design for children. The handcrafted papers, books, frames, and stationery items created by two artists calling themselves Two Women Boxing bring fine craftsmanship, distinctive materials, and convention-busting design to parents of small children. Many businesses offer photo albums and baby diaries, products that are intended to preserve the memories of infancy. But unlike most mainstream concerns, which offer a commonplace, and limited, assortment of gender-descriptive colors and patterns, Two Women Boxing has created a unique range of bindings, papers, and wrappers that at once evoke childhood but are free of the most timeworn children's clichés.

Each product is a hand-bound and wrapped one-of-a-kind object. The mere presence in the nursery of goods marked by such a stylish sensibility cannot help but influence the child's developing aesthetic.

writing sampler **Children's Box**

Children enjoy kits. The appeal is that in a single bag or box one can receive a variety of little gifts. Papier Deux's Children's Box is an elegant, but not formal, variation on the kit theme. It includes pencils and sharpener, illustrated notecards and writing pad, writing book, and T-shirt, all unified by playful design and packaged in a cardboard container printed with patterns of the woodcut illustrations that are also used on the items inside.

58

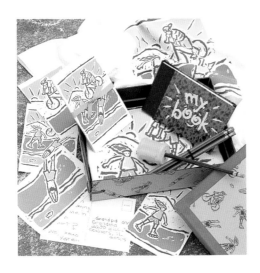

**Children's Box,
Party Invitations**
CLIENT: *Papier Deux,
Atlanta, Georgia*
PHOTOGRAPHER:
*Nelda Mays,
Atlanta, Georgia*

This gift is without artifice or conceit. The simple thematic illustrations of children bike riding, roller skating, and swimming are well executed and discreetly colored. The writing book is perfect-bound with a boldly scrawled "My Book" painted on the cover in white.

artful invites Party Invitations Theme

birthday parties are always in vogue, and the gift and party stores are stocked with paper products featuring popular characters and trends for just that purpose. But for those parents and children who choose to throw a more traditional bash, Papier Deux's party invitations, announcements, and thank-you cards do the job well and without the graphic excesses found on most mass-market items.

These cards are printed on high-quality papers in muted though eye-catching pastels. The drawings, including a figure playing a clarion and an elephant waving a flag in its trunk, are economically rendered in a humorous style. The lettering on the cards is loose, ornamented with the occasional swash.

bookplate special Bookplates

Some of the designs used for children's bookplates have been around for decades. They are serviceable but perhaps a little on the generic side aesthetically. Today's visually adventurous children's books cry for something more, and Robert Sideman of Oakdale Press has addressed this need by commissioning a series of witty and graphically fresh ex

Bookplates
CLIENT: *Oakdale Press,
Chicago, Illinois*
ART DIRECTOR: *Tom
Greensfelder*
ILLUSTRATORS: *Left to
right, top row: Lynda
Barry, Ann Jonas, Milton
Glaser, Norris Hall,
Stephen Alcorn; bottom
row: Leslie Evans, Steven
Guarnaccia, Philippe
Weisbecker, Peter
Hannan, Cathie Bleck*
(© Oakdale Press)

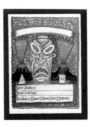

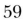

Bookplates for Children
CLIENT: *Papier Deux,*
Atlanta, Georgia
PHOTOGRAPHER:
Nelda Mays,
Atlanta, Georgia

Valentine Dinosaur Card
CLIENT: *Hallmark*
Cards Inc., Kansas
City, Missouri
DESIGN FIRM: *Hallmark*
Cards Inc.

libris, each by a different illustrator, and each printed in muted tones on uncoated stock and packaged in a textured paper envelope. The letterforms differ from plate to plate, lending the series variety at the same time that packaging, paper stock, and format tie the individual works together.

pretty papers **Bookplates** Although they are still manufactured—and, in a continuance of tradition, various printers commission popular artists to design them—bookplates today are considered somewhat arcane. Nevertheless, Papier Deux has created a line of bookplates for children featuring nineteenth-century woodcut and wood-engraved vignettes that have been recolored in soft, contemporary shades. These offer more than nostalgia;

they serve to emphasize a child's responsibility to his or her book, and instill pride through that ownership.

dino card **Hallmark** In and of themselves greeting cards are nice, but greeting cards that offer activities are even better. Hallmark has achieved both of these desirable traits with its Valentine Dinosaur and puppet cards. Designed with new-wave motifs, bright colors, and childlike illustrations, the valentine allows the recipient to punch out and fit together the pieces of a postmodern tyrannosaurus, and the puppet card provides a hand puppet and scenic backdrop rendered in a graffitilike scrawl. The boldly colorful, raucous aesthetic is unusual in a card market noted for soothing and safe design.

60

Puppet and
Cityscape Card
CLIENT: *Hallmark*
Cards Inc., Kansas
City, Missouri
DESIGN FIRM:
Hallmark Cards Inc.

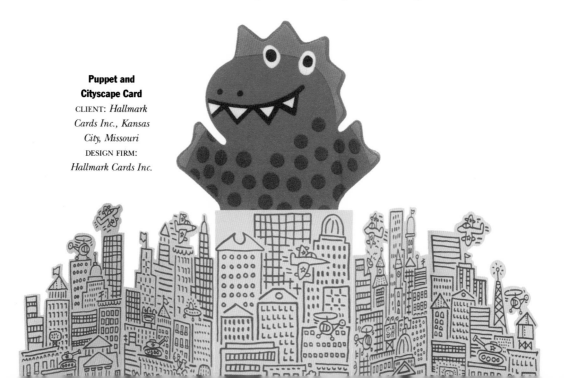

pop pencils

Pentech How does the manufacturer of a common #2 pencil distinguish its product from the scores of other brands on the market? Easy: Give it personality through an appealing package. It takes keen intelligence to foresee that pencils wrapped in and adorned with alluring cartoon, comic, and storybook illustrations could make a dent in an already tight market. And it takes a certain level of taste to select the right artists to create vignettes that will appeal to school kids.

Pentech's pencils are a delightful blend of the absurd (such as Elwood H. Smith's "Grouchy: 5 Completely Impossible Pencils") and the sublime (for example, Lou Brooks's "Comix: Five Hopelessly Romantic Pencils!"). Each set, which contains five pencils, is dressed in the respective illustrator's funny, horrific, or romantic style. In fact, there's a style for every mood and every preference. The packages themselves are well-composed marriages of lettering and image created by the individual artist, emphasizing the theme of each pencil set. What sets the artwork on these items apart, however, from the conventional licensed cartoon or film images that adorn lunchboxes, notebooks, and other back-to-school paraphernalia is that it does not exploit trends or fashions, but rather, celebrates cartooning and design as entertainment. No pretense here, just well-designed fun.

Pentech
CLIENT: *Pentech International, Inc., Newark, New Jersey*
DESIGN FIRM: *Pentech Studio*
CREATIVE DIRECTOR: *Dana Melnick* DESIGNERS/ ILLUSTRATORS: *Clockwise from top left: "Stage Dive," Gary Panter; "Mad Dog," Gary Baseman; "Freaks," Mitch O'Connell; "Comix: Five Hopelessly Romantic Pencils!" and "Nutz!", Lou Brooks; "Grouchy," Elwood H. Smith; "Comix: Blam!", Lou Brooks*

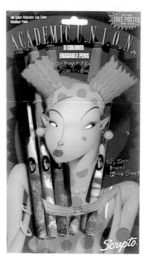
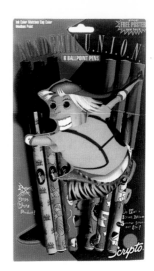

Academic U.N.I.O.N.

CLIENT: *Scripto-Tokai Corp.,*
Fontana, California
DESIGN FIRM: *Scripto*
Art Department
DESIGNER: *Bill Haffner*
ILLUSTRATOR: *Bill Mayer*
PHOTOGRAPHER:
Peter Samuals

write stuff **Academic U.N.I.O.N.** The

name of the game in commerce is "Monkey see, monkey do," and since new good ideas are hard to come by, why not borrow and build upon existing good ideas? Academic U.N.I.O.N. pencils and markers are afforded cachet by their delightful postpunk packages. Like Pentech's pencils, these mundane stationery items are transformed through design into fashion statements.

Finally, pens and pencils are imbued with the symbolism of student rebellion. This is a novel but not totally unique idea—pencils have traditionally been used for advertising and propaganda purposes, and have long been emblazoned with certain cartoon characters. Yet Scripto's packages, whose *Mad*-inspired comic mascots are rendered

in appealing postmodern colors, are decidedly contemporary, and even a tad risqué. Each includes a saying like "Rejected by society" and "More fun than a week of detention." While parody and satire have also been used before on other school supplies, such as protective book covers (who can forget the famous "School of Hard Knocks"?), lunchboxes, and so forth, this new series of pens and pencils takes the tradition a step forward—or backward, depending on who's in the position to judge.

62

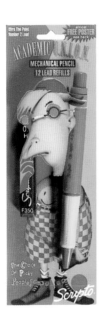
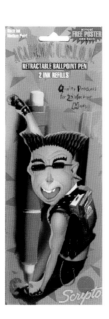

Children's Rugs

DESIGN FIRM: *Reactor Art & Design Limited, Toronto, Ontario, Canada*
DESIGNERS: *Clockwise from left: "Jungle," Rene Zamic; "Dice Dog," "Characters," "Cowboy," and "Robotman," Steven Guarnaccia*

under foot Children's Rugs A child's

room is a special sanctuary filled with the artifacts of inno-
cence and experience. Designers take great pleasure in
building environments for children that reflect their own
passions and fascination with the child's world. The result
is a range of furnishings—from beds to bed sheets, lamps
to lampshades—designed with child-oriented motifs. Reac-
tor Art & Design's rug project was initiated to explore what
artists and designers could do to enliven the home in such
ways. Among the results Reactor generated is a fascinat-
ing collection of limited-edition children's area rugs that
feature imagery kids adore (and seem unable to resist)—
robots, cowboys, jungles, monsters, and wacky characters—
all produced with fidelity to the original art.

63

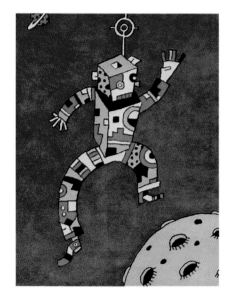

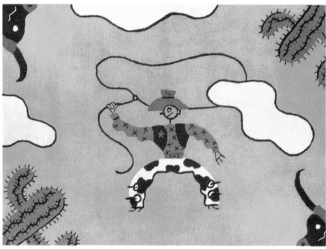

toys and games

The baby boom has spawned a generation of designers who, in the best sense of the Peter Pan Principle, keep childhood alive through their work. As mass-market toys become more grating (cowboys have been replaced by ninjas), there seems to be a growing backlash against not only violent content but cold-hearted manufacturing as well. Although not all molded plastic toys are frigid, a large number of them are void of any aesthetic virtue—which is why the young designers represented in this section prefer natural materials, basic forms and shapes, and beguilingly simple composition in the playthings they invent.

Most of the toys created by these designers are not targeted at a mass market. They are featured not in Saturday-morning TV commercials but in mail-order catalogs, amid more conventional fare. Many are made in the craft tradition, by an individual artist rooted in the aesthetics of contemporary design. The best reflect the personality of their creators, and appeal precisely because they are imbued with quirkiness. While the toys shown in this section may not be produced in very small, limited editions, neither are they "generic"; each attempts to reconcile individuality with the needs of the marketplace.

A young toy maker once said, "A present is something one buys, a gift is something one makes." In this sense the most splendid new toys and games are gifts, and packaging is a significant component of such items. In some cases the package is an integral part of the gift that is designed to be saved and reused, and perhaps even displayed as an artifact. In others the package is a simple container adorned with graphics that add to the allure and enjoyment of the product. The defining characteristic of these new toys and games is the attention paid to the aesthetic details that compose the whole.

chapter four

Double-Feature; Infant Stim-Mobile
CLIENT:
Wimmer-Ferguson Child Products, Inc., Denver, Colorado
DESIGN FIRM:
Wimmer-Ferguson Child Products, Inc.
DESIGNER: *Ruth Wimmer*
PHOTOGRAPHER:
Tom Virtue
CATALOG:
One Step Ahead

basic black & white

Double-Feature and **Infant Stim-Mobile** New babies see contrast rather than colors. During the first four months of their lives babies are stimulated by the basics, and in recent years designers have been catering to that aspect of infant development and to parents' taste with a variety of black-and-white toys. Among the most enticing is Wimmer-Ferguson's Stim-Mobile, which is designed to hang over the crib. Composed of three circles and two squares, it is illustrated with checkerboards, concentric circles, diagonal lines, and high-contrast human faces. For later stages of development colorful cards may be inserted.

Double-Feature, shown at left, is a mirror toy for infants with design features similar to those of the Stim-Mobile.

66

fabric friend

Wiggle Worm Ultimately, aesthetics are second to function in the design of baby toys. The new infant requires playthings that are safe, durable, and stimulating. Wiggle Worm is a good example of just such a toy, as it is designed to give the baby various play options: It makes three intriguing sounds (rattle, crackle, and squeak), has three rings for pulling and teething, and is made of a soft, washable fabric that can be folded and crunched, which encourages holding and grasping. Younger babies respond to the toy's bright, contrasting colors (green, red, blue, and yellow), which later allow parents to teach basic color names. In addition, Wiggle Worm has an appealing cartoonlike personality that makes it a friend as well as an object of delight.

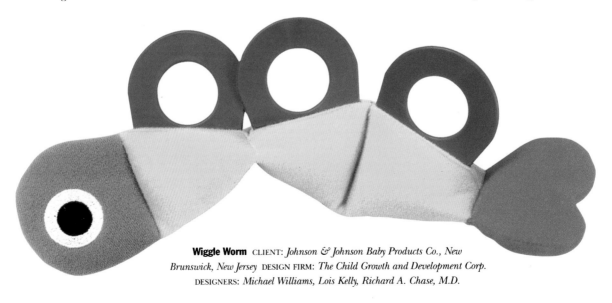

Wiggle Worm CLIENT: *Johnson & Johnson Baby Products Co., New Brunswick, New Jersey* DESIGN FIRM: *The Child Growth and Development Corp.*
DESIGNERS: *Michael Williams, Lois Kelly, Richard A. Chase, M.D.*

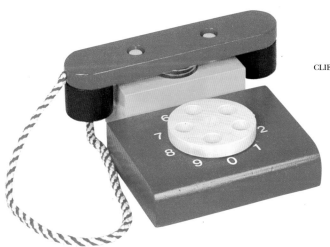

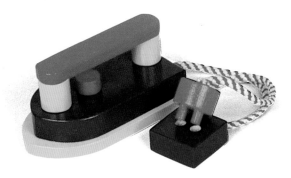

Wooden Telephone and Wooden Iron
CLIENT: *Guidecraft, Inc., Garnerville, New York*

humble appliances Wooden

Telephone and **Wooden Iron** Toddlers are quite aware of the world around them and take stock of the objects that comprise their universe. Simple playthings based on the activities of everyday life are useful in orienting children at this age into their surroundings. Paring down the most common products and appliances into component shapes is one way of teaching children about such accouterments. Unlike some toddler appliances, which employ soft, molded plastic lines, garish colors, and saccharine cartoon graphics, this telephone and iron feature primary colors, wood construction (they are crafted from recycled farmed hardwoods), and near-abstract design, raising them above the norm.

soft sell Spots the Dog Fabric activity books

are excellent tools for inducing young children to involve themselves not only in books but also in a variety of challenges ranging from buttoning to zipping, pocketing, tying, and reconfiguring. There are scores of soft fabric books on the market, each offering the same basic components, but most of them have an annoying anonymous quality, the various methods of sewing and cutting the fabric affording a given book whatever personality it might have. Furthermore, most such books lack a theme on which to hang all the activities. *Spots the Dog* takes that extra step with the addition of a central character, which not only makes this toy more booklike but also provides a context within which the various activities can be played out quite enjoyably.

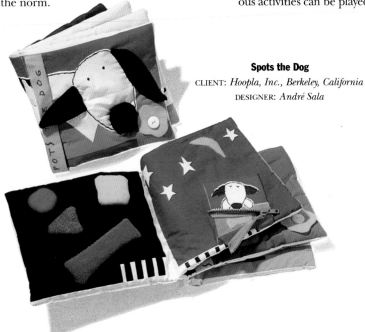

Spots the Dog
CLIENT: *Hoopla, Inc., Berkeley, California*
DESIGNER: *André Sala*

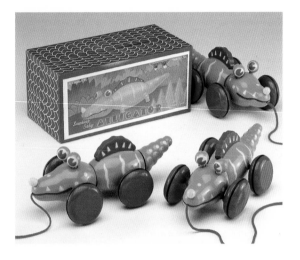

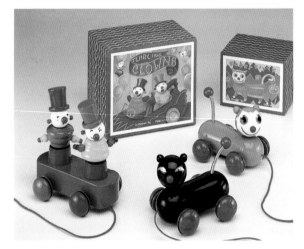

beautiful basics **Hoobert Toys**

In a market overwhelmed by action figures and movie tie-ins, Hoobert products provide a welcome calm. These back-to-basics toys are born of imagination, not market testing. The company's variations on classic wooden wheeled pull-toys (including its Sneaking Baby Alligator, Twirling Clowns, Kooky Kitty (gray or black), Chiming Octopus Boat, Hopping Bug, and Space Robot) and stacking toys (including a robot and skeleton) are aimed at young children but are so handsomely designed that they appeal to adults. In fact, David Kirk, the founder of Hoobert, Inc., originally created handmade, hand-painted wooden toys that were sold primarily to adults.

Hoobert toys are simultaneously very nostalgic and contemporary, and thus are reflective of their maker's passions. David Kirk's painting and drawing style takes inspiration from period imagery yet transcends the mustiness of the past. His toys are but one element in a total aesthetic that includes the company's logo and packaging.

Hoobert, Inc.'s packages are giftlike. The detailed, lovingly handlettered labels are paintings in the cartoon-fantasy tradition, evoking a wonderland sensibility, and the simple, colored cardboard boxes are embellished with line drawings to simulate wrapping paper. The boxes that contain the stacking toys are labeless but are adorned with delightful, eye-catching line decorations dropped out in white from a flat, colored background.

Filled with assortments of generic plastic and rubbery

68

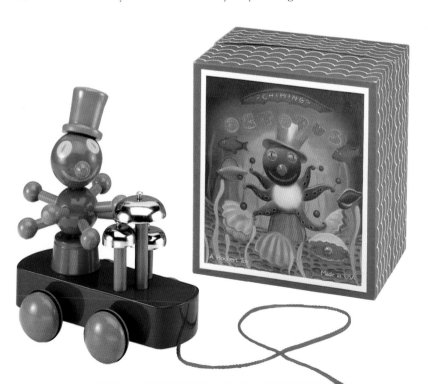

Hoobert Toys CLIENT: *Hoobert, Inc., Jamaica Plain, Massachusetts* DESIGNER: *David Kirk*

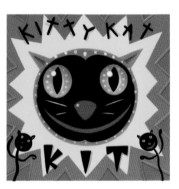

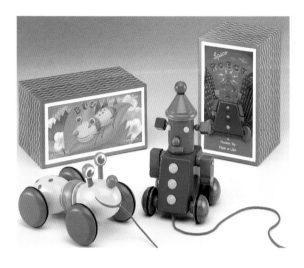

beasts and creatures, the Jumbo Can O' Friendly Dinos and Jumbo Can O' Creepy Insects are reminiscent of the cylindrical Tinker Toy packages of old, yet are more stylish. Like all of Hoobert's packages, these canisters are as fun to own and display as the toys inside them.

Kirk's interest in simple playthings is further revealed in the Creature Craft and Kitty Kat Kit activity boxes. Adorned with beautiful renderings of surreal, almost Bosch-like beasts, Creature Craft is a collection of feathers, pipe cleaners, beads, and bows that allows children to make their own toys and test their imaginations. Kitty Kat Kit, identified by a marble-eyed, smiling comic feline, provides the tools for turning out, as the order form says, "half-an-umpteen" wonderful "kitty kat" creations.

69

Brio Toys

CLIENT: *Brio Corp., Milwaukee, Wisconsin* DESIGN FIRM: *Brio AB*
DESIGNER: *Ingvar Pedersson*

pure and simple Brio Toys Like

Hoobert, Inc., Brio uses low-tech, high-quality materials. Many of the firm's toys are modeled on traditional forms (such as the push-and-pull variety) and have been in production virtually unchanged for decades, though they have an unmistakably contemporary look based on a Swedish modern aesthetic. These toys are designed for active use and, more importantly, are meant to excite the young child's perceptions.

Unlike Hoobert toys, which were influenced by Brio's products, and which are defined by their maker's artistic personality, Brio toys employ pure forms unfettered by decoration, and with only the sparest suggestion of char-

70 acter. The Brio racing car is red with black-and-white

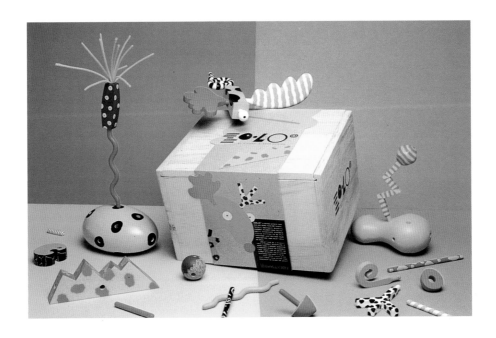

wheels, and a faceless yellow globe serves as a driver. The mini-dachshund has a slick, black tubular body accented by yellow ears and collar, and red-and-white wheels, with only the eyes offering a hint of expression. The stacking clown is more typical of traditional children's toys, with colored rings for the body and a classic clown face.

Brio also has a line of activity toys, which include a watering pump and pail and watering can, each designed using primary colors and clear plastic to attract and guide the eye toward how these objects work.

abstract art Zolo When it was introduced, Zolo was a conundrum. Was it a toy or was it art? Was it for children or adults? It represented a new design

sensibility. This kit of wacky shapes and biomorphic forms in a goofy but elegant wooden container was a stepchild of the madcap Memphis style, the cartoon-based design mannerism that influenced furniture, product, and graphic design in the early 1980s. In fact, Zolo is the quintessential translation of Memphis mania into a functional form.

While the motives and influences behind Zolo are unimportant to children, they are inducements for adults to buy the toy for their kids, and for themselves. The package, which features raucous lettering and bizarre creatures, is itself alluring. Zolo 2's round box with string latch combines purity of form with a boutique sensibility especially well. And the materials inside, colorful multiform sticks, bows, bolts, squiggles, and corkscrews for constructing toys according

71

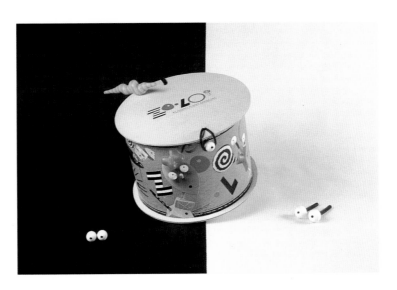

Zolo 1 (above),
Zolo 2 (left)
CLIENT: *Zolo Inc.,*
Dogue, Virginia
DESIGN FIRM: *Higashi*
Glaser Design
DESIGNERS: *Byron*
Glaser, Sandra Higashi
PHOTOGRAPHER:
Don Chiappinelli

UFITS puppet CLIENT: *HATS OFF! Development Corp., Rochester, New York* DESIGN FIRM: *HATS OFF!*

to one's fancy, transcend typical handcrafted elements yet seem homemade and custom made at the same time.

hand holder **UFITS puppet**

Making things is among the most satisfying experiences a child can have. And to make something that he or she can actually use begets an immeasurable sense of pride. UFITS puppets offer that possibility, as they are designed to be dismantled and reconstructed according to whim. Although the eyes, nose, and mouth are clearly defined, there is a certain latitude in the use of other decorative fabrics. In the tradition of Zolo (page 71), Luna (this page, below), and Wizbits (opposite page, below), UFITS puppets allow the child to build a reality from abstract components.

fractured forms **Luna**

Luna is based on supplying children with the raw materials and letting them invent their own crazy contraptions. Luna (the *U* in the logo is cleverly made from a crescent moon) is a jumble of quirky cardboard shapes of various colors that are joined by fasteners. Unlike Zolo and Wizbits, this is not just a collection of random shapes but includes certain pairs that allow the child to understand formal relationships such as balance and symmetry. Thus, the potential for creating a harmonious composition is greater, even though the result may just as often be an amorphic mass.

72

Luna
CLIENT: *DGI/Buki,*
Miami, Florida

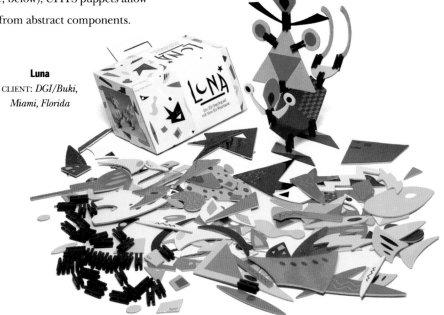

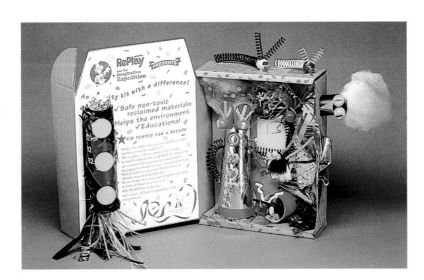

The Imagination Expedition

CLIENT: *Pappa Geppetto's Toys Victoria Ltd./RePlay, Blaine, Washington*

DESIGN FIRM: *Imagination Market, Vancouver Island, B.C., Canada*

DESIGNERS: *Linda Prior, D. J. Alperovitz*

comic cuts Wizbits and Giant Wizbits

Children love to cut and paste, and the shapes they make are often based on no known geometric forms. Of course, that is what makes them so charming. Wizbits, a construction toy consisting of ready-cut cardboard shapes, builds upon this naïveté, yet adds a few controls. Many of the shapes are seemingly arbitrary, while others are deliberately formed and perforated to encourage the child to make creatures with legs, heads, eyes, and antennae. The colors are uncharacteristic for a young child's toy—shades of purple, green, and orange—and are muted with colored halftone and mezzotint patterns. The result is a collection of inspirational forms that can stimulate a child's imagination.

stuffed stuff The Imagination Expedition

Billed as "Safe non-toxic reclaimed materials. Helps the environment. Educational," this RePlay activity kit is based on the same make-anything premise as Zolo, yet is more anarchic and less pristine. Indeed, one gets the impression that every box contains different stuff, selected randomly—including springs, cones, confetti, cotton balls, and streamers—for making a variety of beasties and things. In this way The Imagination Expedition enables the child to follow his or her own muse.

73

Wizbits *(right)* **and Giant Wizbits** *(below)* CLIENT: *The Wizbits Corporation, Orangeburg, New York* DESIGNERS: *Stephanie Shultz, Karen Erla*

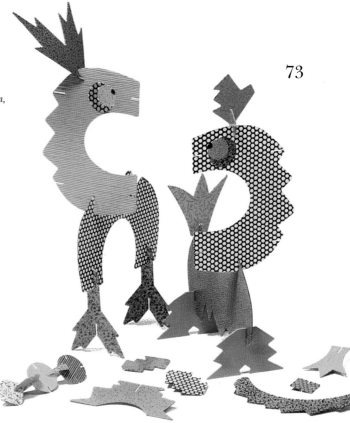

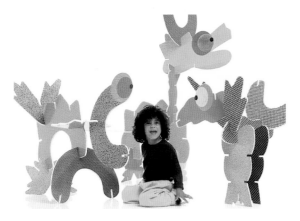

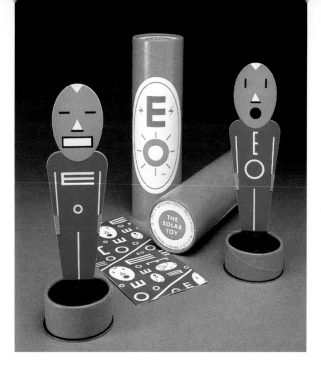

E-O
CLIENT:
Richard McGuire Toys, New York
DESIGNER:
Richard McGuire

solar power **E-O**

E-O is not a toy in the strictest sense. A child cannot exactly *play* with it, but can interact with it. In fact, E-O has hypnotic qualities, the result of its ingeniously simple design—striking orange and blue colors, kinetic typography, and constant movement. Billed as "The Solar Toy," E-O is a low-tech activity, something between a lava lamp and a flip book.

Housed in a short orange tube, the two-sided cardboard cutout E-O figure stands at military-style attention atop a photocell base. One side of his perfectly elliptical head is distinguished from the other by a different mouth shape, and each side of his body bears the letters *E-O* in a different configuration. When placed under an incandescent light or in the sun, the E-O man spins furiously, which makes him appear to be saying "E-O E-O E-O."

Richard McGuire, E-O's inventor and designer, brought the same fascination for low-tech simplicity to Puzzlehead, a puzzle game of interlocking heads, and Go Fish, a postmodern variant on the standard children's card game.

spaced out **Space Phone**

The colors are bright. The package is unusual. The form looks like the thrusters on the space shuttle booster rocket (or the end of a stethoscope). What is it? Space Phone. The two conelike cylinders connected by a plastic tube somewhat simulates that old telecommunications marvel, two tin cans on a string. Although relatively functionless, like many aesthetically pleasing, enigmatic objects, this toy opens

74

Space Phones CLIENT: *DaMert Co., San Leandro, California* DESIGN FIRM: *Toy Science*

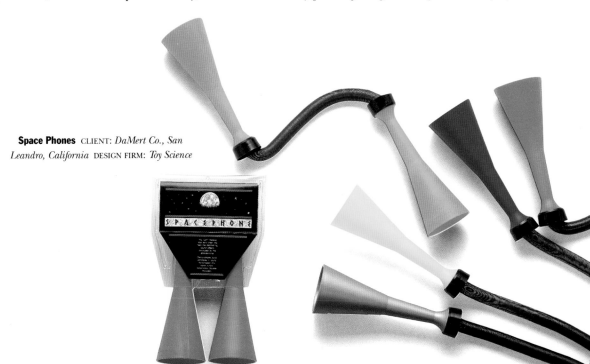

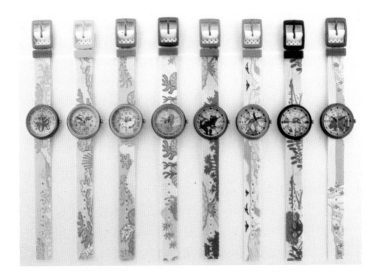

flik flak® Watches
CLIENT: *flik flak,*
New York
DESIGN FIRM:
Dupont Design
DESIGNER:
Nicole Dupont
PHOTOGRAPHER:
Ferdinando
Godenzi
(flik flak is a
registered trademark
of ETA SA)

up the doors of the imagination. It can be used as a telephone, or whatever the child's mind can conjure.

wacky watches flik flak Watches

Swatch, the Swiss timepiece company, revolutionized the marketing of watches in the 1980s. Instead of time-honored necessity they became costume jewelry—rather than one watch serving all functions, many watches served various moods. Swatch not only introduced hundreds of appealing face and wristband designs, they made their products affordable, too.

With the rise of the watch as a popular accessory, it was only a matter of time before children were targeted as consumers. But a watch is not just a piece of jewelry or a toy,

it is an instrument that requires a certain amount of skill to decipher. If the advent of digital watches has hindered children's ability to tell time the traditional way (the big hand is on…the little hand is on…), then flik flak has developed a line of imaginatively designed watch faces that are helping to rectify the situation.

Flik flak faces are no-nonsense when it comes to the clarity of the numbers, but they are nevertheless full of delightful detail, such as the character-shaped big and little hands, and the multicolored watch faces and bands. Telling time is made simple with two levels of numbers—minutes on the outside and hours on the inside circle. A more advanced model comes with a sweep hand that indicates seconds, too. While the graphics include some

75

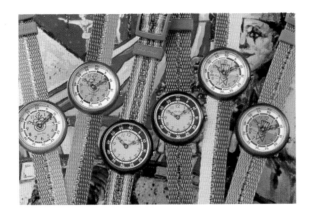

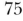

The Learning Clock™ CLIENT: *Learning Resources, Inc.,
Lincolnshire, Illinois* DESIGN FIRM: *Learning Resources, Inc.*
PHOTOGRAPHER: *Mike Brosilow*
(The Learning Clock™ is a trademark of Learning Resources, Inc.)

gender-specific stereotypes (e.g., spaceman for boys and princess for girls), they are used primarily as inducements for children to use a watch that will efficiently help them learn how to tell time by the longstanding analog method.

time changes Learning Clock, Kinder Clock, and Teaching Clock

Despite the popularity of digital readout clocks, parents and educators realize the need for children to learn to tell time on an analog clock. Few teaching clocks on the market are as progressive as these, which not only teach time according to hours and minutes (some in arabic as well as roman numerals) but make a game out of it. The easy-to-read Learning Clock has visible gears on its face to demonstrate a clock's inner workings. The Kinder Clock is a puzzle that encourages the child to look at the individual numerals of a clock as parts of a larger unit. It consists of odd-shaped pieces the child snaps together, arranging the numerals in a specific sequence. The Teaching Clock, with quartz movement and four interchangeable faces, can be used in the classroom.

bad bouncer UnpredictaBall!

Billed as "an inflatable ball challenging the laws of gravity & centrifugal motion," UnpredictaBall! has a lot to live up to. How can a mere inflatable keep its promise to test the laws of physics and make them comprehensible to children? Consistent with its sophisticated package, which asks questions about physical phenomena rather than hypes the

76

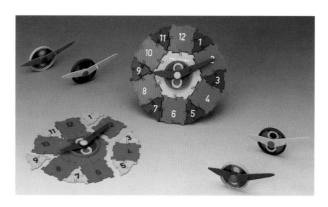

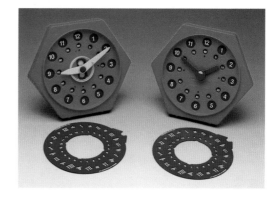

Kinder Clock (left); Teaching Clock (right) CLIENT: *Polydron U.S.A, Inc., Fountain Valley, California*
DESIGN FIRM: *Polydron UK Limited, England* DESIGNERS: *Edward H. Harvey (Kinder Clock), Ronan F. Harvey (Teaching Clock)*

Unpredictaball!
CLIENT: *The Nature Company, Berkeley, California*
DESIGNERS: *Karl Heiselman, Kathy Warinner, Kristin Bumgarner*

Tony the Tattooed Man®
CLIENT: *Mattel, Inc., El Segundo, California*
DESIGNER: *Marc Segan*

Tony the Tattooed Man is a trademark owned by Mattel, Inc. © 1992 Mattel, Inc. All rights reserved. Used with permission.

product, UnpredictaBall! is a well-designed experiment. "Try to throw it straight and it zigzags like a bat," says the copy. "Most of the time you won't be able to catch it at all! The secret is a tiny weight glued to the inner wall which takes off on its own separate journey every time you throw the ball. The weight adds a third force *(centrifugal motion)* to the two normal forces *(gravity* and *acceleration)* that determine a moving object's direction."

water weapons Aqua Wacky Poolverizers

Anthropomorphism—the application of human characteristics to animals—is a tool of satire as old as antiquity. It was in vogue during the nineteenth century and continues as a popular convention in books, comics, and toys. Among the most cleverly designed toys in this vein are Aqua Wacky Poolverizers, brightly colored molded plastic hose nozzles in the form of kooky anthropomorphized animals. Startling caricatures, several different creatures are available, including a snake, fish, shark, and alligator, each with either a hip or a menacing human affectation.

triumphant tattoos Tony the Tattooed Man

Mainstream toys are made from molds, literally and figuratively. Even the cleverest mass-market merchandise lacks the warmth of toys that do not adhere to the clichés and stereotypes of childhood—which is why when a mass-market toy that is truly witty and fun does come along, it should be celebrated. Tony the Tattooed

77

Aqua Wacky Poolverizers CLIENT: *Little Kids Inc., East Providence, Rhode Island* CONCEPT DESIGNER: *Tate Allen* INDUSTRIAL DESIGNER: *Keith Patterson* CHARACTERS, ILLUSTRATION, AND SCULPTURE: *Andy Kalns*

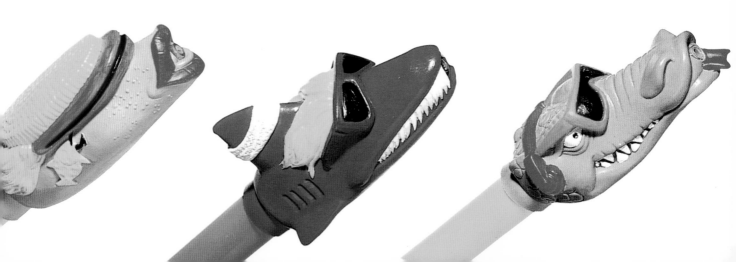

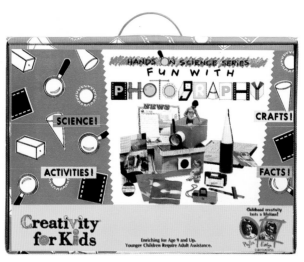

Glow Bugs/Glow Creatures
CLIENT: *Creativity for Kids, Cleveland, Ohio*
PRODUCT AND PACKAGE DESIGN: *Product and Development Team at Creativity for Kids*

Fun with Photography
CLIENT: *Creativity for Kids, Cleveland, Ohio*
PRODUCT DESIGN: *Product and Development Team at Creativity for Kids*
PACKAGE DESIGNER: *Jim Tomasewski*

Man looks like a cartoon wrestler, but with an added dimension. He is not a rock 'em sock 'em character but a tabula rasa on which children (mostly boys) can affix a large number of silly, wacky, and comic tattoo decals. Tony offers little to a child's educational development, but certainly does the job as a charming diversion.

pandora's box Creativity for Kids

An imaginative package can be a distinctive part of a product and not just an advertisement. Such is the case with Creativity for Kids's Glow Bugs/Glow Creatures, a collection of rubber insects and thingies that can be painted with fluorescent colors. Here the box is not a covering or appendage, but integral with the gestalt of the toy itself.

The title is scrawled on the shiny black surface of the box as if this were some kid's personal treasure chest. In a market dominated by packages laden with facts and testimonials, this concept is courageous in its simplicity.

With its photographic illustration of the contents, the package for Fun with Photography, though more conventional, is also a component of the product. The word *photography* is a delightful game that hints at many of the activities to be found inside the kit. Selling children on photography, however, is more difficult than getting them interested in worms and bugs. Consequently, this package is layered with an excessive amount of information. The type bands that proclaim "science," "activities," "crafts," and "facts" seem intended to attract the adult gift buyer

Finger Puppets, Fuzzy Hand Puppets, Clothespin People
CLIENT: *Creativity for Kids, Cleveland, Ohio*
PRODUCT DESIGN: *Product and Development Team at Creativity for Kids*
PACKAGE DESIGNER: *Marla Gutzwiller, Epstein, Gutzwiller and Associates*

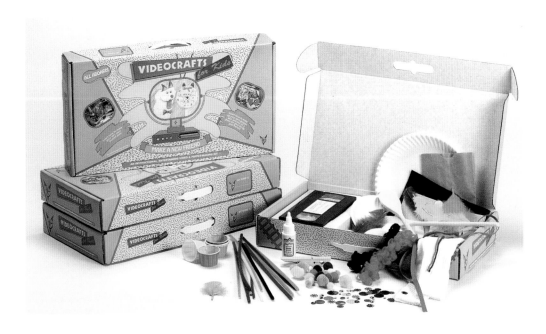

rather than the curious child. All in all, the package is over-laden with imagery; perhaps just the central panel with the title and photograph would have been enough.

The packages for Finger Puppets, Fuzzy Hand Puppets, and Clothespin People also rise above convention in the use of burlap bags as containers. But even this approach is hindered by a label that attempts to tell too much of the story through studio photographs of children playing with the toys. The puppets are so delightfully rendered that maybe their image alone would have been more effective.

video valise **Videocrafts for Kids** Tech-nologies that did not even exist ten years ago are now inte-gral parts of children's activities. Television, that "vast

wasteland," as former F.C.C. chief Newton Minow referred to it in the 1960s, has become a primary communications link to children. With the advent of videotape players, chil-dren have even more reasons to watch TV. And while this may be a mixed blessing, more quality shows have been produced. In addition to the entertainment and educa-tional tapes on the market, many toy manufacturers are now including a video component with their toys.

Videocrafts is one such company, offering hands-on activities such as face painting and jewelry making. Kits include simple, low-tech materials like paints, feathers, pipe cleaners, and glue, and come with an instructional videocassette. With such basic contents the packaging has the important job of appealing to child and adult alike.

79

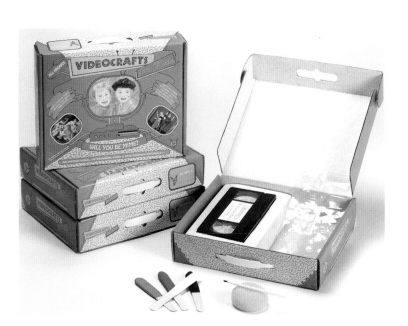

Videocrafts for Kids
CLIENT: *Krafty Kids, Inc.,*
Des Moines, Iowa
DESIGNER: *Linda Swan*

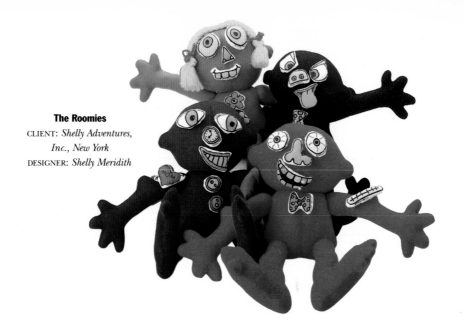

The Roomies
CLIENT: *Shelly Adventures,*
Inc., New York
DESIGNER: *Shelly Meridith*

The packages for Will You Be Mine, a face-painting kit, and Make a New Friend, a create-a-creature kit, are ambitiously designed. The containers are cardboard boxes constructed like valises. The graphics use postmodern colors and patterns—pastels against primaries, with squiggle and bean shapes. The photo-based illustrations are uncharacteristically abstract for a mass-market toy. A touch of nostalgia (a 50s-vintage television) in a contemporary context is a particularly inviting detail.

goofy gang **The Roomies** Children love

wacky toys—and the wackier the toy, the closer it is to a kid's own art. The Roomies, a collection of dolls with Velcro stick-on features, offer controlled wackiness. The player is given options—bloodshot eyes, buck teeth, rosy lips, bulging nose, as well as a tattoo, tie, and watch face—rendered in a raw cartoon style. The idea is to compose one's own silly creature, changing its mood as desired. The result is a toy that shows the child how different expressions can be achieved by various overt and subtle means.

monkey business **Monkeys**

Dolls are not only instruments of play but also outlets for children's emotions. It is therefore not surprising that

80

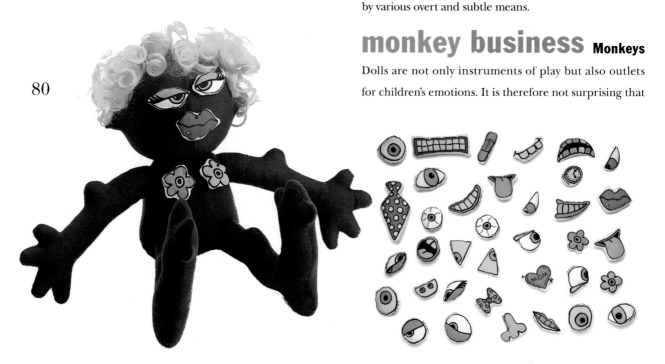

Monkeys DESIGN FIRM: *Reactor Art & Design Limited, Toronto, Ontario, Canada* DESIGNER: *Jamie Bennett*

dolls come in so many forms, abstract to hyperrealistic. Jamie Bennett's handcrafted chimps, a group of finely dressed and bejeweled primates, are rooted in the toys of indigenous cultures, similar to Latin American cloth dolls. Bennett's monkeys are basically black figures dressed in colorful imported fabrics, the males attired to resemble old organ grinders' pets, the females brought up to date in miniskirts.

star struck Flight and Aerodynamics Kit and Astronomy Kit For decades the producers of

chemistry sets and other science-based activity kits have excited youngsters with the accouterments of discovery. The challenge has not been in attracting children per se,

but in vying for their attention within a fairly competitive market. This is where packaging can make a big difference. Among the most enticing packages on the market today are The Nature Company's Flight and Astronomy kits.

These science kits are full of accessible activities, their design a signpost. Wrappings in this genre commonly show photographs of children playing with their educational toy, but not here; instead, The Nature Company speaks up to both kids and adults through sophisticated typography on uniquely shaped boxes. The Flight and Aerodynamics Kit is housed in a tube printed with sketches of Leonardo da Vinci's flying-machine inventions, over which is placed a handsomely designed label using a blend of nineteenth- and twentieth-century typefaces. The Astronomy

81

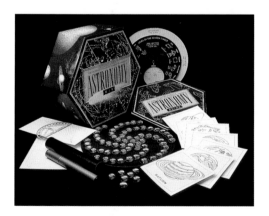
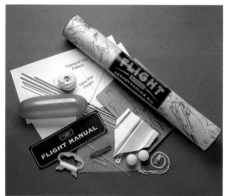

Astronomy Kit, Flight and Aerodynamics Kit
CLIENT: *The Nature Company, Berkeley, California* DESIGN FIRM: *The Nature Company* DESIGNER: *Jean Sanchirico*

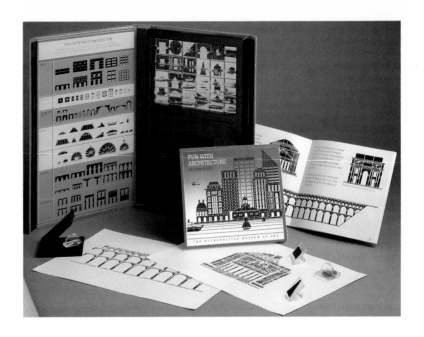

Kit comes in a hexagonal box with a map of the solar system and typographic label printed on the top. The six sides of the box feature beautiful renderings of the planets. The materials inside both kits are designed to echo their packages, giving uniformity to the diverse activities offered therein.

fabulous prefab Fun with Architecture

Building with blocks is a traditional early childhood activity. Building with any material—sand, stone, plastic—can hold a child's interest for long periods of time. When the fundamental impulse to construct things is wed to a basic fascination with houses and other buildings, the

results can be exciting. Such is the idea behind Fun with Architecture, an introduction to the art of building.

The kit includes thirty-five rubber stamps of a variety of architectural forms (bricks, pediments, windows, columns, arches, and the like) that can be used to construct numerous edifices ranging in style from Gothic to modern, castle to ranch house, and traditional to outrageously eccentric. Fun with Architecture offers children some insight into balance, symmetry, and harmony, and deconstructs the building process into its component parts. The instructions are accessible yet provide a fairly sophisticated introduction to the history of architecture.

**Fun with Architecture
by David Eisen**
CLIENT: *The Metropolitan Museum of Art, New York, Department of Special Publications*
DESIGN FIRM: *Miriam Berman Design*
DESIGNER: *David Eisen*
ILLUSTRATIONS & TYPESETTING: *Mulavey Studio, Boston, Massachusetts*

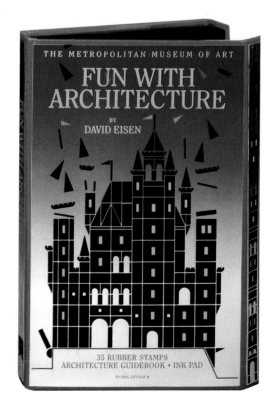

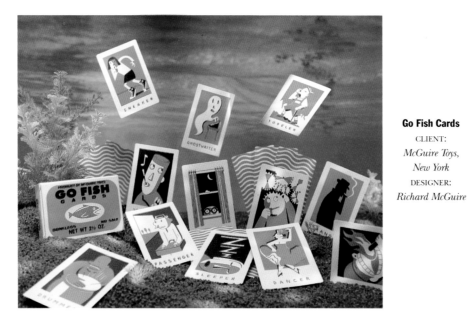

Go Fish Cards
CLIENT:
*McGuire Toys,
New York*
DESIGNER:
Richard McGuire

decked out Go Fish Cards

Go Fish is one of the first card games a child masters. Like Old Maid, it is fairly simple and offers young children a sense of accomplishment as they learn to make pairs from diverse images. There are scores of versions of Go Fish, but few are as imaginative as Richard McGuire's witty reinterpretation.

Rather than the typical motif (i.e., fish), McGuire draws on ten different character types, including a yodeler, dancer, and ghostwriter (a ghost at a typewriter). These form the repertory of possible pairs. The cards are rendered in a comic style that recalls 1930s illustration, yet they are not nostalgic in any way. McGuire uses audacious flat color combinations of orange, green, and black that mirror his sophisticated tastes rather than convention. The package is a parody of a typical sardine can—with the subtitles "boneless" and "no salt" being statements of truth more than comedy. McGuire's acute design aesthetic brings new life to an innocent and favorite childhood game.

serpentine solution Snakes and Ladders

In this limited edition of the perennial favorite Snakes and Ladders, Jeff Jackson has replaced the typically gaudy graphics of children's board games with uncharacteristically moody pastel imagery that seems inspired by Persian miniatures. But who can say that the dark hues and impressionistic images on Jackson's board are not more appealing than conventional cartoons? Jackson's version is certainly playable. The same basic

83

Snakes and Ladders
DESIGN FIRM: *Reactor Art
& Design Limited,
Toronto, Ontario, Canada*
DESIGNER: *Jeff Jackson*

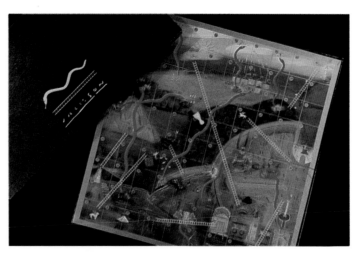

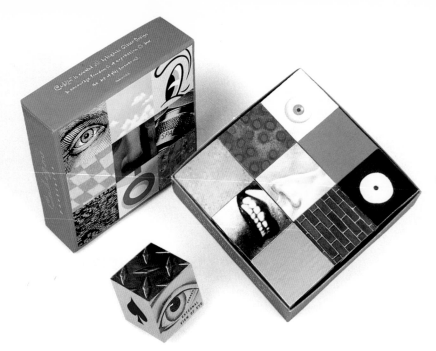

Cubizm
CLIENT: *Zolo Inc.,
Dogue, Virginia*
DESIGN FIRM: *Higashi
Glaser Design*
DESIGNERS AND
ILLUSTRATORS:
*Byron Glaser and
Sandra Higashi*
PHOTOGRAPHERS:
*Don Chiappinelli,
Peter Kaplan*

features are offered: a grid that players must navigate, replete with numerous snakes and ladders that either facilitate or hamper movement. The only differences are aesthetic ones; thus, the success of this more sophisticated version ultimately relies on whether children like to play the game.

block party **Cubizm** Playing with blocks

is quintessential child's play that is meant to teach and entertain simultaneously. Many variations of blocks are on the market, including alphabet and number, picture, and puzzle blocks. Yet most are visually traditional. Higashi Glaser Design has developed a very witty approach to the picture puzzle that uses tightly cropped fragments from paintings, photographs, and graphics. Inscribed on the

84

box is the philosophy behind the toy's creation: "to encourage freedom of expression and the art of play forever." The game includes nine blocks featuring fifty-four random images that can be arranged to make various giddy designs, from funny faces to abstract landscapes. The key to Cubizm is serendipity.

face off **Puzzlehead** Puzzlehead is as fun to

display as it is to play. The beguiling simplicity of the package is a pleasure, while the puzzle itself, composed of rectilinear heads that ingeniously interlock, is a masterpiece of surreal-comic design. Adults will want to preserve Puzzlehead as a work of art, while children will be captivated by its wit and humor. Richard McGuire's game works as both

Puzzlehead
CLIENT:
*McGuire Toys,
New York*
DESIGNER:
Richard McGuire

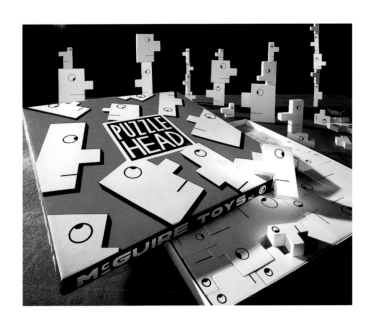

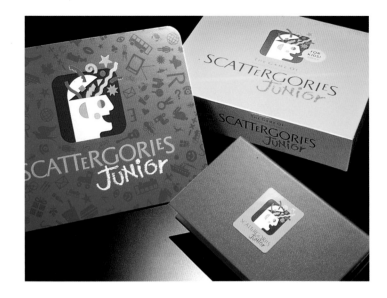

Scattergories Junior
CLIENT:
Milton Bradley,
East Longmeadow,
Massachusetts
DESIGN FIRM:
Sibley Peteet Design

a puzzle and a stacking toy. The interlocking heads seem as if they would be easy to reconfigure correctly, yet they pose a real challenge. Since all the pieces are white, there are few clues to help in their proper arrangement. As stacking toys, the distinctive little faces offer a variety of comic possibilities.

brainteaser Scattergories Junior The

package for Scattergories Junior, the child's version of the adult brainteaser, is designed to communicate the serious fun inside. The bright primary colors on the various game boxes demand attention, and the silly silhouetted head shooting off new-wave squiggles, waves, and bolts into the air identifies this as pleasure for the mind.

extra extra Lilliput News A newsletter

is not a newspaper or a magazine, although it is related to both. It is usually a quick and inexpensive means of communicating timely information. *Lilliput News* is a toy catalog cleverly designed to simulate the aesthetic of a newsletter and the format of a newspaper. It has banner headlines, a lead story, and a masthead (logo) that is on a par with those of the most striking newspapers.

The Lilliput Motor Company sells classic Schuco cars, boats, planes, and military vehicles, miniature replicas of conveyances old and new. Schuco, founded in 1951, may not have been the originator of microvehicles but developed the highest-quality ones. *The Lilliput News* is both a checklist of these items and an informative history of Schuco's products.

85

Lilliput News CLIENT: *Lilliput Motor Co. Ltd., Yerington, Nevada*
DESIGN: *Donald Battershall Design* DESIGNER: *John Watson* ILLUSTRATOR: *Ellery Knight*

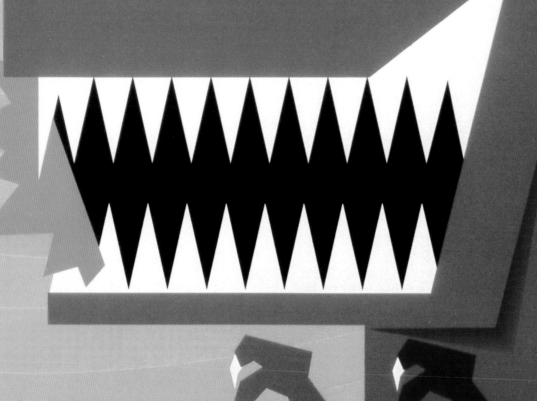

newspapers and magazines

Since World War II there has been no dearth of children's periodicals; doctors' waiting rooms and school libraries can attest to that. Two decades ago, when American newspapers were on more solid financial ground, major dailies published weekly or monthly student editions edited by news professionals. With the decline of newspapers in general the number of children's newspapers also fell, yet supplements for kids in adult newspapers increased— a children's page or pages, often edited and sometimes designed by the kids themselves. In contrast to the predigested content of the newspapers geared specifically toward a juvenile audience, these new supplements allow children to make fundamental decisions while learning about the editing, designing, and news-gathering processes. A supplement also makes it possible for young readers to become engaged with the newspaper as a whole.

Many national magazines for adults have published condensed versions for children. Rather than simply concentrate or simplify content, the best of these are written and designed exclusively for children in a language they can understand, but that also challenges their senses by forcing them to look things up and analyze meaning. Yet format is a double-edged sword. Most adult magazines can be too conservative and thus not inviting enough for children, but a typical children's design format can be too cliché-ridden. The trick is to come up with a format that appeals but does not pander to or patronize children.

Magazines devoted to children (as opposed to kids' versions of adult periodicals) face a similar problem. The fine line between good and bad design is measured by accessibility. While it is unnecessary to design a children's magazine on a strict grid, neither is it wise to create a format that is so raucous that it becomes detached from its readers. 87

chapter five

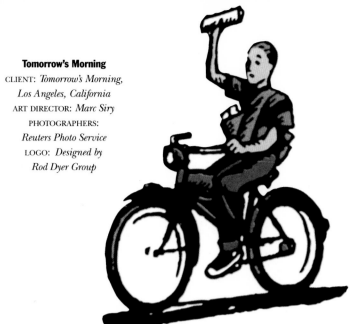

Tomorrow's Morning

CLIENT: *Tomorrow's Morning,*
Los Angeles, California

ART DIRECTOR: *Marc Siry*

PHOTOGRAPHERS:
Reuters Photo Service

LOGO: *Designed by*
Rod Dyer Group

gorgeous gazette Tomorrow's

Morning Advertisements appearing in comic books from the 1950s and 60s recruited children into the service of selling *Grit*, a weekly broadsheet newspaper published in part to help kids earn extra money. *Grit*'s mascot, a newsboy, became an icon of the age.

The generation who grew up on *Grit* eventually turned to *USA Today*, and the children of that generation now have their own weekly. *Tomorrow's Morning*, with the time-honored newsboy prominently featured in its logo, may be spiritually related to *Grit*, but its visual and editorial style is drawn directly from what is known in the newspaper trade as "McPaper," a term likening the colorful *USA Today*, with its news-bite quality, to the ubiquitous fast-food chain.

Tomorrow's Morning is a journal of current events aimed at children ages 8 to 14. In addition to the usual games and quizzes, it features summaries of important breaking and developing news.

Tomorrow's Morning neither panders to nor shies away from its target audience. Color is employed generously but not garishly or sensationally. The front page is devoted to national and international news in condensed, well-illustrated features. Along the left side of the page a blue band frames the weekly summaries, punctuated by one or more color photographs to approximate this kind of section in adult newspapers. The features inside provide a variegated view of issues and events illustrated by witty graphics and straight news photographs. Info-graphics

Funpages CLIENT: *Boston Globe, Boston, Massachusetts* DESIGN: *Boston Globe*

(charts, graphs, and diagrams) are also intelligently presented to aid comprehension and appreciation for this kind of visual approach. While at first glance *Tomorrow's Morning* looks like any current adult newspaper, the combination of serious news and kid-oriented graphics is a sure sign that this gazette respects its readers.

nifty news Funpages, Student Briefing Page on the News, and Kidsday

Newspapers or sections of newspapers for children have a long history. In addition to the celebrated *My Weekly Reader*, which accessibly reviewed the week's news, during the 1950s and 60s various major American dailies published exclusive classroom editions. Although the number of newspapers in publication

has steadily declined in recent years, the need for informed children has not abated in kind.

While *The New York Times* folded its *School Weekly* years ago, the *Boston Globe* and *Newsday* have continued to publish supplements for, and with the assistance of, kids in elementary schools. The *Boston Globe's Funpages* and *Newsday's Kidsday* are edited by children, who not only contribute story ideas and articles, but in many cases choose or create the artwork as well.

The formats are preset to insure consistency. The design of *Funpages* is consistent with the *Globe's* distinctive airiness. Bold Gothic headline types are used to grab the reader's attention. Short, concise headlines do not confuse the reader as they might in the adult news pages. Most of the

89

Student Briefing Page

CLIENT: *New York Newsday, Melville, New York*

DESIGN DIRECTOR: *Robert Eisner*

DESIGNERS: *Left: Robert Eisner; right: Robert Eisner, Lee Levine*

Kidsday
CLIENT: *New York Newsday, Melville, New York*
DESIGN DIRECTOR: *Robert Eisner*
DESIGNER: *Miriam Smith*

stories are, in fact, about fun and games, offering more information about trends, fads, and fashions than hard news.

Newsday's *Student Briefing Page on the News* covers more hard news and is designed to be used and discussed in social studies classes. The content therefore demands a format that is more subdued than *Funpages*. The visuals are often variations on the same news photos that run in the main news sections. And information graphics, popular features of most American newspapers, are often designed using kids' drawings. On the other hand, *Kidsday, Newsday*'s "Section for Kids, by Kids, Mostly," takes a lighter look at the child's world with stories about places to go and see, exceptional families, and the current hot jokes.

Balancing news and entertainment—providing what is

of interest to kids and making it accessible—is the challenge of any children's newspaper supplement. *Funpages* and *Kidsday* accomplish this in different ways, both succeeding because their content and design are handled with intelligence and do not play down to their target audiences.

jive journal **ZuZu** A generation ago *Highlights* and *Humpty Dumpty* were among the most popular children's activity magazines, featuring an assortment of stories, games, and diversions. Today various attempts have been made to involve children more directly in the process of publishing.

ZuZu is foremost among the interactive newspapers for kids. Inexpensively printed on newsprint, it is characterized

90

ZuZu CLIENT: *Restless Youth Press, New York* DESIGNER: *Beck Underwood* ILLUSTRATORS: *Cover art by ZuZu readers, children 6–12 years old*

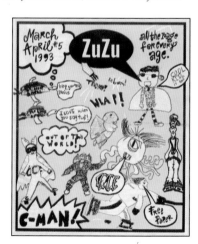

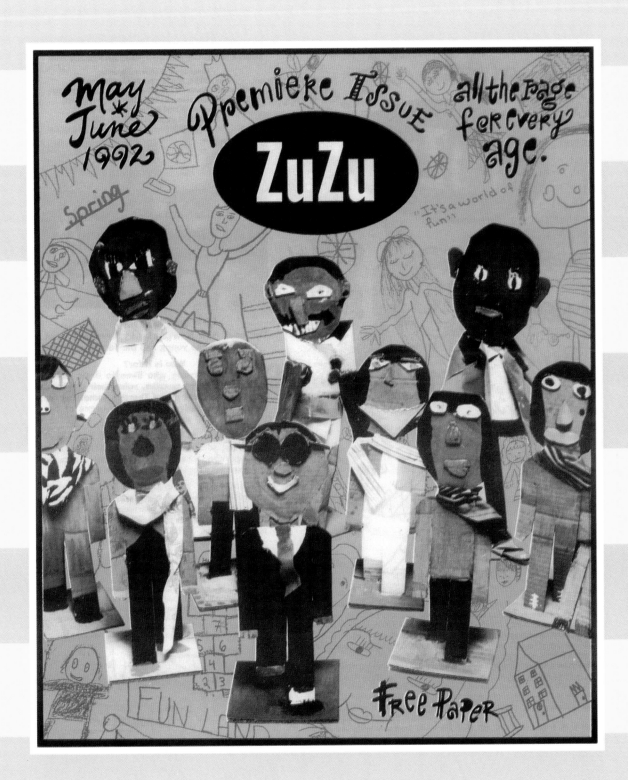

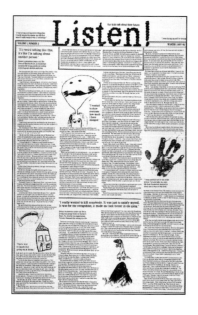

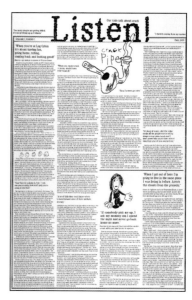

Listen!

CLIENT: *Coleman Advocates for Children, San Francisco, California*

DESIGNER: *Dugald Stermer*

ILLUSTRATORS: *Various children*

EDITOR: *Jeanie Kortum-Stermer*

by a loose format and a nonsense title that recall the anarchic underground papers of the 1960s that influenced many of today's parents. The covers are illustrated with children's drawings on various themes; these artworks are selected not for their virtuosity but for raw expression, regardless of technique or subject. While the paper's basic structure is defined through adult design terms, the content is a free-floating mélange of activities and tidbits.

The generous use of kids' own materials in this publication serves as a model for children who may feel self-conscious about expressing themselves openly. Although it is subtitled "all the rage for every age," *ZuZu* is deliberately, and quite successfully, designed solely for the enjoyment of children.

news views

Listen! Good design is measured not only by how deft the typography or imagery is, but by how effectively information is communicated. *Listen!* is a low-budget, high-energy periodical that is a compilation of children's thoughts on drugs and crime. Designed on the Macintosh using bit-mapped typefaces, it bears no hint of artifice.

Does *Listen!* appeal to children, or to adults? Both are touched: children in that their words are turned into a document, and adults in that they can read these affecting testimonies. How effective is the "nondesign" of *Listen!* in engaging both groups? Very, in view of the fact that issues sell out, and that the publication has generated considerable interest among the news media.

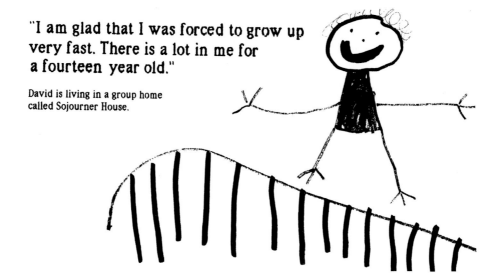

"I am glad that I was forced to grow up very fast. There is a lot in me for a fourteen year old."

David is living in a group home called Sojourner House.

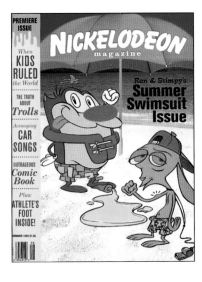

Nickelodeon Magazine
CLIENT: *Nickelodeon,*
New York
DESIGN DIRECTOR:
Alexander Isley
ART DIRECTOR: *Noël Claro*
DESIGNERS: *Alexa*
Mulvihill, Peter Gatto

sublimely ridiculous

Nickelodeon Magazine In the 1950s and 60s *Mad* magazine was popular for its irreverent sendups of contemporary advertising, television, and other cultural and social phenomena. Two subsequent magazines helped a generation weaned on Alfred E. Newman and *Mad*'s "usual gang of idiots" grow into adulthood. In the late 60s *The National Lampoon* was aimed at baby boomers then in their late teens and early twenties. In the 1980s *Spy* was targeted at virtually the same audience, its members then in their late twenties and early thirties. While the substance of the humor changed from age to age, the spirit remained.

Mad continues to publish for preteens today but has lost much of its distinctive acerbity, in part due to other mass media that have introduced even wilder and wackier sensibilities. Nickelodeon has contributed to this evolution through its zany cartoon shows, and currently is giving *Mad* some competition with its *Nickelodeon Magazine.*

Designed with tips-of-the-hat to *Mad, The National Lampoon,* and *Spy, Nickelodeon Magazine* has claimed the crown of silliness, grossness, and irreverence. Typographically it is a smorgasbord of excess—novelty typefaces informed by cartoon lettering are the primary display faces. It is also a mélange of visual absurdities, including radical scale changes of pictures that are shockingly juxtaposed, oddball photo manipulations, intrusive border decorations, ridiculous spot illustrations, and wacky "info-graphics." Yet amid the graphic anarchy there is a curious order. Text

93

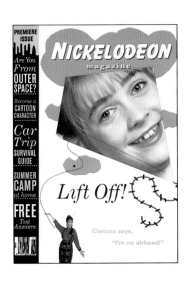

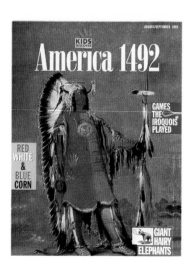

faces, for example, are stark but subdued, and nothing in the magazine is illegible. While stuffing in as much visual lunacy as will fit between its covers, *Nickelodeon* is exceptionally well paced, and downright enjoyable.

learning curves Kids Discover

Magazines for children have changed radically since the 1960s, when high printing costs and conservative aesthetics made many of them lackluster. Today the cost of producing a full-color periodical has been tremendously reduced, and desktop publishing technology has further slashed prepress expenses. *Kids Discover* magazine is a fine example of intelligent graphic design that works in the service of a computer-generated publication.

Kids Discover is also a smart idea. Each issue of the monthly is devoted to one topic—"Trees," "Oceans," "Bubbles," and "Columbus," for instance. Each featured topic is thoroughly explored through both obvious and obscure examples. In the issue "America 1492," in addition to articles on Native Americans, are others titled "Red White & Blue Corn" and "Giant Hairy Elephants," presenting a wonderfully varied look at this piece of history. The text is lively and informative, as in these cover lines from the "Trees" issue: "Birds, Sloths & Other Shady Characters," "Clean, Green Oxygen Machines," and "Have Seeds Will Travel," all bad puns that add to the reader's enjoyment.

Kids Discover has a format that is well defined (meaning that the typefaces and column widths are predetermined

94

Kids Discover
CLIENT: *Kids Discover, New York*
DESIGN FIRM: *Hopkins/ Baumann Design, New York*
PHOTO RESEARCH: *Carousel Research Inc.*
PHOTOGRAPHERS: *"Pyramids," "Oceans," Walter Iooss; "Bubbles," Pete Turner*
ARTISTS: *"Pyramids," George Catlin, Art Resource; "America 1492" from the Granger Collection, attributed to Ridolfo del Ghirlandaio*

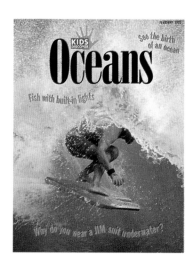

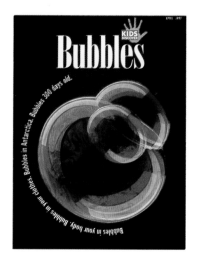

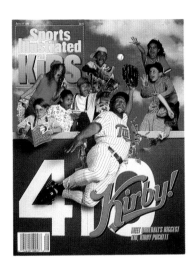
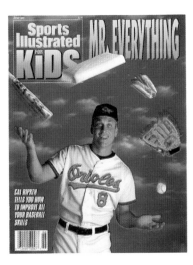
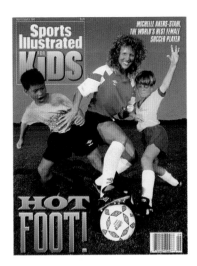

and maintained) but loose enough to allow the subject matter to dictate how images and type are used. The type on the cover of the "Oceans" issue, for example, flows with the waves, while the type on the cover of the "Bubbles" issue conforms to the shape of a bubble. The interior is set up as a collection of large and small "factoids," with extra space devoted to more substantive articles. The total effect is accessibly encyclopedic—one whose bite-size kernels of knowledge are a feast for the eye and mind.

remarkable makeover

Sports Illustrated for Kids Adapting an adult magazine for kids is not easy and often results in strained text and overdone design. Not so with *Sports Illustrated for Kids.*

This makeover of America's most influential sports weekly is more than simply a condensation of the original: It's been rewritten, rephotographed, and redesigned exclusively for the sports-conscious child.

Covers are designed using manipulated images of sports celebrities in comic or fantastic poses. For instance, basketball star Clyde Drexler, known as "Clyde the Glide," is fitted with an airplane body, while quarterback Warren Moon dons a NASA space suit to take a moon walk. Wit is the watchword here. Whenever the opportunity for a comic or satiric twist occurs, *Sports Illustrated for Kids* seizes it. The inside layouts are equally exciting. Gently reined within a strict format, the pages and spreads are invitations to read the entertainingly informative text.

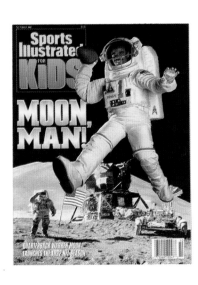
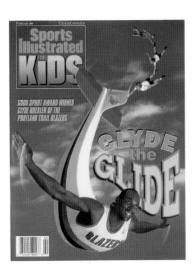

**Sports Illustrated
for Kids**
CLIENT:
Time Inc., New York
ART DIRECTOR:
Rocco Alberico
DIRECTOR OF
PHOTOGRAPHY:
Nik Kleinberg

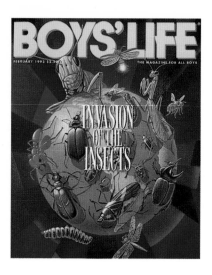 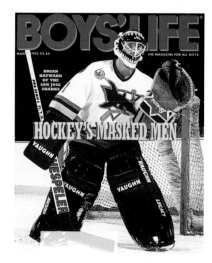

Boys' Life

CLIENT: *Boy Scouts*
of America,
Irving, Texas
DESIGNER:
Joseph Connolly
ILLUSTRATOR:
Left: Ignacio Gomez
PHOTOGRAPHER:
Right: George Olson

boys' monthly **Boys' Life**

The magazine *Boys' Life* was at its best in the 1950s and 60s, when it employed some of America's most celebrated realist and magic-realist illustrators and was the size of the old *Life* magazine. These features made it lavish and majestic in the realm of children's magazines. During the late 1970s, however, it both reduced its size and unfortunately lost some of its cachet when trends in illustration shifted from realism to expressionism.

After struggling for a visual identity, *Boys' Life* appears to have regained a compelling style, thanks to, in part, the addition of color to the inside of the magazine and the use of both action photography and striking conceptual illustration on its covers.

teen mags **Extra Credit** and **Futures**

Not long ago the teenage market for publications was a kind of no-man's-land, and intelligent magazines for teenagers were quite rare. Today for this age group many periodicals on a variety of significant topics are published—and some of these are designed as well as, if not better than, those aimed at adults. Two significant examples are *Extra Credit*, a business magazine, and *Futures*, a career guide. Both employ imaginative studio photography and fashionably sophisticated typography to reach their audiences.

Scholastic has traditionally employed designers who have worked on mainstream adult magazines, and who bring an understanding of these formats to publications devoted to children and teens. The result is that Scholastic's

96

Futures
CLIENT: *Scholastic Inc., New York*
DESIGNERS: *Ellen Jacob,*
Jim Kelley, Scholastic
PHOTOGRAPHER: *Jade Albert*

Extra Credit
CLIENT: *Scholastic Inc., New York*
DESIGN FIRM:
Shankweiler Sealy Design
DESIGN DIRECTOR:
Ellen Jacob, Scholastic
DESIGNERS: *Linda Shankweiler,*
Gerard Sealy

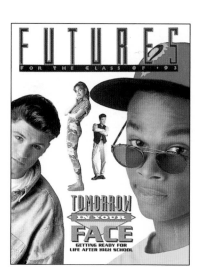 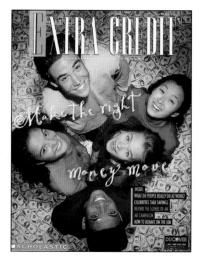

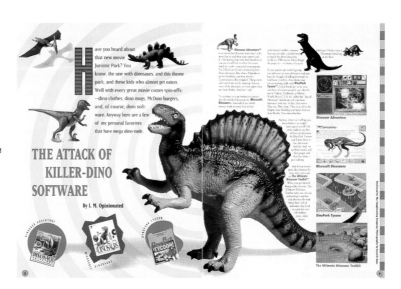

Club Kidsoft

CLIENT: *Kidsoft,
Los Gatos, California*

DESIGN FIRM:
Woods + Woods

magazines may use a more souped-up palette and more teenage references than adult news or business magazines, but the overall design of these publications is refreshingly up to the standards of their adult counterparts.

hyper kids **Club Kidsoft** As computers have become more accessible to children, it has seemed inevitable that an interactive publication designed for kids would appear. *Club Kidsoft*, which is to software for children what *Consumer Reports* is to adult products, focuses on the new technology through offerings of free computer and stereo CDs and catalogs of "kid-tested/parent-tested software." The fall 1993 issue, for example, exposes the current wave of "dino-info" software.

Club Kidsoft is designed using state-of-the-art computer aids. The fall 1993 cover, for instance, features a computer-drawn dinosaur that wittily employs the postmodern conventions of sharp edges and geometric shapes—stylistic elements the computer generates with ease.

97

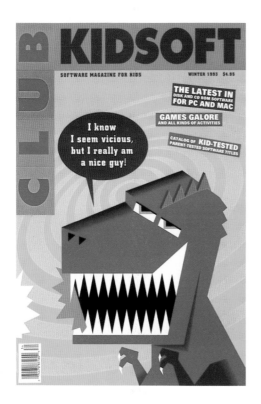

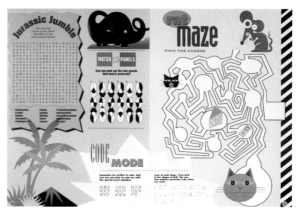

computers and electronics

Not long ago the closest a child might have come to a computer was a battery-operated gizmo that was supposed to simulate the operation of a real machine. Then, as out of the pages of science fiction, along came the first primitive video games involving real computer technology. It was only a short leap from arcade machines to home-entertainment systems. Personal computers soon followed. For almost a decade digital and laser disk technologies have been essential parts of educational and entertainment programs. Currently, Silicon Valley technologies are offering dramatic interactive possibilities, with CD-ROM players now standard options in certain personal-computer models.

Many publishers have begun "new media" divisions that are developing alternatives to traditional printed books and magazines. In fact, software publishing—which includes not only games and personal-computer systems, but also digitized textbooks, novels, and other more conventional literary forms—is now larger than print publishing.

Today's children represent the first generation totally born into computer literacy. Software and "new media" companies have targeted this young audience with a variety of products from games to encyclopedias. Designing the products themselves is challenging, but their packaging is even more crucial. How are sophisticated systems marketed to children? Can conventional graphic formulas be used, or must new design paradigms consistent with the new media be developed? For now, the answer is to tread slowly: Raise the qualitative level of design, but don't jump beyond accepted levels of understanding.

Besides computer advancements, industry introduces the young to other electronic media: user-friendly radios, tape recorders, and boom boxes designed just for children.

chapter six

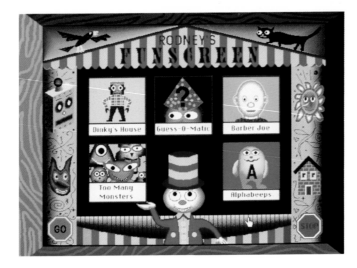

digital madness Rodney's Funscreen

Ingeniously packaged as a breakfast cereal for the mind, Rodney's Funscreen, the creation of sculptor, painter, and children's book author Rodney Alan Greenblat, is an ensemble of five interactive games that include a menagerie of Greenblat's quirky comic characters. Each game is accompanied by a score of synthesized music and sound effects composed by the artist, a feature activated by various keyboard commands. The games include "Dinky's House," an activity that teaches children how to use a computer mouse; "Guess-O-Matic," a classic memory game that requires the child to find certain objects; "Alphabeeps," an alphabet game; "Too Many Monsters," a counting game; and "Barber Joe," a computer update of the popular magnetic affix-the-hair-on-the-person game.

The lettering on the package, like the Funscreen graphics themselves, recalls both the crassness of cheap novelty toys and the abandon of silly comic books. The box is a multifaceted parody featuring a humorous "ingredients" panel ("Contains not less than 50% of the daily minimum requirements of these important features: Funny sounds, 97; Strange ideas, 100; Weird characters, 100"; and so on). As the box asserts in typical genre hyperbole, Funscreen "helps build young minds in 12 exciting ways."

smooth software Kid Pix and Kid Cuts

The computer age has ushered in a new visual language. In an effort to make computers friendly, the

Rodney's Funscreen CLIENT: *Activision, Los Angeles, California*
DESIGNER: *Rodney Alan Greenblat* PROGRAMMER: *David Anderson* PRODUCER: *Jim Stark*

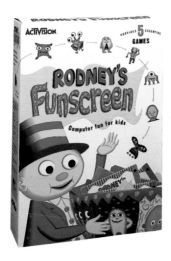

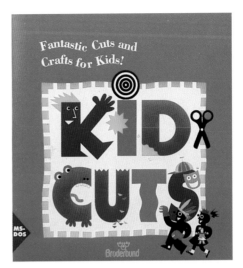

Kid Pix, Kid Cuts
CLIENT: *Broderbund,
Novato, California*
DESIGNER:
*Craig Hickman,
Broderbund*

icons that are designed to guide users through most functions are somewhat juvenile, if amiable, in their simplicity. Until recently computer programs were aimed solely at adults needing to master new challenges. But now children have been targeted as needing their own software.

The packaging for adult programs has by and large featured simple design as a means to reduce audience resistance to technological bugaboos. But how should packaging for children's programs be designed? And whom is such packaging really designed for, parent or child? The answer to the latter is, both. The challenge in designing packaging for high-tech materials is to make the product appear friendly and accessible to all.

Kid Pix and Kid Cuts are picture or "swipe" files for

kids—in essence, electronic sticker books filled with images children can manipulate in various ways. The package design for these computer programs solves the problem of accessibility by making the product name into a collection of humorous letterforms. Although adults are perhaps equally attracted by witty lettering, making faces out of letters and decorating the alphabet with patterns are effective ways to signal directly to children that this is *their* product.

puzzling pixels **Jigsaw!** Computer

literacy is almost as important for today's child as reading, writing, and math. As a tool that assists in the attainment of these three skills, the computer can open worlds of experience and knowledge to a child in a way not heretofore

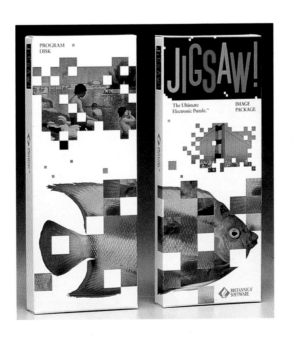

Jigsaw!
CLIENT: *Britannica
Software, Carlsbad,
California*
DESIGN FIRM:
Woods + Woods

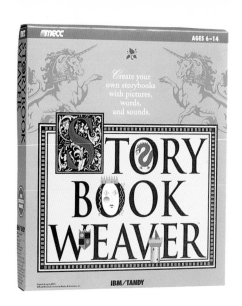

The troll says, "Hey you, go back to the other side of the bridge or I will make goat stew out of you!"

Story Book Weaver CLIENT: *MECC, Minneapolis, Minnesota* DESIGN FIRM: *Woods + Woods*

possible. Although many computer activities are little more than diversions, some games designed for children offer real substance, and at the same time allow the player to hone fundamental computer skills.

Jigsaw! The Ultimate Electronic Puzzle is a computer program that is designed to improve a child's dexterity and focus the eye and mind while providing a variety of fascinating images of people, places, and things. The program's packaging does not speak down to children. The colorful type is appropriately playful, and the graphics reveal the pixelated and modular nature of the activity through a design that promises fun and delivers it.

interactive activity **Story Book Weaver** and **Zurk's Learning Safari** The conventions of packaging computer-oriented materials have too quickly become locked in the minds of marketers. In an attempt to distinguish program packages from computer games, many graphics professionals have designed the former conservatively. Story Book Weaver is a program that allows children (ages 6 to 14) to "create [their own] storybooks with pictures, words, and sounds." This is a new, exciting medium that will change the way children relate to books and stories. Paradoxically, this new technology has been packaged in old clothes.

The cover design features a quaint title panel. A baroque illuminated initial *S* is appropriately used to begin

102

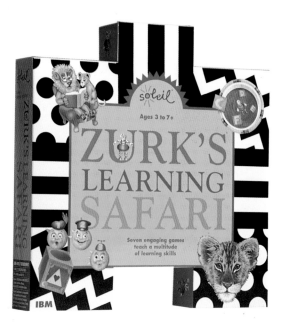

Zurk's Learning Safari
CLIENT:
Soleil Software, Palo Alto, California
DESIGN FIRM:
Woods + Woods

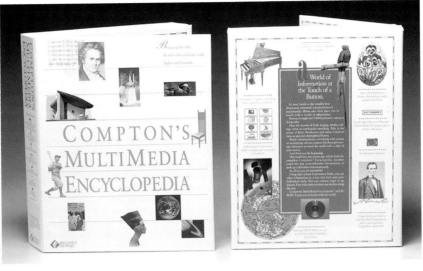

the title, with two other letters serving to frame medieval symbols. Two unicorns border the subtitle, which is dropped out of the pale green background color. Unfortunately, the overall effect is staid. While it must be granted that this package is aimed at adults, it nevertheless could have benefited from a lighter, looser storybook feeling consistent with its content.

To catch the eye of parents and children interested in early learning software, Woods + Woods eschewed the conventional rectangular box and designed a package that looks like a puzzle piece. Zurk's Learning Safari uses the metaphor of a safari as a gateway to basic learning. Underscoring the on-screen interface, the package design employs bold graphics based on African tribal patterns.

discopedia Compton's MultiMedia Encyclopedia

Compton's Picture Encyclopedia was once considered the poor-person's *Encyclopaedia Britannica*, yet it was one of the most accessible resources of its kind. In the multimedia age it's no surprise that Compton's has placed its reservoir of knowledge on CD-ROM. But given the staid appearance of most encyclopedias, it *is* surprising, and refreshing, that its package is so airy and inviting.

The liberal use of small color photographs against a white background, framed by elegant settings of classical typefaces, suggests both the range and seriousness of this product. The study and navigational guide is designed in the same accessible manner, which inspires confidence in even the most diehard technophobe.

103

Compton's MultiMedia Encyclopedia

CLIENT: *Compton's New Media, Carlsbad, California*
DESIGN FIRM: *Woods + Woods*

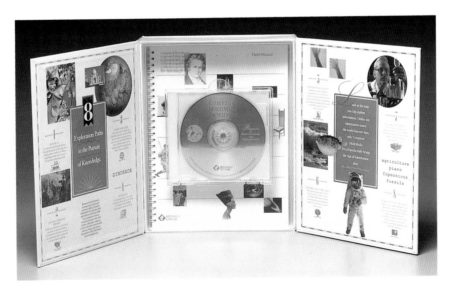

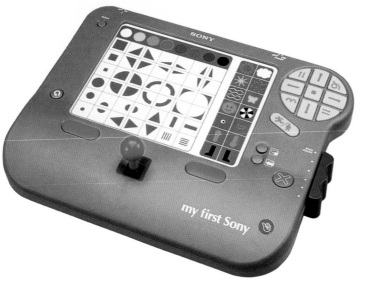

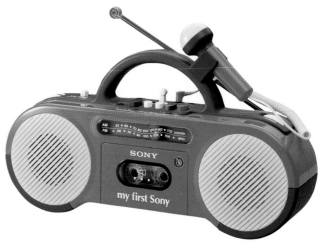

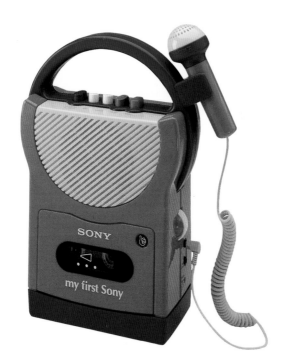

electrifying electronics

My First Sonys Children get the same kicks out of tape recorders, personal cassette players, and computer-driven activities as their parents. So why inflict the matte black, high-tech aesthetic on them at an early age? Why not target them with a line of products fitted with the exciting colors of childhood? Such is Sony's strategy in making radio, tape, and computer equipment for children. And indeed, its My First Sony electronics are very appealing.

Through distinctive primary colors, clever detailing (for example, wavy typography), and functional necessity (oversize buttons, pictograms rather than words), they give the child a sense of ownership and responsibility. The mini-boom boxes and tape recorders have a microphone

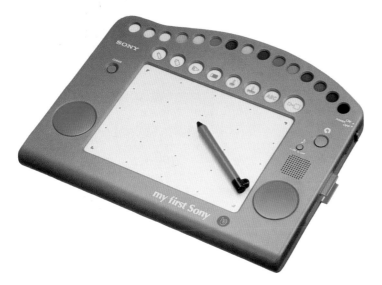

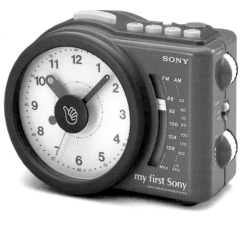

My First Sonys CLIENT: *Sony Electronics Inc., Park Ridge, New Jersey*
DESIGN FIRM: *Design Center at Sony Electonics Inc.*
Courtesy of Sony Electronics Inc.

feature that directly involves the child. The computer draw-
ing stations have icons similar to those on adult comput-
ers, but exaggerated. Sony's entire line of electronics for
children provides entry points into new and existing tech-
nology that will be with us into the child's future.

talkin' back **Rappin' Robot** Sony elec-

tronics for children are cartoon-style interpretations of
adult products, but Rappin' Robot, a tape recorder, *is* a
cartoon character, and a delightful one. It is designed to
look like a robot, its functional parts anthropomorphized
so that the base becomes feet, the speaker a mouth, and
the tape spools eyes. This child-friendly imagery teaches
kids how to use and respect a real machine.

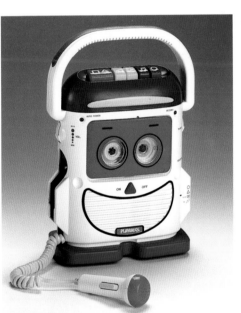

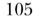

105

Rappin' Robot
CLIENT: *Playskool*
Electronics/KIDdesigns,
Jersey City, New Jersey
DESIGN FIRM: *KIDdesigns*

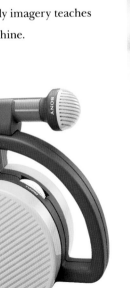

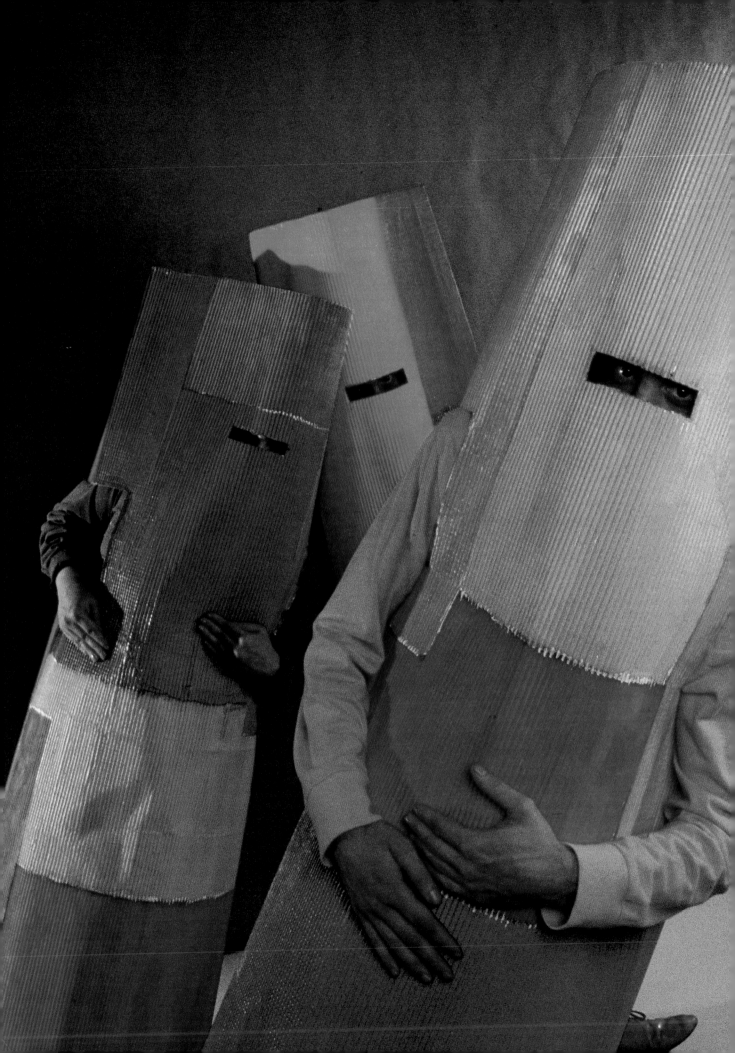

theater and performances

Remember when the circus came to town? The parade, the fanfare, the poster? The classic circus poster featured a clown's laughing face, a lion with a majestic mane, or other prized human and animal attractions. The "circus typeface" was drawn from the original ornate nineteenth-century woodblock letters and evoked a splendid nostalgia. These graphics are still used today by the grandest and oldest three-ring circuses, as well as by the small touring shows that travel from town to town, but in recent years the modern circus poster, promoting a decidedly contemporary circus, has taken center stage.

The new circuses, like the posters that represent them, are rooted in tradition but are more unpredictable. The new circuses wed traditional attractions to more theatrical, up-to-date acts. Likewise, the graphics used to identify and promote the programs of these innovative troupes are inspired by the past yet are created by contemporary designers and illustrators using styles of the present. Some of these graphics are exceptionally modern in look, while others are fashionably retro.

In addition to the circus, the number of theatrical productions designed for children has skyrocketed in recent years, a trend that coincides with a decline in the number of theatrically released movies for children. Need being the mother of invention, today various troupes and companies around the United States and Canada are devoted to entertaining children, and many of them use graphic design to promote themselves and establish an identity. Some even use graphics as a key element of their sets and costumes. As the need to provide alternatives to television and video increases, live entertainments and performances are becoming more sophisticated on the stage and through their graphics.

107

chapter seven

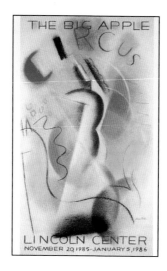

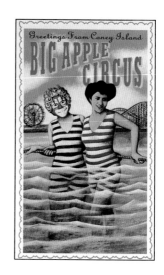

big top bonanza Big Apple Cir-

cus Over a decade ago, as baby boomers began siring their own children, they became nostalgic for the great old circuses of their childhoods. And yet for many former circus aficionados, the big ones were just too big—too difficult to see and enjoy comfortably—and the smaller ones were too amateurish. A new approach eventually emerged: the not-too-big, not-too-small circus, rooted in tradition but built on contemporary aesthetics.

The one-ring Big Apple Circus is one of the most visible of this new breed. What differentiates it from the conventional three-ring circuses is not only the acts and performers, but the graphic materials used to promote and identify the troupe. Its logo, a baby elephant standing atop a big ball while balancing the letters that spell out the company's name, was designed and illustrated by Ivan Chermayeff, who has also designed a few of the circus's posters. Other posters have been created by Paul Davis, Milton Glaser, Jeanne Fisher, and Jim Miller. The stylistic range is wide; Davis's posters are rooted in traditional nineteenth-century circus graphics, Fisher's are reminiscent of French art deco graphics of the 1930s, and Chermayeff's are influenced by Matisse. While the Big Apple Circus identity is unified by the primary colors—blue, yellow, and red—of the big top itself, the collateral graphics distinctively reflect the changing annual theme of the shows.

108

Big Apple Circus
CLIENT: *Big Apple Circus, New York*
DESIGNERS/
ILLUSTRATORS:
Posters, top row, left and right: Paul Davis; center, Jeanne Fisher; bottom row, left: Paul Collier; opposite page: Paul Davis
LOGO: *Designed and illustrated by Ivan Chermayeff*

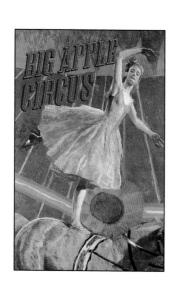

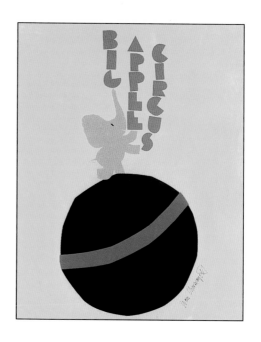

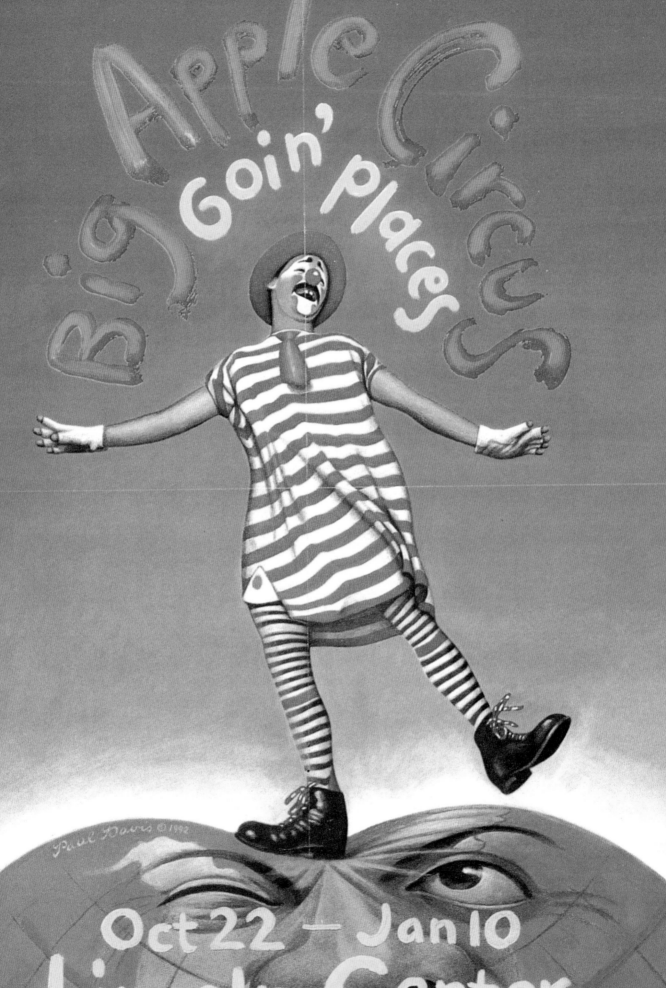

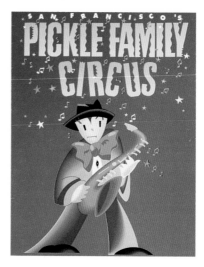

acrobatic antics Pickle Family

Circus Word-of-mouth advertising is one means of attract-
ing an audience. Another is to create an unmistakable visu-
al identification through the use of graphics. The Pickle
Family Circus, one of San Francisco's most critically
acclaimed performance troupes, is known as much for its
exciting graphics as for its lively attractions. While the
images used are based on traditional circus activities, the
airbrush-rendered, highly stylized figures are not at all
conventional. The logo employs a kind of new-wave let-
tering, where Gothic letters are given wavy and sawtoothed
contours. The color palette is bright, at times even fluo-
rescent. And the image that is projected is one of unbri-
dled fun in a buoyant circus context.

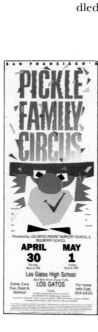

Pickle Family Circus
CLIENT: *Pickle Family Circus, San Francisco,
California* DESIGN FIRM: *Cronan Design*
DESIGNER: *Michael Patrick Cronan*
ILLUSTRATORS: *Michael Patrick Cronan, Robert
Schwartzbach* PHOTOGRAPHER:
Terry Lorant WRITER: *Jon Carroll*

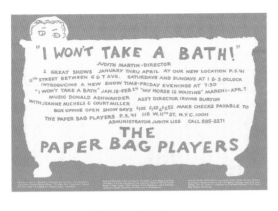

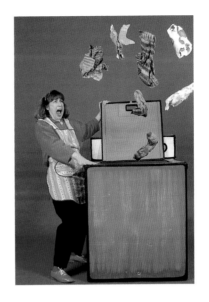

The Paper Bag Players

CLIENT: *The Paper Bag Players, New York, New York*
DESIGNER: *Judith Martin* ILLUSTRATOR: *Judith Martin*
PHOTOGRAPHERS: *Top right: Martha Swope;*
center right: Scott Heiser

paper pyrotechnics

The Paper Bag Players Not all theatrical performances are so notable for their sets and scenery. But one shining example is the troupe aptly named The Paper Bag Players, whose props and costumes are fabricated largely from common paper products such as bags, boxes, and wrapping. At some children's performances such supporting accouterments are second in importance to the script and the acting, but The Paper Bag Players' graphic settings are integral to the character of their theatrical presentations.

The sampling of stage sets and props shown here, including faux horses and an exploding washing machine, are but a few of the strong graphic works that have been created on a shoestring (or rather, paper bag) budget, employing the wildest of imaginations and the most economical of fabrication materials.

The Paper Bag Players' aesthetic is translated into two dimensions through their printed materials. Flyers and posters exhibit the same refreshingly rough style as the sets themselves. In fact, the company's letterhead is printed on butcher's paper, and the envelopes are paper bags.

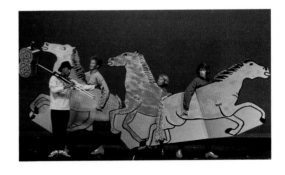

111

books and posters

Despite widespread cutbacks in library and school budgets, there has never been a more fertile period for children's books. The quantity published annually may not be any larger than in previous eras, but the number of unconventional approaches has increased as much to meet the wants of children as to satisfy the needs of a new generation of authors and illustrators. In addition to repackages and reinterpretations of perennial favorites and time-honored classics are books that test the limits of perception and provide young readers with alternatives.

The children's book has been, on the one hand, a proving ground for experimentation with type and illustration, and on the other, a field governed by tradition. This tension has kept kids' books exciting not only for children and adults, but for the many artists and designers who would not necessarily think of themselves as exclusively children's authors or artists and whose unique ideas have been welcomed. As the typographic canon has been reassessed in adult-oriented design, innovations in type treatment have surfaced in children's literature as well—and often with more success. While all would agree that young readers should not be confused by language in their formative years, that does not mean they should not be challenged. A new typography concerned with liberating language from the confines of archaic typographic principles is used in children's books to visualize speech, and to offer variations in cadence and timbre.

Children's books are also taking unusual forms. Looking back to nineteenth-century "mechanical" books, designers are exploring various kinds of paper engineering. Pop-up, lift-up, and other such interactive books are consequently more plentiful these days as printed materials vie with electronic media to attract and hold a child's attention.

113

chapter eight

liberating library Creative Edu-

cation The design of most children's books is governed by specific conventions—some time-honored, others time-worn—that usually are determined by adults from the library and publishing fields. Books for children should be clear and not confusing, and while some books do benefit from freewheeling or playful typography, most, particularly those intended for early readers, are best served by easy-to-follow typesettings. However, subdued type composition need not mean that the type be transparent. Type is as integral to the art as to the content of a book, and must be seamlessly woven into the overall format. Yet somehow it must also be a clear component of the design.

Owing to the nature of children's books, and to the fact that the designers (and sometimes illustrators) who design them vary widely in visual sensibilities, few juvenile publishers maintain a consistently formatted line. Often enough, following established typographic guidelines avoids bad design and meets the young reader's need for legible text. Unfortunately, doing so can also lead to uninteresting typography. But when devised thoughtfully and applied well, consistent standards need not be the hobgoblins of imagination. This is why the individual titles and series of books designed for Creative Education's prodigious annual list is so special. Each is deliberately laid out according to the requirements of the content and needs of the audience, yet Creative's typographic standards push the limits of convention. The type treatment is not so

114

Creative Education CLIENT: *Creative Education, Minneapolis, Minnesota* DESIGN FIRM: *Delessert & Marshall* DESIGNER: *Rita Marshall* ILLUSTRATORS: *This page, clockwise:* Fitcher's Bird, *Marshall Arisman;* Little Red Riding Hood, *Sarah Moon;* Beauty and the Beast, Old Pipes and the Dryad, *and* Raymond's Run, *Etienne Delessert; facing page, top:* A Christmas Carol, *Roberto Innocenti; center:* Mowgli's Brothers, *Christopher Wormell; bottom:* The Legend of Sleepy Hollow, *Gary Kelley; page 116, top:* Little Lou, *Jean Claverie; page 117, top left:* I Hate to Read, *Etienne Delessert; page 117, top right:* Alphabet, Numbers, *and* Opposites, *Monique Felix*

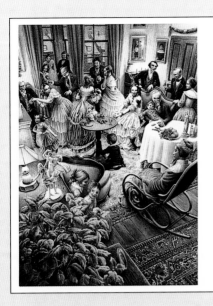

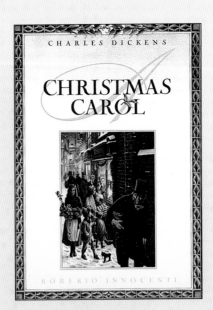

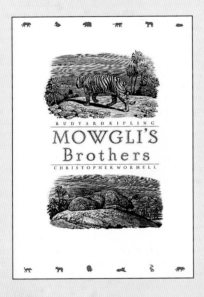

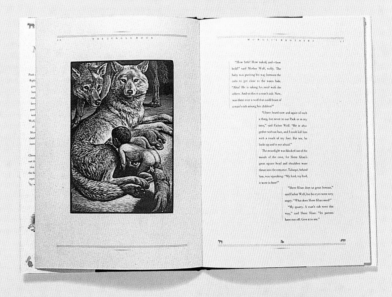

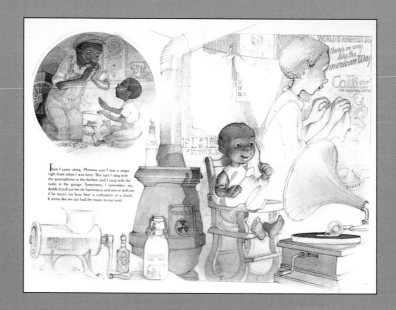

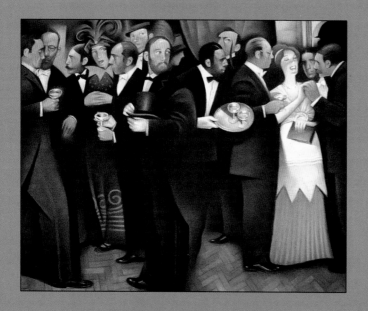

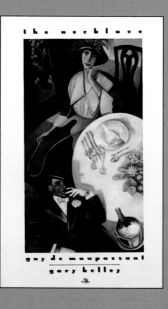

The Necklace
CLIENT: *Creative Education,*
Minneapolis, Minnesota
DESIGN FIRM: *Delessert & Marshall*
ART DIRECTOR: *Rita Marshall*
DESIGNER: *Louise Fili*
ILLUSTRATOR: *Gary Kelley*

The Moon, Cells
CLIENT: *Creative Education,*
Minneapolis, Minnesota
DESIGN FIRM: *Delessert & Marshall*
DESIGNER: *Rita Marshall*
DESIGN ASSISTANT: *Tom Lawton*
PHOTO: *Stock*

rarefied that it prevents comprehension, but the application of typefaces not usually associated with children's books extends the visual possibilities for young readers, and draws them into a new reading experience. In fact, learning to read well-designed pages can only expand the child's developing aesthetic values.

Creative's books also present some of the finest art and photography published in the children's field today. Artists such as Etienne Delessert, Guy Billout, and Gary Kelley, all of whom are also known as editorial illustrators, combine conceptual acuity with artistic virtuosity in images that excite and challenge. The exemplary design underscores the art by allowing images breathing room (meaning illustrations are framed by generous white space) that

is balanced by harmonious typography. Design is (ideally) ever the handmaiden of communication, but with these books it takes an even more important role. Whether driven by picture or text, the design of Creative Education's books enhances the reading experience through its respect for both reader and creator alike.

mixed metaphors A Long Long Song and Ashes Ashes

Many children's characters are based on inner demons—fears domesticated by the imagination and manifested as beings. Rendered in watercolor, Etienne Delessert's creatures in these two books embody aspects of the unknown that are both mysterious and liberating for young readers

 117

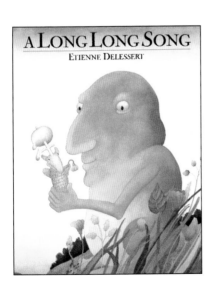

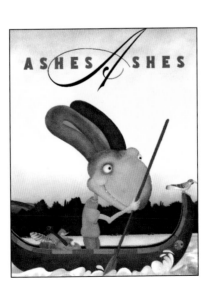

A Long Long Song
CLIENT: *Farrar, Straus & Giroux*
DESIGN FIRM: *Delessert & Marshall*
DESIGNER: *Rita Marshall*
AUTHOR/ILLUSTRATOR: *Etienne Delessert*

Ashes Ashes
CLIENT: *Stewart, Tabori & Chang, New York*
DESIGN FIRM: *Delessert & Marshall*
DESIGNER: *Rita Marshall*
AUTHOR/ILLUSTRATOR: *Etienne Delessert*

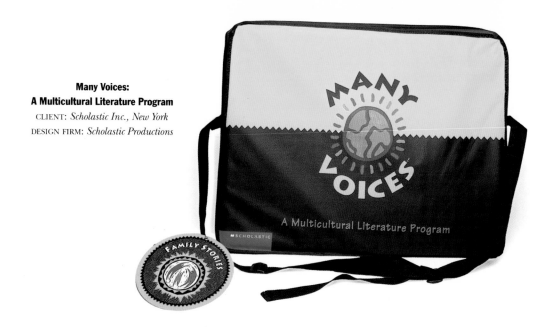

Many Voices:
A Multicultural Literature Program
CLIENT: *Scholastic Inc., New York*
DESIGN FIRM: *Scholastic Productions*

bag o' books **Many Voices: A Mul-ticultural Literature Program** Teachers' aids come in

many shapes and sizes. Scholastic Productions conveniently packages its study guides and texts in large portfolios that include books, workbooks, wall posters, and various materials that teachers can employ in the classroom. Many Voices, an introduction to the writings of authors who represent various ethnic, racial, and religious groups, is a broad-based collection of materials that are designed to be studied over a limited period of time.

Linked to the overall theme of multiculturalism, each component of the teacher's kit can be studied individually or as a part of the whole. The program logo used on the wall hangings enforces the idea that this ensemble is a cohesive program. A study guide allows the teacher to follow or diverge from the program as befits the class. For practicality, the design of the package allows for easy storage and transportation of materials.

masterpiece theater

Roaar Calder's Circus *Roaar Calder's Circus* is a witty interpretation of Alexander Calder's playful sculpture, which is on permanent view at the Whitney Museum of American Art in New York. With photographs by Donatella Brun, the book is written by Maira Kalman, an illustrator whose faux-naïf paintings are spiritually related to Calder's wire and fabric figures. Designed by M & Co. using expressive typography that modulates with every word or

118

Roarr Calder's Circus CLIENT: *Whitney Museum of American Art, New York* DESIGN FIRM: *M & Co.*
DESIGNERS: *Tibor Kalman, Emily Oberman* PHOTOGRAPHER: *Donatella Brun* AUTHOR: *Maira Kalman*

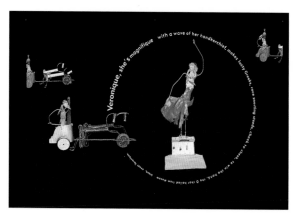
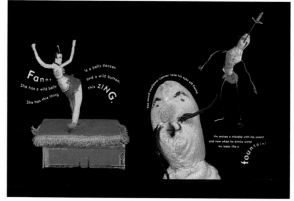

Pegasus can fly up into the sky over the stars and the paper man can jump off the world. His dress is a parachute and he lands softly down.

phrase, *Roaar Calder's Circus* brings a delightful environment to life. Kalman gives the ringmaster a voice as he introduces these heretofore unnamed performers. The muted earth tones of Calder's wire and mesh are set against fields of black in a simulation of the big-top experience. The seamless marriage of voice and image is enough to hold the interest of even the youngest reader.

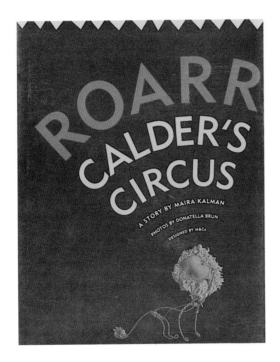

glow book **A Little Night Book** If glowing in the dark were its only virtue, *A Little Night Book* would probably be written off as a mere novelty. That it is an imaginative and perceptually challenging collection of activities allows it to transcend its gimmickry.

A Little Night Book employs some of the principles on which modern graphic design is built. Here the problem is to construct imagery that will entice a child without resorting to conventions. In Bauhaus tradition this is neatly solved with pure design forms. The book takes a basic circle—the shape representing the sun and the moon—and reduces it to nongeometric components that when reconfigured become a circle. Text is minimal because the activity—that abstraction derives from realism—says it all.

119

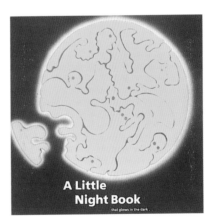

A Little Night Book CLIENT: *Works Editions, New York* DESIGN FIRM: *Studio Works* DESIGNER/ILLUSTRATOR: *Keith Godard* WRITER: *Emmett Williams*

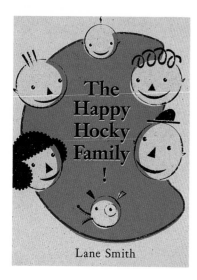

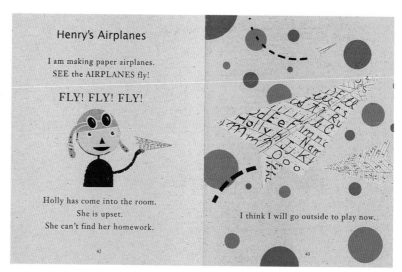

complex simplicity The Hap-
py Hocky Family

Because stick figures are such a significant part of children's art, they can be the worst contrivance for an adult to use. For such artlessness to be transformed into art, a masterful hand is required—which is what Lane Smith, the illustrator of *The Stinky Cheese Man*, among other popular children's books, reveals in *The Happy Hocky Family*. Combining the naïveté of a child's drawings with a slick 1950s graphic style, Smith has created characters that prod the funny bone. The short tales he tells are twists on early-reader storybook narratives, as exemplified by this quote from the tale "Henry's Airplanes": "I am making paper airplanes. SEE the AIRPLANES fly! FLY! FLY! FLY! Holly has come into the room. She is upset. She can't find her homework. I think I will go outside to play now." A full-page illustration reveals that Henry Hocky has used his sister's notebook pages for his airplanes.

The book's design ties the wry stories and the witty drawings together. Smith uses flat colors printed on a light yellow Speckletone stock that is uncoated, which causes the inks to sink into the paper and results in a coarse, slightly off-register newsprint aesthetic. Mixing Gothic and serif typefaces and alternating all-cap with uppercase and lowercase words are aesthetic choices that perfectly recall the style of children's books from the 1950s. The distinctive tactile quality of the matte butcher-paper cover and uncoated stock makes this book fun not only to read but also to hold.

We Are the Hocky Family

I am Mr. Hocky!

I am Mrs. Hocky!

I am Baby Hocky!

I am Henry Hocky!

I am Holly Hocky!

I am Newton!

7

The Happy Hocky Family CLIENT: *Viking Penguin, New York* DESIGNER: *Molly Leach* AUTHOR/ILLUSTRATOR: *Lane Smith*

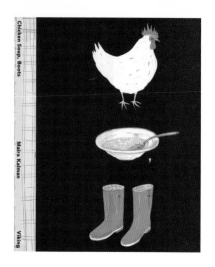

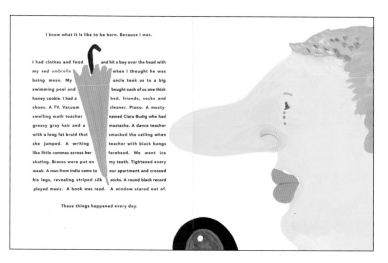

stream o'consciousness

Chicken Soup, Boots Maira Kalman's books (including *Hey Willy, See the Pyramids, Ooh-La-La Max in Love, Max Makes a Million*, and *Max in Hollywood, Baby*) routinely push the limits of the MAYA (most advanced yet acceptable) principle. They are delightfully unique, from the deceptively naïve paintings—which, despite their roughness, are highly polished—to the artfully rambling prose—which reads like stream of consciousness but is in reality focused narrative—to the overall book design—wherein concrete typography simulates the human voice. Kalman entertains children of all ages and challenges convention whenever possible. Yet while her work is courageous in its assault on clichés, it is also safely rooted in the realm of nonsense.

The cover for *Chicken Soup, Boots* is a rebus that spells out the title, which appears in words only on the spine and back cover. The title is enigmatic at first, because the book is not about chickens, soup, or boots, but occupations. Yet it is not your usual job listing—"What will you be when you grow up?" asks Kalman on the back cover, "a lion tamer? an astronomer? a piano tuner? a prune pincher? a fire fighter? a doctor? a smell doctor? a barber? an architect? a dreamer?" The job descriptions are uncommonly rich in texture (even for a children's book). They are at once silly: "Now, Dr. Smellman was madly in love with my cousin Venezuela (grapefruit shampoo, Violette perfume) who could never smell a thing due to a perpetually stuffy nose. When she was little, Venezuela always had her head

Chicken Soup, Boots
CLIENT: *Viking Penguin, New York*
DESIGN FIRM: *M & Co.*
DESIGNERS: *Emily Oberman, Tibor Kalman*
AUTHOR/ILLUSTRATOR: *Maira Kalman*
© 1993 Maira Kalman. Used by permission of Viking Penguin, a division of Penguin Books USA Inc.

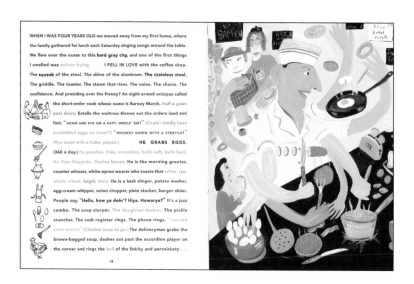

NOW, DR. SMELLMAN WAS MADLY IN LOVE with my cousin Venezuela (grapefruit shampoo, Violette perfume) who could never smell a thing due to a perpetually stuffy nose. When she was little, Venezuela always had her head in the clouds. Now, older, taller, her head is in the stars. SHE IS an astronomer. Dr. Venezuela Katz. She looks at the heavens, and asks questions. How was the world created? Do we control our lives? Why doesn't time go backwards? She knows that the Earth is 93 million miles from the Sun. (No short stroll to the corner.) Looking through giant telescopes, she has seen the rings of Saturn, the moons of Pluto. SHE HAS brainstorms. Makes notes. On white tablecloths. On the bottom of a shoe. Now her questions are extraordinarily extraterrestrial. She is hoping to hear "Hello, how are you, did you order a pizza?" from people living far out in the Milky Way galaxy. Did somebody say PEOPLE? Two headed? Green? Made out of rubber? Are we really not alone? Here is the simple formula that she uses: $N = R_* \times f_p \times n_e \times f_l \times f_i \times f_c \times L$. Is that clear? I should hope so. Venezuela is very scientific, but every night with eyes closed she makes a wish on the first star. "I am," she says, "a space wanderer. A space wonderer." She calls her mother (Rose) who has just burned her finger taking cinnamon rolls out of the oven.

in the clouds. Now, older, taller, her head is in the stars. She is an astronomer." And didactic: "Dr. Venezuela Katz. She looks at the heavens, and asks questions. How was the world created? Do we control our lives? Why doesn't time go backwards?"

Underscoring the rollicking narrative and the various fluctuations in voice, the typography changes color between certain sentences. And, instead of paragraph breaks, extra space is placed between different thoughts.

The paintings are rendered in Kalman's characteristically bright hues. What these images lack in anatomical realism is made up in caricatural extremism. But most impressive about *Chicken Soup, Boots* is its seamlessly woven quilt of concept, image, and type.

mouse tale **Maisy Goes to the Playground** and **Maisy Goes to School** "Lift the flap, pull the tab" books have grown in popularity during the past decade, partly because they beckon children to books and away from electronic media. Many books in this and the pop-up genre are works of complex engineering, eye-catching and mind-boggling feats that touch an immediate nerve. As inventive as these may be, however, simpler ones are more enduring as books.

The books in the Maisy series, including *Maisy Goes to the Playground* and *Maisy Goes to School*, are masterpieces of simplicity for their uncomplicated yet witty pull-tab activities and for their drawing style. Using negative space as the primary graphic element, the renderings have the

123

Maisy Goes to the Playground; Maisy Goes to School
CLIENT:
Candlewick Press, Cambridge, Massachusetts
AUTHOR/DESIGNER/ ILLUSTRATOR:
Lucy Cousins
© 1992 Candlewick Press

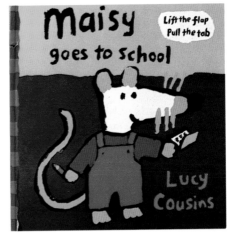

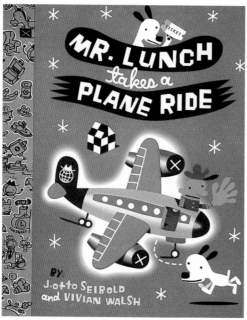

looseness of sketches or monotypes, giving Maisy a distinctive graphic personality. The colors are bold and bright, and the juxtaposition of flat reds against siennas and purples is fairly uncommon in children's books. The pull tabs are not novelties but fundamental elements of the economical stories in which Maisy does everyday things, like dress, brush her teeth, drink milk, and go to sleep at night. Simple routines are made joyful in this seamless marriage of drawing and low technology.

joyful jumble Mr. Lunch Takes a Plane Ride

There is something familiar about this mélange of pictures and words, which is not to say that *Mr. Lunch Takes a Plane Ride* is a rehash of picture-book clichés. In fact, the book is unique in many ways, from the raw drawing style (an amalgam of new-wave and nostalgic shapes, patterns, and figurations) to the bizarre comic characterizations of a dog and his master. What's familiar is that in the jumbled juxtaposition of kooky characters, comic lettering, and wacky situations, the art is reminiscent

124

But this was no ordinary scientific supercake. Each piece had a different flavor, and the cake was big enough for everyone in the audience to have a slice.

What had seemed so bad, now looked like the baking breakthrough of the century.

of the kinds of pictures that children—and adult doodlers—love to draw, except that they are rendered with the skill that only a seasoned artist can have.

Lushly excessive and excessively accessible, *Mr. Lunch Takes a Plane Ride* offers the sort of image overload that children (especially those who are visually hip) will appreciate precisely for the controlled anarchy. The nonsensical story about a dog who finds love and food in the luggage bin of an airline is a vehicle for the artwork, which was created entirely on a Macintosh computer.

textured texts Literature Activity Books

In recent years there has been a notable shift in textbook design. Gone are staid formats; they have been replaced by comparatively lively ones. With visual culture becoming more pervasive throughout society, the educational publishing community has come to recognize the increasing importance of providing teachers with textbooks that are visually exciting and that will hold the interest of their students.

Make a Splash and *Beat the Story Drum*, two titles in Macmillan/McGraw-Hill's Literature Activity Book series, are designed with lively illustrations and sophisticated typography and are at once playful and vigorous. The covers and titles of these textbooks suggest that they are not rote learning tools but repositories of challenge and surprise. More importantly, the refined graphics help instill a sense of pride in the student who uses the books.

125

Make a Splash;
Beat the Story Drum
CLIENT: *Macmillan/ McGraw Hill, New York*
DESIGN FIRM: *Pentagram Design Inc.*
DESIGNER: *Jackie Foshaug*
ILLUSTRATORS: Make a Splash, *Alex Murawski;* Beat the Story Drum, *Pearl Beach*

Aunt Ippy's Museum of Junk CLIENT: *HarperCollins Publishers, New York* DESIGNER/ILLUSTRATOR/AUTHOR: *Rodney Alan Greenblat*

camp counselor Aunt Ippy's Museum of Junk

Rodney A. Greenblat is a sculptor and painter who draws inspiration from the commercial culture vernacular, especially that related to children's products of the 1950s and 60s. His gallery work is an anarchic Candyland full of gaudy colors and playful graphic forms. But not all is sweetness and light in this utopia; there is an edge to it that both adults and children can appreciate. In the gallery work Greenblat's homage to kid culture is deliberately satiric, while in his children's books and computer games he uses it as part of a personal visual language.

Aunt Ippy's Museum of Junk may have a surface crudity, but this provides an entry point for children. Every page of this book is composed deliberately and stuffed with visual minutiae to carry the young reader through a fantastic world that is nonetheless rooted in reality. Many children's authors have tackled the theme of environmentalism, but few have presented it as accessibly and wackily in word and image as Greenblat has here. On one level *Aunt Ippy's* is a silly (though not improbable) story of a woman who maintains a monument to junk, and on another, it is a cleverly designed tale of social accountability.

monotone monopoly Black on White and White on Black

It is never too early to appreciate books. Those designed for very young children should be neither complex nor unnecessarily simpleminded. Tana Hoban's books of shapes and colors are

126

Black on White; White on Black CLIENT: *Greenwillow Books, New York* DESIGNER/ILLUSTRATOR/AUTHOR: *Tana Hoban*

Six was used for marmalade.

the right balance of art and pragmatics, of simplicity and sophistication. *Black on White* and *White on Black* are stimulants that enhance a child's perceptual skills while offering early intellectual challenges. These books teach children how to identify silhouettes and, at the same time, steer them through more complex issues of negative and positive space. On the surface the books are simple, but behind their facades lie important lessons.

slice of life The Orange Book In this,

his first children's book, Richard McGuire has developed an individual style that echoes the past but is firmly rooted in the present. *The Orange Book* is an exquisitely economical, two-color narrative that traces the fate of fourteen oranges. Laid out in two-page spreads, the artwork is simply rendered with just the hint of a 1930s style and is printed in blue on cream stock, with only the fruit in its various guises appearing in the second color, bright orange. McGuire's subtle story line in this nontraditional counting book gives the reader a glimpse of the abstract nature of numbers. *The Orange Book* is a tale of balance; each picture is meticulously composed with just the minimum of visual information. While not a breakthrough in storytelling or illustration, it is proof that in an age when the book itself is being reassessed, the honest ones are still the best.

127

The Orange Book
CLIENT: *Children's Universe Publishing, New York*
DESIGNER/ILLUSTRATOR/AUTHOR: *Richard McGuire*

Let's Make Rabbits CLIENT: *Alfred A. Knopf, New York*
DESIGNER/ILLUSTRATOR/AUTHOR: *Leo Lionni*

© 1982 Leo Lionni Reprinted by permission of Pantheon Books, A division of Random House Inc.

cut and paste Let's Make Rabbits

Leo Lionni began writing and illustrating children's books quite accidentally. The esteemed editor, art director, graphic designer, photographer, and painter realized that the collages he made to entertain his grandchildren during their visits to his home had a much broader potential audience, and thus he began to produce a book a year, introducing to the world such wonderful characters as Swimmy the fish and Frederick the mouse.

Some of Lionni's books involve traditional drawing techniques, but his primary method of illustration is cut-paper collage. One might say that *Let's Make Rabbits* is on the cutting edge—it is definitely quintessential Lionni. His delightful creatures evolve from wrapping and wall papers. With the touch of imagination that the young reader brings to the book, the images become as real as any live animal.

Lionni is a master of simplicity. The design of this book, like all his others, is not overly embellished. The typeface is Century Schoolbook, the same face Lionni used in his design for *Fortune* magazine, a publication whose look he, as art director, based on modern design principles. And just as in his magazine design, in children's books he allows enough white space for the images to breathe.

facial frolics Making Faces

Before there were interactive computer games there were interactive books. Pop-up, pull-out, flip, and flap books were little masterpieces of ingenuity and engineering that

128

Making Faces
CLIENT: *Dorling Kindersley, New York*
ILLUSTRATOR:
Norman Messenger

 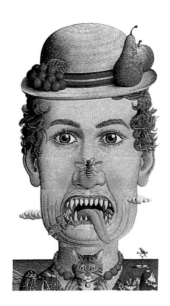

changed form to reveal hidden treasures. The master of the art was the nineteenth-century German illustrator and designer Lothar Mergendorfer, who invented the most complex mechanisms for bringing his gloriously imaginative pictures to life. He also created some of the simplest, and popular among these is what is commonly referred to as the "mix 'n match" book, in which a variety of unusual, often surreal, faces can be made simply by turning over cut pieces of paper illustrated with corresponding human or animal features like the mouth, nose, eyes, and so on. Such books are not unlike the criminal identification systems used by police, except that they are usually more absurd. While the mix 'n match book has never completely gone out of fashion, it is so low tech by today's standards,

even among contemporary pop-up books, that in recent years new ones have been rare. However, given a renewed interest in paper toys, mix 'n match may very well make a comeback, and Norman Messenger's *Making Faces* is the first successful sign.

From hats with flowers and fruits to heads impaled on nails, and to ears crawling with bugs and noses pierced with rings—a veritable cornucopia of delightful grotesquery—come over 65,000 possible composite faces. Messenger is a British artist with a talent for magic realism and caricature. Inspired, no doubt, by the police identification system, Messenger provides a profile and front view of each "suspect," which not only gives three dimensions to his two-dimensional world, but allows for twice as many visual gags.

129

His people are posed against a variety of surreal landscapes and seascapes that also transform as the panels are turned. *Making Faces* is no ordinary mix 'n match book. In addition to the extraordinary number of permuations he includes in the book, Messenger draws exquisite details in a realistic comic style. He has not created just any old nose or mouth, for each feature is possessed with a distinct character trait, which when combined with others is not comic merely by accident, but by design.

details details **Dorling Kindersley**

"God is in the details," said Ludwig Mies van der Rohe; as if in tacit agreement with this idea, Dorling Kindersley's dictionaries, encyclopedias, atlases, and activity books are chock-full of details. DK is the most prolific children's book company today, and one of the most adventurous, given the range of subjects on its list. In the Eyewitness Visual Dictionaries series are books on themes as diverse as special military forces and dinosaurs; in the See & Explore Library are *How People Lived*, *The Earth and How It Works*, *Prehistoric Life*, and *Flight and Flying Machines*; the Sticker Activity Books series comprises books for young children titled *Shapes*, *Color*, *Opposites*, and *Sorting*. *The Body Atlas* is the quintessential pictorial guide to human anatomy.

Dorling Kindersley

CLIENT: *Dorling Kindersley, New York*
ART DIRECTORS: Amazing Buildings, *Dorian Spencer Davies, Chris Scollen* DESIGNERS: The Visual Dictionary of Buildings, *Paul Calver;* The Visual Dictionary of Dinosaurs, *Ellen Woodward* ILLUSTRATORS: The Visual Dictionary of Buildings, *John Woodcock, Simone End, Kathleen McDougal;* The Visual Dictionary of Dinosaurs, *John Temperton, Graham Rosewarne;* Amazing Buildings, *Paolo Donati* PHOTOGRAPHERS: The Visual Dictionary of Buildings, *Tim Ridley, Andy Crawford;* The Visual Dictionary of Dinosaurs, *Andy Crawford*

Dorling Kindersley's series offer unusual, often innovative approaches to common and uncommon material for readers of every childhood age. *My First Encyclopedia* brings together hundreds of images for the preschooler that highlight such categories as "Games and Sports" and "Traveling on Land," and it is illustrated with a variety of photographs and drawings designed to capture and hold the reader's attention.

DK's visual personality is expressed in its extensive use of meticulously rendered drawings and paintings and highly detailed photographs, which are scrupulously captioned to explain every integral feature. Among the enjoyably complex books is *Amazing Buildings*, which contains minutely detailed plans and elevations of the world's most significant structures. Where drawings are not appropriate, photography is used. Books in the Eyewitness Science series—*Evolution*, *Chemistry*, and *Energy*—are illustrated with both documentary and studio photographs, including some images of rare apparatuses and experiments. Great care is taken in the styling and shooting of these didactic images, with the emphasis being on clarity. Photographs of objects and models are also key elements in the books for younger children. The Sticker Activity Books, for example, are replete with striking, colorful photographs of common objects. And books in the Let's Explore Science series, including the titles *Seasons & Weather*, *Water & Floating*, *Sound & Music*, and *Color & Light*, show vignettes of children doing the experiments described.

131

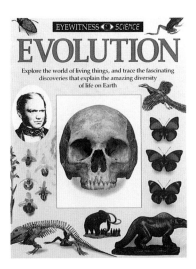

el tren

Dorling Kindersley
CLIENT: *Dorling Kindersley, New York*
ART DIRECTORS: The Body Atlas, *Christopher Gillingwater;* Mon Premier Livre de Mots en Français *and* Mi Primer Libro de Palabras en Español, *Penny Britchfield*
ILLUSTRATOR: The Body Atlas, *Giuliano Fornari*

Even the most commonplace object is carefully prepared according to strict aesthetic and content guidelines. The images must work harmoniously with one another on the page or spread. Therefore each image is composed for maximum impact. Balance is of utmost importance. As an example, each title in the My First Book bilingual series aimed at preschoolers includes one thousand small color photographs, each illustrating a word in French or Spanish. These images are selected for their formal merits, and for what, say, duck or lamp might best appeal to children.

The typography is elegant, and great care is taken to integrate type and image. Most books include detailed captions or explanatory copy blocks. In the more complex books—*The Visual Dictionary of Dinosaurs*, for example—

there are many different labels, which must be accessible though unobtrusive. In *The Body Atlas* the dense text is organized according to a hierarchy, with the introduction, narrative, captions, and labels distinguished by type that varies in weight accordingly.

The word *eyewitness* in some of the series titles is apt. In fact, readers who do not have access to the actual experiment or object are presented with the next best thing, and in beautifully explained, well-designed packages.

132

l'ours en peluche

les pêches

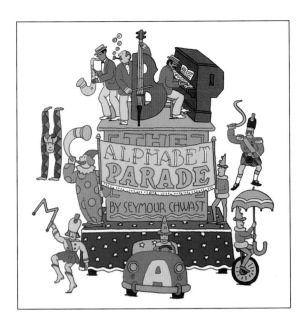

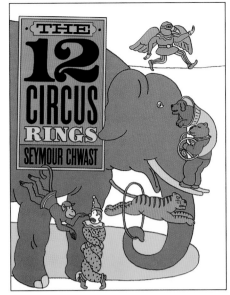

letters and numbers

The Alphabet Parade and **The 12 Circus Rings** Bookstore shelves overflow with alphabet and number books for young readers and preschoolers. So to create books in this genre that both stand out and transcend convention is a challenge. Seymour Chwast's *The Alphabet Parade* and *The 12 Circus Rings* rise to the occasion through an accessibly surreal approach to letters and numbers using the artist's colorful, comic drawings, which are especially good at attracting the attention of young children.

The Alphabet Parade is a street-long cavalcade of comic and curious characters either shaped like, or beginning with, specific letters (for example, Abe Lincoln represents *H*, for his hat). Watching from the sidelines is an audience that includes people who also represent the letters, thus giving the child various levels of stimulation. The textless book approximates how someone might see a parade from an apartment window. *The 12 Circus Rings*, set to the tune of "The Twelve Days of Christmas," is a counting book in which increasing numbers of various circus performers and animals are introduced spread by spread until the final image is stocked with everything from one aerialist to twelve leapers leaping. To add a further level of challenge to this counting game, the troupers and animals take different poses or wear different costumes from page to page.

Despite the large number of elements on the pages, each of these books is so well balanced that the addition of things occurs naturally, and comprehensibly.

**The Alphabet Parade,
The 12 Circus Rings**
CLIENT: *Gulliver
Books/Harcourt Brace
Jovanovich, New York*
DESIGN FIRM: *The
Pushpin Group Inc.*
DESIGNER/ILLUSTRATOR/
AUTHOR: *Seymour Chwast*

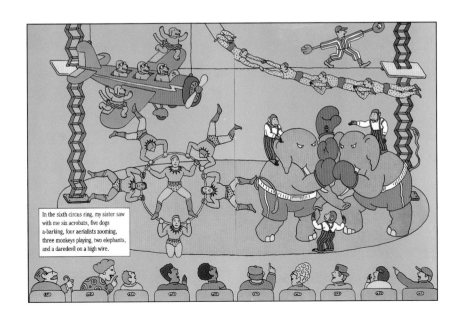

In the sixth circus ring, my sister saw with me six acrobats, five dogs a-barking, four aerialists zooming, three monkeys playing, two elephants, and a daredevil on a high wire.

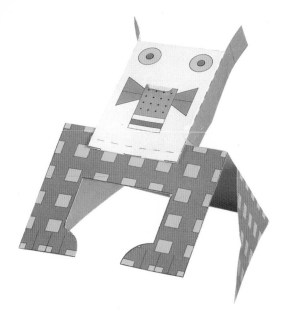

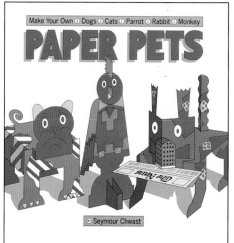

Paper Pets
CLIENT: *Harry N. Abrams, Inc., New York*
DESIGN FIRM: *The Pushpin Group Inc.*
DESIGNER/ILLUSTRATOR: *Seymour Chwast*
DESIGN ASSISTANT: *Jeff Powers*

krazy kennel **Paper Pets**

Seymour Chwast's *Paper Pets* utilizes neoclassical and art deco motifs to create a postmodern extravaganza. The pets, which include three dogs, two cats, a parrot, a rabbit, and a monkey, are a synthesis of the artist's varied design influences and inspirations. Yet despite the sophisticated visual references, the geometric shapes and abstract patterns are very appealing to children.

Unfortunately, these paper pets are not designed for small children to construct; even adults might find the saw-toothed and stair-stepped appendages hard to maneuver with common scissors. The reward for all the intensive labor, however, is a splendid collection of imaginative designs that ultimately make enjoyable toys.

facial farce **Dogs & Cats: A Mask Book**

How can books appeal to children in a multimedia age? That question is paramount in the minds of publishers and editors as they seek out new talents. For better or worse, in addition to searching for unique drawing or painting books, editors are also on the lookout for novelties—even some that are not so new. Masks, for example, have long been a staple of the child's entertainment experience. Mask books, however, are a relatively new twist on the old toy.

While a variety of mask books have been published within the past five years, few have risen above the constraints of two-dimensional form. So what makes a mask transcend the paper it is printed on? The artistry behind it. David Kirk's sculptural paintings bring toys to life, and

134

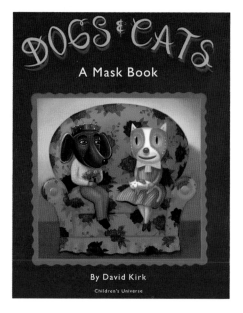

What Are Rocks Like?

Did all the rock and soil pictures look the same? Probably not. The world has many different kinds of rocks.

Marble

Shale

Sandstone

Granite

Basalt

Rocks and Soil
CLIENT: *Scholastic Inc., New York/ Cranbrook Institute of Science, Bloomfield Hills, Michigan*
Used with permission of publisher.

now bring flat masks into three dimensions. His *Dogs & Cats: A Mask Book* is both an activity book and, in the way it harks back to the wonderfully farcical imagery that was so common in kids' art of the 1940s and 50s, a paean to kids' culture. The images are soft but startling, sweet but biting. There is more than a touch of nostalgia in the basic forms, and yet they are also timeless.

no-nonsense nature Rocks
and Soil
Interest in their natural surroundings comes early to most children. By digging in the dirt and collecting stones, kids are exposed to and become fascinated by the many small things that together make up the environment. The Scholastic Science Place series, which includes *Rocks and Soil: How Weather and Other Forces Change the Earth*, builds upon the curiosity that begins in the yard, park, or playground by presenting vivid examples of natural wonders in the didactic context of a textbook.

From the face made of dirt and stone on the cover and the lighthearted comic border that surrounds it, the reader gets the sense that this book (developed in cooperation with Cranbrook Institute of Science) is not a dry text. Using many of the illustration principles found in Dorling Kindersley's books, *Rocks and Soil* (and others in the series) is replete with photographs so naturalistic it seems as if the objects shown are before you, ready to be touched. The didactic component is set in readable type blocks without fanfare or flourish, which respects the young reader.

135

Dogs & Cats: A Mask Book CLIENT: *Universe Publishing, New York* DESIGNER/ILLUSTRATOR: *David Kirk*
Published by Universe Publishing, New York, in 1992. © Universe Publishing. Reproduced by permission of the publishers.

A Leaf Named Bud
CLIENT: *Universe Publishing, New York*
DESIGNER/ ILLUSTRATOR: *Sara Schwartz*
AUTHORS: *Paula Schwartz and Sara Schwartz*
Published by Universe Publishing, New York, in 1992. © Universe Publishing. Reproduced by permission of the publishers.

And, down the hill, under the twinkling sky, Bud danced with his new-found friends.

a new leaf **A Leaf Named Bud**

There are many ways to create an illustration, and the children's book has been the proving ground for virtually all the possibilities. Sara Schwartz paints over clay sculptures with colors that are reminiscent of a child's poster paints, then glazes the pieces so that they will capture sharp highlights. The sculptures are then photographed.

This approach to illustration works well for the fantastic voyage of the title character in *A Leaf Named Bud* as he journeys from spring to fall. The *art brut* style adds figurative and literal dimension to the reading experience, so that reading this book is almost like reading a frieze. The hand-painted text, rendered with a thick brushstroke, is consistent with the book's overall aesthetic.

heady design **Blockheads**

Blockheads is one of the more pleasurable examples of a current trend in books-as-objects and paper toys. A simple activity book intended for young children, it contains perforated drawings that are meant to be punched out, folded, and constructed into a cast of characters. Six figures (three paper bodies printed with a different character on each side) serve as pedestals for three boxes with six different faces. The bodies include a spaceman, cowboy, pirate, and baseball player with appropriate heads, plus sixteen other surreal, anthropomorphic, and otherwise absurd visages. Guarnaccia has based the form on a 1930s-vintage French advertising display. But rather than a nostalgic reprise, *Blockheads* takes a fresh approach to a form from the past.

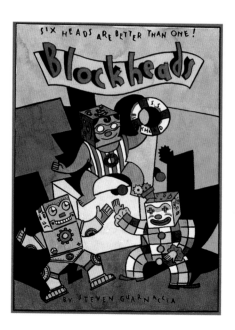

Blockheads
CLIENT: *Universe Publishing, New York*
DESIGNER/ILLUSTRATOR: *Steven Guarnaccia*
Published by Universe Publishing, New York, in 1992. © Universe Publishing. Reproduced by permission of the publishers.

![The House that Bob Built by Robert A.M. Stern, Rizzoli]

The House That Bob Built
CLIENT: *Rizzoli International Publications, New York*
DESIGN FIRM: *Milton Glaser, Inc.*
ILLUSTRATOR: *Andrew Zega*
AUTHOR: *Robert A.M. Stern*

home boy **The House That Bob Built**

The most surprising children's books are often those created by people who are not known exclusively as children's book artists or authors. In recent years the photographer Cindy Sherman, fashion designer Karl Lagerfeld, and artist William Wegman have aimed their idiosyncratic art at children. One of the least expected books for young readers is *The House That Bob Built*, architect Robert A.M. Stern's insider's look at the conception as well as the construction of a private house on Long Island—sort of a *Mr. Blandings Builds His Dream House* for kids.

In contrast to the cutting-edge tomes born of literary marriages between artists and picture books, Stern's book is rooted in quiet traditionalism. And yet, that is what makes it so special. The design is without flourish and the illustrations are subdued; the end result is an enlightening anatomy of how and in what we live.

monster mania **Skateboard Monsters**

Children are fascinated by little monsters. Oddly formed creatures (the most famous being E.T.) hold a special place in their hearts. But these ostensibly cute grotesqueries should not be confused with the terrifying freaks and beasts found in most horror and science fiction fare. Kids' monsters are weird but funny, different but not threatening. They often do everyday things—eat ice cream, play records, ride bikes. Such are the beasties in Daniel Kirk's *Skateboard Monsters*, a repertory of fuzzy, furry, pink, green,

137

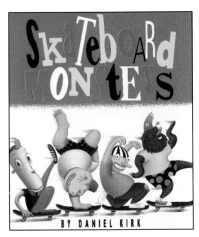

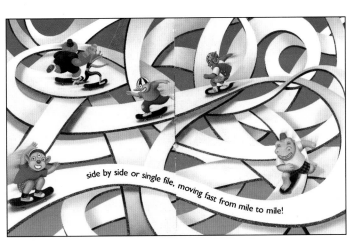

side by side or single file, moving fast from mile to mile!

Skateboard Monsters CLIENT: *Universe Publishing, New York* DESIGNER: *Julia Gorton* AUTHOR: *Daniel Kirk*

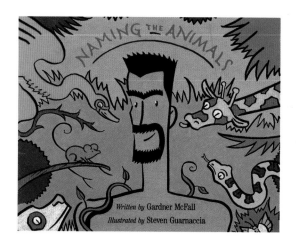

and blue creatures whose primary activity is skateboarding.

The characters are rendered in colorful airbrushed illustration. With the exception of the title and the occasional word, which are set in mismatched "ransom note" letters and script faces, respectively, the type is of one family but is set to conform to the timbre of the rhyme that continues through the book.

jungle journey Naming the Animals

Children's picture books can be narrative sequences full of detail, or designed spreads in which the composition of the page says almost as much about the story as the images and words. *Naming the Animals* falls into the second category. While the book is rich in imagery, the details

take a backseat to the dynamism of the overall design.

An orange horse runs across a two-page spread, its shadow intersected by a yellow rabbit, evoking the sense of speed. A blue elephant's head is cropped off the page, suggesting the immensity of the creature and the grandeur of its stride. The colored pencil art is both bright and muted, recalling a fauvist palette. Design here is not merely imposed order but a narrative tool for moving this delightful trek forward.

pull-and-poke Pat the Beastie *Pat the Beastie* is an example of diabolical wit that works on at least two levels. First, of course, Drescher's "pull-and-poke" book is a sendup of Dorothy Kunhardt's famous touchy-feely toddlers' classic, *Pat the Bunny*; it is also a quirky novelty

Naming the Animals CLIENT: *Viking Penguin, New York* ILLUSTRATOR: *Steven Guarnaccia* AUTHOR: *Gardner McFall*

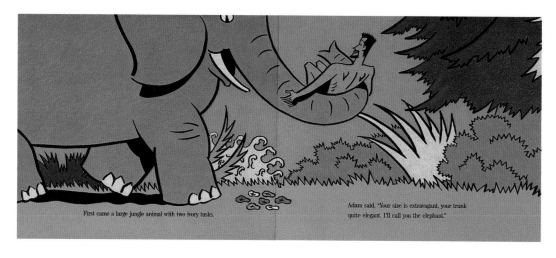

First came a large jungle animal with two ivory tusks.

Adam said, "Your size is extravagant, your trunk quite elegant. I'll call you the elephant."

Pat the Beastie
CLIENT: *Hyperion Books for Children, New York*
DESIGNER: *Patrick Flynn*
ILLUSTRATOR/AUTHOR:
Henrik Drescher

package that succeeds on its own merits whether the reader knows the original reference or not.

Pat the Beastie is Henrik Drescher at his best—the book is at once a commentary on the banality of innocence and an acerbic moral tale that raises two important issues. On one hand the devilish children who torment the grotesque beastie are really acting out the all-too-common tendency some kids have to abuse those they perceive as being different from themselves (and thus fear); on the other hand these are also the kinds of children who annoy pets and other animals. So for all its overtly grotesque humor, *Pat the Beastie* is not just a comedy but an attack against cruelty to others, be they human or beast.

romance reading Spanish Reading Series

Getting children interested in reading is a challenge in any language. So encouraging bilingual proficiency through exciting textbooks is an important step in increasing literacy among the various cultures the United States melting pot comprises. Producing textbooks with any degree of panache is a challenge, which is why the Cuentomundos Spanish Reading Series is such a welcome tool in the war against multicultural illiteracy.

Although editorial direction is key to the success or failure of a series such as this, the design—from the decorative covers to the kinetic layouts—is what induces the reader to participate. With this particular series, design is not just packaging; here, it provides structured pathways

Cuentomundos Spanish Reading Series
CLIENT: *Macmillan/McGraw-Hill School Publishing Co.*
PROJECT DIRECTORS: *Ilsa Berzins, Paula Darmofal*
DESIGN FIRM: *Designframe Inc., New York*
CREATIVE DIRECTORS: *James Sebastian, Margaret Biedel*
DESIGNER: *Sharon Gresh* ILLUSTRATORS: *Top row:*
Buen Viaje, *Betsey Everitt;* Donde Digo, Digo,
John Pirmin; Acuarelas, *Maxine Boll;* Naranja Dulce,
Jose Ortega; Luna, Lunera, *Jose Cruz; bottom row:*
Puerta del Sol, *Jeanne Fisher;* Caracola, *Nic Wilton;*
Ala Rueda, Rueda, *Stefano Vitale;* A Navegar,
Terry Widener; A Girar, Girasol, *Doug Smith*

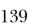

Fish Eyes: A Book You Can Count On
CLIENT: *Harcourt Brace Jovanovich Publishers, New York*
ILLUSTRATOR/AUTHOR: *Lois Ehlert*

Color Farm
CLIENT: *J. B. Lippincott, New York*
ILLUSTRATOR/AUTHOR: *Lois Ehlert*
Copyright © 1990 by Lois Ehlert. Reprinted by permission of HarperCollins Publishers.

Circus
CLIENT: *HarperCollins, New York*
ILLUSTRATOR/AUTHOR: *Lois Ehlert*
Copyright © 1992 by Lois Ehlert. Reprinted by permission of HarperCollins Publishers.

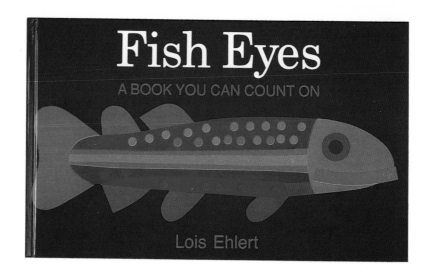

by which the reader and teacher can navigate the various challenges and experience the satisfaction of learning.

Of course, once the structure is established it is necessary to lure the reader in through aesthetics. The Spanish Reading Series therefore uses lively illustration on its covers and throughout the books. No two volumes in the series are alike, giving young readers not only a sense of novelty but of progress as they make their way through a variety of subjects and themes.

color forms Fish Eyes: A Book You Can Count On, Color Farm, and Circus Children have the capacity to learn on various levels, and Lois Ehlert's books are tools that can help them in that process of

140

discovery. While the premises of her books are easy to grasp, the results are often complex. *Fish Eyes: A Book You Can Count On*, for example, teaches the child about color perception as well as counting; and not only does the reader count the number of fish on a given page or spread, but the number of shapes on a given fish as well. *Color Farm* uses a variety of geometric shapes to show how in concert, certain forms can evoke a creature; so doing reveals to children the wonders and possibilities of abstraction. *Circus* also allows children to see how one group of images and forms can be used in combination with others to make still more images and forms.

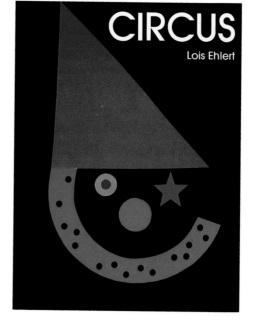

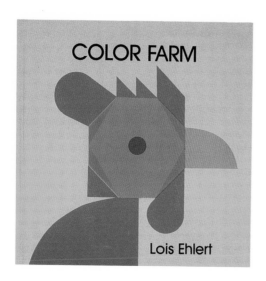

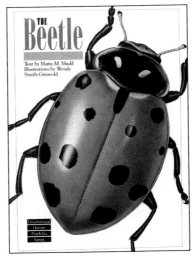

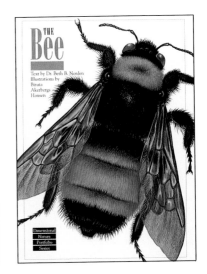

pop eyes Dimensional Nature Portfolio

Series Pop-up and other engineered-paper books date back to the nineteenth century, but never have they been so prodigious as now. Among the most inspirational and educational are those in Stewart, Tabori & Chang's Dimensional Nature Portfolio Series. Each book includes one centerpiece pop-up (such as the monarch butterfly in *The Butterfly)* and assorted others between the pages of the text panels on either end of the book. Each also examines a single type of insect (such as spiders, bees, beetles, and butterflies) and a variety of its species. The illustrations are exquisitely drawn in colored pencil and are expertly designed to simulate an accurate natural setting. The lie-flat binding allows for easy reading of the didactic text,

which is found in two vertical half-page signatures. Two- and three-dimensional illustrations of details as well as life-size and magnified specimens are included.

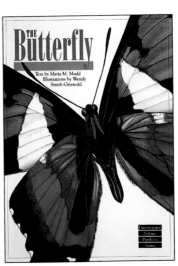

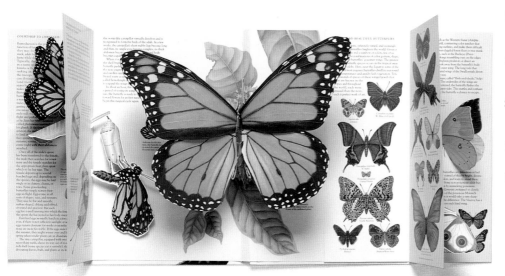

Dimensional Nature Portfolio Series CLIENT: *Stewart, Tabori & Chang, New York* DESIGN FIRM/PACKAGER: *White Heat, Ltd.* DESIGNER: *Lynette Ruschak* ILLUSTRATORS: The Spider, *Toma Narashima;* The Beetle *and* The Butterfly, *Wendy Smith-Griswold;* The Bee, *Biruta Akerbergs Hansen* WRITERS: The Spider, *Louise Woelflein;* The Beetle *and* The Butterfly, *Maria M. Mudd;* The Bee, *Dr. Beth Norden* PAPER ENGINEER: *James Diaz*

form follows function

Square Triangle Round Skinny Basic geometry is the essence of modern design theory and the fundamental language of art. Children are introduced to circles, squares, triangles, and rectangles at young ages because virtually all objects in the real world can be quickly identified by referring to these forms. *Square Triangle Round Skinny* encourages children to learn about shapes and sizes and at the same time relate them to a variety of natural and man-made objects. Through the four "books," which are shaped like a circle, triangle, square, and long, narrow rectangle and are bound by a small metal hinge that allows the pages to be fanned out, the reader is treated to colorful linocut illustrations that introduce a variety of forms.

With their pages fanned out the books become samplers of distinctive images. The covers are solid, primary colors—red, yellow, green, and blue—so that when the books are seen through the transparent cover of their box, the whole assemblage looks like a cross between modern geometric artwork and a child's toy

Forms included in the red circular book *(Round)* are a button, a tire, and the sun; the blue rectangular book *(Skinny)* features a pencil, a dachshund, and a saw; the green triangular book includes an uppercase *A*, a hanger, a nose, and a sail; the yellow square book has windowpanes, a suitcase, and a patch. Unlike conventional static shape and object books, these rotating pages encourage the child to play; having four separate elements invites contrasts and

142

Square Triangle Round Skinny
CLIENT: *Henry Holt and Company, Inc., New York*
DESIGNER: *Vladimir Radunsky*
AUTHORS: *Eugenia and Vladimir Radunsky*
© *1992 Eugenia and Vladimir Radunsky. All rights reserved. Permission granted by the publisher and by Vladimir Radunsky*

comparisons that allow learning by association. In addition to the books a poster showing how these shapes work in concert is included. The overall design is pleasing to both parent and child. The books are packaged in a shallow black box with a see-through cover on which the title, rendered in linocut, is printed in white. Seen over the colored forms, it evokes a sense of sophisticated play.

earth alert What Do We Do Now?

Posters have long been among the most effective classroom media for informing students about a variety of subjects from social to health issues. Yet school walls and bulletin boards often resemble outdoor hoardings, with scores of posters competing for space and attention. In this cluttered environment, how does a poster succeed?

Scholastic produces posters that are at once bold and contemporary. The poster promoting an "idea search" in concert with the three environmental *R*s—Reduce, Reuse, Recycle—packs a wallop through the integration of a strong comic graphic, large lettering, and a screaming yellow background. The headline "What Do We Do Now?" serves as a challenge to students that's hard to ignore.

143

What Do We Do Now?
CLIENT: *Scholastic Inc., New York*
DESIGN DIRECTOR: *Ellen Jacob*
DESIGN FIRM: *Shankweiler Sealy*
DESIGNERS: *Linda Shankweiler, Gerard Sealy*

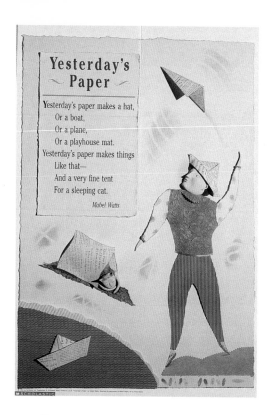

Yesterday's Paper
CLIENT: *Scholastic Inc., New York*
ART DIRECTOR: *Bob Lascaro*
DESIGNER: *Liza Wai*
ILLUSTRATOR: *Alexa Grace*

The Meal
CLIENT: *Scholastic Inc., New York*
ART DIRECTOR: *Bob Lascaro*
DESIGNER: *Winnie Whipple*
ILLUSTRATOR: *Gary Baseman*

A Gorilla Family
CLIENT: *Scholastic Inc., New York*
ART DIRECTOR: *Bob Lascaro*
DESIGNER: *Matt Fernberger*
ILLUSTRATOR: *Garnet Henderson*

poetry corner **Yesterday's Paper**

and **The Meal** Scholastic's posters are designed to help improve reading skills in the early grades. *The Meal* and *Yesterday's Paper* are illustrated rhymes that use comic art and classic typography to engage children. What is the little boy on *The Meal* poster doing with all those flying foods? What is to become of the discarded newspapers shown on the poster *Yesterday's Paper*? The answers are in the poems, and finding them provides youngsters with a strong incentive to develop reading skills.

144

ape art **A Gorilla Family** Textbooks are infor-

mative, posters are inspiring. When reproduced in a large-scale, poster-size format, an image like the one created for *A Gorilla Family* demands attention, while the same image in a book, no matter how well executed, can be passed over amid the mass of information.

Scholastic's didactic posters coincide with specific classroom curricula and are tools for engaging and supporting the interests of students. This poster is illustrated

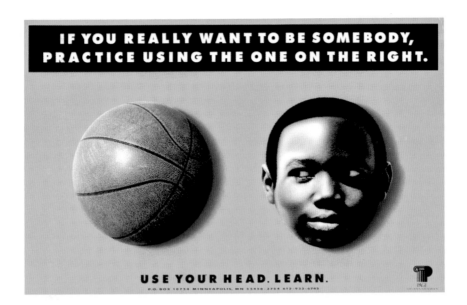

IF YOU REALLY WANT TO BE SOMEBODY, PRACTICE USING THE ONE ON THE RIGHT.

USE YOUR HEAD. LEARN.
P.O. BOX 16734 MINNEAPOLIS, MN 55438-3734 612-933-6745

in a representational watercolor technique. Although realistic, the image is not photographic. This not only allows the artist to compose the scene he wants, but also grants the student license to interpret and imagine.

DON'T BE A PINHEAD.

USE YOUR HEAD. LEARN.
P.O. BOX 16734 MINNEAPOLIS, MN 55438-3734 612-933-6745

street art **Use Your Head. Learn.** School hallways are covered with cautionary posters advocating safe sex or warning against drugs. Some are potent red flags. The Use Your Head. Learn. poster campaign that circulated throughout the Milwaukee area is a vivid reminder that education is a key to success. The posters are simply designed in black and yellow and employ manipulated high-contrast photographs that serve as exclamation points. A tiny head on a large body in a "cool" posture against a flat color field contrasts being hip with being dumb in *Don't Be a Pinhead.* In the poster shown above, the comparison between a basketball and a kid's head (note the eyes) neatly expresses the idea that becoming "somebody" on athletic merits alone is a one-in-a-million shot.

145

Use Your Head. Learn.
CLIENT: *Page Education Foundation, Milwaukee, Wisconsin* DESIGN
FIRM: *Hoffman, York, and Compton*

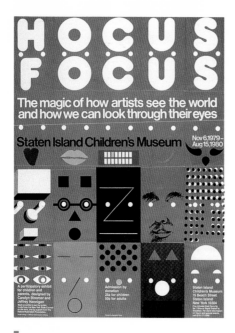

eyekons **Hocus Focus** To attract adults and children to a Staten Island Children's Museum event exploring how artists see their world, Keith Godard chose an eye motif as a metaphor for the range of artistic visions. Illustrated with a diversity of visual forms, the two-color poster is a real eyestopper.

zoo art **FL&C Kids' Party at the Zoo** This simple poster was designed to raise funds for the Milwaukee County Zoo. While the message is targeted at adults, the clever image of a horse assembled from Tinker Toys gives the poster broader appeal. Using a child's iconography to symbolize the institution's essence is an effective way to reach the adult's heart (and wallet) and the child's senses.

far off faces **Masks** Posters in the classroom have a dual function: to enliven the school environment and to convey information. *Masks* is a clever and handsome way of teaching students about different cultures through their indigenous art forms. Ceremonial and folk masks are particularly apt examples of such art forms, since they embody significant characteristics of the cultures from which they originate. This poster is designed as though the masks were hanging on a classroom wall

146

Hocus Focus
CLIENT: *Staten Island Children's Museum, New York*
DESIGN FIRM: *Keith Godard/Studio Works*
DESIGNER: *Keith Godard*

Masks
CLIENT: *Scholastic Inc., New York*
ART DIRECTOR: *Bob Lascaro*
DESIGNER: *Liza Wai*

FL&C Kids' Party at the Zoo
CLIENT: *Laughlin/Constable Advertising and Public Relations, Milwaukee, Wisconsin*
DESIGN FIRM: *Laughlin/Constable Advertising and Public Relations* DESIGNER: *John Kirchen*
PHOTOGRAPHER: *David Vander Veen, Milwaukee, Wisconsin* COPYWRITER: *George Brumis*

THE PLAYFUL IMAGINATION: A SHOW OF TOYS BY ARTISTS

In the Making hosts an exhibition of artist-made toys and playful objects in support of Inner City Angels • Queen's Quay Terminal, 2nd floor • Nov. 1, 1989 – Jan. 7, 1990 • Open 7 days a week 10 a.m. – 9 p.m.

Queen's Quay Terminal *at Harbourfront*

against a piece of fabric. The sharply detailed photographic treatment of the masks imbues this poster with a startling, almost tactile three-dimensional quality.

for all ages The Playful Imagination

To announce an exhibition of toys designed by artists, four different posters were created, each featuring a reproduction of one of the toys included in the show. The objects represented include traditional puppets, precarious acrobats, a quirky sea vessel, and a monkey with its arms stretched out to impossible (and amusing) lengths. Although the posters were handsomely designed to attract an adult audience, the dramatically photographed toys appeal to people of all ages.

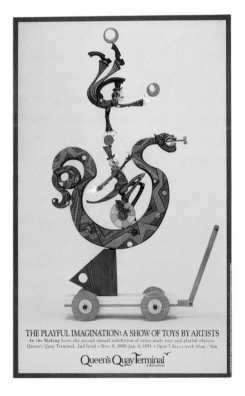

THE PLAYFUL IMAGINATION: A SHOW OF TOYS BY ARTISTS
In the Making hosts the second annual exhibition of artist-made toys and playful objects. Queen's Quay Terminal, 2nd level • Nov. 8, 1990–Jan. 6, 1991 • Open 7 days a week 10am – 9pm

Queen's Quay Terminal *at Harbourfront*

147

The Playful Imagination

CLIENT: *In the Making/Queen's Quay Terminal, Toronto, Ontario, Canada*
DESIGNERS: *Clockwise: Monkey, David Wyman; pull toy, Scott Purdy Advertising and Design; flying ship, Scott Purdy Advertising and Design*
PHOTOGRAPHERS: *Clockwise: Monkey, Scott Ewen; pull toy, Nancy Shanoff; flying ship, Peter Stranks*
TOYS: *Clockwise: Monkey, Jamie Bennett; pull toy, Werner Arnold; flying ship, Lois Alvarez*

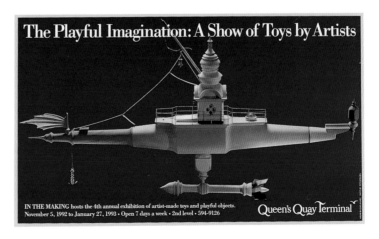

The Playful Imagination: A Show of Toys by Artists

IN THE MAKING hosts the 4th annual exhibition of artist-made toys and playful objects.
November 5, 1992 to January 27, 1993 • Open 7 days a week • 2nd level • 594-9126

Queen's Quay Terminal

 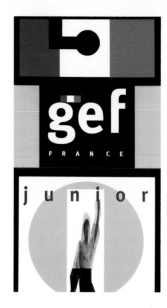

hip threads
Gef Posters The computer-generated imagery that dominates the Gef Clothing for Kids posters signals the highest level of hip for the image-oriented, video-literate generation of preteens and teens who comprise the target audience. April Greiman's use of abstraction (consistent with Gef's labels and packages) runs counter to the traditional wisdom that says parents and children want to see how the clothes really look. Rather than show products, these typographic images suggest a distinctive personality and exude a sophistication the target audience can relate to. The stylish posters can also be used, in the tradition of turn-of-the-century commercial posters, as wall hangings, thus allowing the Gef name to resonate after the advertising campaign is over.

148

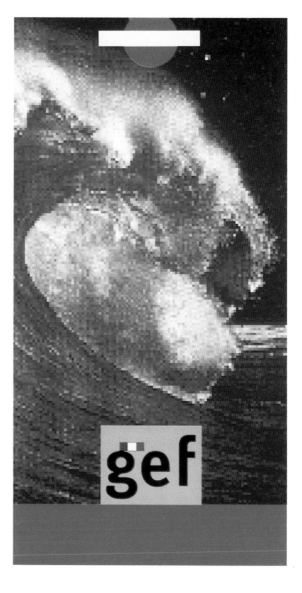

Gef Posters
CLIENT: *Gef Clothing
for Kids, Medellín,
Colombia*
DESIGN FIRM:
April Greiman Inc.
DESIGNER:
April Greiman
DESIGN ASSOCIATE:
Sean Adams

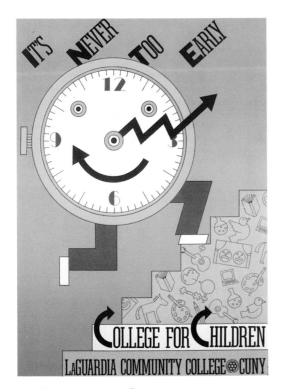

College for Children
CLIENT: *LaGuardia
Community College
(CUNY), New York*
DESIGN FIRM: *The
Pushpin Group Inc.*
DESIGNER/
ILLUSTRATOR:
Seymour Chwast

early warning College for Children

"It's Never Too Early," reads the headline on this surreal poster promoting an unusual educational experience. Sponsored by one of New York's most respected community colleges, College for Children is not a typical liberal arts program but an extracurricular program that offers remedial and extension courses for elementary school students in the arts, sciences, computers, and reading. In using the clockman (whose mouth is the hour hand, an arrow pointing upward) running up the metaphoric stairs of knowledge, Seymour Chwast underscores the idea that advanced education can begin at any time in a child's life. The forward-thrusting arrow motif is further used to form the Cs in the title *College for Children*.

playful promo Imagination Series

Brio's posters are a hard-soft sell. The products are only alluded to in the imagery, and the tag lines, such as "To Play Is to Learn" and "Imagination Is More Important Than Knowledge," emphasize abstract concepts over commerce. The colors and forms are consistent with the look of the products and suggest the simplicity of Brio's toys and the activities they involve. The four posters are designed with shared graphic elements, such as a slice of the rainbow, so that when hung together they work as a mural.

149

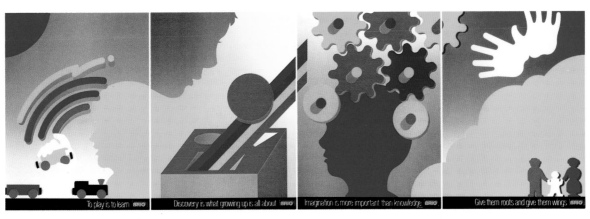

Brio Poster Series CLIENT: *Brio Scanditoy, Sweden* DESIGN FIRM: *Tharp Did It* DESIGNERS/ILLUSTRATORS: *Rick Tharp, Thom Marchionna*

logos

Children are not sophisticated enough to comprehend the deep symbolic significance of a logo or trademark, yet no group is more susceptible to its power. Young children learn to read logos before letters and words. Older children relate to them as badges of allegiance. Therefore, a logo for a children's program, activity, or product potentially carries a lot of clout.

The logos surveyed here identify and characterize. Most are for children's products and are designed with the parent in mind, and therefore deliberately include child-oriented iconography that distinguishes them from logos for other businesses or industries. A few are designed primarily with the child in mind, and offer a broader range of images.

cool club Fresh Force

Convincing disaffected inner-city youths to take an active, positive role in their communities is a difficult challenge. In Minneapolis it has been a rousing success, due in no small part to the graphic materials produced for Fresh Force, a volunteer group whose aims are to enhance city neighborhoods in a variety of ways. The Fresh Force logo, a brightly colored, faux military-style insignia emblazoned on its membership card, T-shirts, and posters, gave members a sense of belonging—an esprit de corps.

The Fresh Force identity program was designed with a striking contemporary palette, strong expressionistic graphics, and the same sophistication brought to any commercial or institutional commission. The campaign never lost sight of its end users: It neither was designed above their heads nor pandered to them by coopting inner-city signs and symbols. Paradoxically, by appropriating certain nostalgic elements (for example, old Boy Scout emblems) and eschewing contemporary clichés, the Fresh Force identity established an original and effective image for its members.

150

Fresh Force
CLIENT: *Fresh Force,*
Minneapolis, Minnesota
DESIGN FIRM:
Duffy Design Group
DESIGNER:
Charles Anderson

Brik Toy Co. DESIGN FIRM: *CMA, Houston, Texas*
Basic Fun DESIGNERS: *John Skidmore, Alan Dorfman*
ILLUSTRATOR: *John Skidmore* **Earlscourt Child &**
Family Center DESIGN FIRM: *Reactor Art & Design Inc.*
DESIGNER: *Clare McGoldrick* **Hoobert, Inc.** DESIGNER:
David Kirk **Quality Time Playhouse** DESIGNER: *Susan*
Hochbaum **Jim's Gym; Vidiots** CLIENT: *Milton*
Bradley DESIGN FIRM: *Sibley Peteet Design* DESIGNER/
ILLUSTRATOR: *John Evans* **Kohl Children's Museum**
DESIGN FIRM: *Thirst, Inc.* DESIGNER: *Rick Valicenti*
Sports Illustrated for Kids CLIENT: *Time Inc.* DESIGN
FIRM: *Nancy Butkus Design* DESIGNER: *Nancy Butkus*
Little Kids Inc. DESIGN FIRM: *Little Kids Inc.*
University Children's Medical Group DESIGN FIRM:
Wayne Hunt Design DESIGNER: *John Temple*

Kiddoworks CLIENT: *Danicraft Manufacturing*
Hand in Hand CLIENT: *First Step Ltd.* DESIGN FIRM:
Kaminsky Design **leap Sandcastle Contest** DESIGN
FIRM: *Morla Design* DESIGNERS/ILLUSTRATORS: *Jennifer
Morla, Jeanette Aramburu* **Kensington Day Care Center**
DESIGN FIRM: *Reactor Art & Design Inc.* DESIGNER:
Stephanie Power ILLUSTRATOR: *Rene Zamic* **Real News
for Kids** CLIENT: *TBS* **Discovery Music** DESIGNER:
Holly Sue/Discovery Music **Kin•der•link** CLIENT: *Skools
Inc.* DESIGN FIRM: *Studio 131* DESIGNER: *Behrooz
Shahidi* **Jammers; Kidz** CLIENT: *Caboodles* DESIGN
FIRM: *Sutton Pina Associates* DESIGNER: *David Pina*
Bay Area Discovery Museum DESIGN FIRM: *The Pushpin
Group Inc.* DESIGNER: *Seymour Chwast* **Multi
Cultural Youth Summit of Dallas** CLIENT: *Youth
Getting It Done* DESIGNER: *John Evans*

Caboodles DESIGN FIRM: *Sutton Pina Associates*
DESIGNER: *David Pina* **Hand in Hand Professional**
CLIENT: *First Step Ltd.* DESIGN FIRM: *Kaminsky Design*
DaMert Company DESIGN FIRM: *Dan Gilbert Art Group*
ART DIRECTOR: *Greg McVey* DESIGNER: *Dan Gilbert*
Edmund D. Edelman Children's Court DESIGN FIRM:
Wayne Hunt Design **Rabbit Ears** ART DIRECTOR: *Paul
Elliott* **Yes! Entertainment Corp.** DESIGN FIRM: *Davison
Brunelle Design, Inc.* **Hoopla, Inc.** DESIGNER: *André
Sala* **ZuZu** CLIENT: *Restless Youth Press* DESIGNER: *Beck
Underwood* **No Ends** DESIGN FIRM: *Sagoma Design
Group* DESIGNER/ILLUSTRATOR: *Karen Gelardi* **Shelly
Adventures** DESIGN FIRM: *Meridith Design* DESIGNER:
Shelly Meridith **Electric Mouse** CLIENT: *Pentech
International Inc.* DESIGN FIRM: *Pentech Studio*
CREATIVE DIRECTOR: *Dana Melnick*

resources

The following is a selected list of the artists, designers, design firms, manufacturers, distributors, and producers whose work appears in this book.

Activision
11440 San Vicente Blvd.
Los Angeles, CA 90049

Alfred A. Knopf
201 E. 50th Street
New York, NY 10022

April Greiman Inc.
620 Moulton Avenue
Suite 211
Los Angeles, CA 90031

Basic Fun Inc.
P.O. Box 847
Huntington Valley, PA
19006

The Bay Area Discovery Museum
557 East Fort Baker
Sausalito, CA 94965

Big Apple Circus
35 W. 35th Street
New York, NY 10001

Big Blue Dot
9 Galen Street
Watertown, MA 02172

Boston Globe
135 Morissey Blvd.
Boston, MA 02107

Boy Scouts of America
1325 West Walnut Hill
Lane
Irving, TX 75015

Brik Toy Company
Korterhouse
Communications
9 Newbury Street
Boston, MA 02116

Brio Corporation
6555 West Mill Road
Milwaukee, WI 53218

Broderbund Software, Inc.
500 Redwood Blvd.
P.O. Box 6121
Novato, CA 94948

Brooke Alexander Gallery
59 Wooster Street
New York, NY 10012

Brooklyn Children's Museum
189 Montague Street
Brooklyn, NY 11201

Caboodles
One Fawcett Place
Suite 110
Greenwich, CT 06830

Candlewick Press
2067 Massachusetts
Avenue
Cambridge, MA 02140

Capitol Records
1750 Vine Street
Hollywood, CA 90028

Charles S. Anderson Design Co.
30 North First Street
Minneapolis, MN 55401

The Child Growth and Development Corporation
599 Broadway
New York, NY 10012

Children's Discovery Museum
180 Woz Way
San Jose, CA 95110

The Children's Museum
300 Congress Street
Boston, MA 02210

The Children's Museum of Houston
1500 Binz
Houston, TX 77004

Children's Museum of Manhattan
212 W. 83d Street
New York, NY 10024

Cloud and Gehshan Associates, Inc.
622 South 10th Street
Philadelphia, PA 19147

Coleman Advocates for Children
2601 Mission Street
Suite 804
San Francisco, CA 94110

Compton's New Media Britannica Software
2320 Camino Vida Roble
Carlsbad, CA 92009

Creative Education
123 South Broad Street
Mankota, MN 56001

Creativity for Kids
1802 Central Avenue
Cleveland, OH 44115

Dallas Museum of Art
1717 North Harwood
Street
Dallas, TX 75201

DaMert Company
2476 Verna Court
San Leandro, CA 94577

Danicraft Manufacturing Ltd.
360 Lynn Avenue
North Vancouver, B.C.
Canada V7J 2C5

Deborah Green Company
217 W. 79th Street
Suite 1A
New York, NY 10024

Designframe Inc.
1 Union Square West
New York, NY 10003

DGI/BUKI
P.O. Box 381994
Miami, FL 33138

Discovery Music
5554 Calhoun Avenue
Van Nuys, CA 91401

Donald Battershall Design
7 W. 20th Street
New York, NY 10011

Dorling Kindersley Children's Books
232 Madison Avenue
New York, NY 10016

Duffy Design Group
311 First Avenue
North #200
Minneapolis, MN 55401

The Exploratorium
3601 Lyon Street
San Francisco, CA 94183

First Step Ltd./Hand in Hand
347 Congress Street
Boston, MA 02210

flik flak
353 E. 21st Street
New York, NY 10010

Fresh Force
202 City Hall
Minneapolis, MN 55415

Gef Clothing for Kids
Calle 29N.43A-1
Apartado 1199
Medellín, Colombia

Ghost Writer/Children's Television Workshop
1 Lincoln Plaza
New York, NY 10023

Grafik Communications Inc.
1199 N. Fairfax
Suite 700
Alexandria, VA 22314

Rodney Alan Greenblat
61 Crosby Street
New York, NY 10012

Guidecraft USA
P.O. Box 324
Industrial Terminal
Garnerville, NY 10923

Hallmark Cards Inc.
Maildrop #146
Kansas City, MO 64141

Harcourt Brace Jovanovich
111 First Avenue
New York, NY 10003

HarperCollins Publishers
10 East 53d Street
New York, NY 10022

Hasbro, Inc.
1027 Newport Avenue
Pawtucket, RI 02860

HATS OFF! Development Corporation
343 Oxford Street
Suite 2
Rochester, NY 14607

Henry Holt and Company, Inc.
115 W. 18th Street
New York, NY 10011

Higashi Glaser Design
828 Caroline Street
Suite 2
Fredericksburg, VA 22401

Hoobert, Inc.
284 Amory Street
Jamaica Plain, MA 02130

Hoopla, Inc.
1250 Addison Street
Suite 112
Berkeley, CA 94702

Hopkins/Baumann Design
236 W. 26th Street
Suite 5NW
New York, NY 10001

Hyperion Books for Children
114 Fifth Avenue
New York, NY 10011

Imaginarium, Inc.
1600 Riviera Avenue
Suite 280
Walnut Creek, CA 94596

In the Making
Queen's Quay
Terminal Building
207 Queen's Quay West
Toronto, Ont.
Canada M5J 1A7

Jammers
One Fawcett Place
Suite 110
Greenwich, CT 06830

KIDdesigns
Harborside Financial
Center
400 Plaza Two
Jersey City, NJ 07311

Kiddoworks
360 Lynn Avenue
North Vancouver, B.C.
Canada V7J 2C5

Kids Discover
170 Fifth Avenue
New York, NY 10010

Kidsoft
718 University Avenue
Suite 112
Los Gatos, CA 95030

Kidz
One Fawcett Place
Suite 110
Greenwich, CT 06830

Kinderlink
Skools Inc.
40 Fifth Avenue, Suite 15A
New York, NY 10011

Klutz Press
2121 Staunton Court
Palo Alto, CA 94306

Kohl Children's Museum
165 Green Bay Road
Wilmette, IL 60091

Krafty Kids Inc.
11358 Aurora Avenue
Des Moines, IA 50322

Laughlin/Constable Inc.
207 East Michigan Street
Milwaukee, WI 53202

leap
1409 Bush Street
San Francisco, CA 94109

Learning Resources
675 Heathrow Drive
Lincolnshire, IL 60069

Lilliput Motor Corporation, Ltd.
P.O. Box 447
Yerington, NV 89447

Little Kids Inc.
2757 Pawtucket Avenue
East Providence, RI 02914

M & Co.
50 W. 17th Street
New York, NY 10011

M Plus M Inc.
17 Cornelia Street
New York, NY 10014

Macmillan/McGraw-Hill
10 Union Square East
New York, NY 10003

Richard McGuire
45 Carmine Street #3B
New York, NY 10014

Marshall & Delessert
Box 1689
Lakeville, CT 06039

Mattel Inc.
333 Continental Blvd.
El Segundo, CA 90245

Metropolitan Museum of Art
1000 Fifth Avenue
New York, NY 10028

Michael Mabry Design
212 Sutter Street
San Francisco, CA 94108

Michael Manwaring
1045 Sansome Street
Suite 304
San Francisco, CA 94111

Michael Patrick Cronan Design
1 Zoe Street
San Francisco, CA 94107

Milton Bradley Company A Division of Hasbro, Inc.
443 Shaker Road
East Longmeadow, MA 01028

Miriam Berman Graphic Design
210 Fifth Avenue
New York, NY 10010

Morla Design
463 Bryant Street
San Francisco, CA 94107

Museum of Modern Art
11 W. 53d St.
New York, NY 10019

The Nature Company
750 Hearst Avenue
Berkeley, CA 94710

155

New York Newsday
235 Pinelawn Road
Melville, NY 11797

News for Kids
Turner Broadcasting
TBS Management
One CNN Center
Atlanta, GA 30303

Nickelodeon
Nickelodeon Magazine
1515 Broadway
New York, NY 10036

No Ends
P.O. Box 3037
Kennebunkport, ME
04046

Oakdale Press
2241 Howard Street
Chicago, IL 60645

Tom Otterness
Brooke Alexander Gallery
59 Wooster Street
New York, NY 10012

Page Education
Foundation
P.O. Box 581254
Minneapolis, MN 55458

Paper Bag Players
50 Riverside Drive
New York, NY 10024

Papier Deux
2239 Springwood Drive
Atlanta, GA 30033

Pappa Geppetto's Toys
Victoria Ltd.
816 Peace Portal Drive
Blaine, WA 98230

Pentagram Design Inc.
212 Fifth Avenue
New York, NY 10010
and
620 Davis Street
San Francisco, CA 94111

Pentech International Inc.
75 Broad Street
Red Bank, NJ 07701

Pickle Family Circus
400 Missouri Street
San Francisco, CA 94107

Playskool
A Division of Hasbro, Inc.
1027 Newport Avenue
Pawtucket, RI 02860

Polydron USA Inc.
9874 Red River Circle
Fountain Valley, CA 92708

The Pushpin Group Inc.
215 Park Avenue South
New York, NY 10003

Rabbit Ears
Productions Inc.
131 Rowayton Avenue
Rowayton, CT 06853

Reactor Art & Design, Inc.
51 Camden Street
Toronto, Ont.
Canada M5V 1V2

Restless Youth Press
271 E. 10th Street #64
New York, NY 10009

Rizzoli International
Publications Inc.
300 Park Avenue South
New York, NY 10010

Scholastic Inc.
730 Broadway
New York, NY 10003

Scripto-Tokai Corporation
11591 Etiwanda Avenue
Fontana, CA 92337

J. Otto Seibold
38 W. 21st Street #1101
New York, NY 10010

Shelly Adventures
55 Mercer Street
New York, NY 10013

Shoofly
465 Amsterdam Avenue
New York, NY 10024

Sibley Peteet Design
965 Slocum
Dallas, TX 75207

Skools, Inc.
40 Fifth Avenue
Suite 15A
New York, NY 10011

Sony Electronics Inc.
The Design Center
1 Sony Drive
Park Ridge, NJ 07656

Sports Illustrated for Kids
Time and Life Building
1271 Avenue of the
Americas
New York, NY 10020

Staten Island
Children's Museum
100 Richmond Terrace
Staten Island, NY 10301

Dugald Stermer
1844 Union Street
San Francisco, CA 94123

Stewart, Tabori & Chang
575 Broadway
New York, NY 10012

Studio Works
838 Broadway
New York, NY 10003

Sussman/Prezja
3960 Ince Blvd.
Culver City, CA 90232

Tharp Did It
50 University Avenue
Suite 21
Los Gatos, CA 95030

Tomorrow's Morning
11466 San Vicente Blvd.
Los Angeles, CA 90049

Two Women Boxing Inc.
3002 B Commerce
Dallas, TX 75226

Universe Publishing
300 Park Avenue South
New York, NY 10010

Viking Penguin
375 Hudson Street
New York, NY 10014

The Voyager Company
1351 Pacific Coast
Highway
Santa Monica, CA 90401

Wayne Hunt Design
87 North Raymond
Avenue, Suite 215
Pasadena, CA 91103

Whitney Museum of
American Art
945 Madison Avenue
New York, NY 10021

William Morrow & Co.
1350 Avenue of the
Americas
New York, NY 10019

Wimmer-Ferguson Child
Products, Inc.
P.O. Box 100427
Denver, CO 80250

Wizbits Creative
Creature Designs
50 Ramland Road
Orangeburg, NY 10962

WNYC-FM
1 Centre Street
New York, NY 10007

Woods + Woods
414 Jackson Street
Suite 304
San Francisco, CA 94111

Works Editions
838 Broadway
New York, NY 10003

Yes! Entertainment
Corporation
Smith/Fischer Partners
4640 Admiralty Way
Suite 800
Marina Del Ray, CA 90292

Zolo Inc.
P.O. Box 53
Dogue, VA 22451

ZuZu
271 E. 10th Street, #64
New York, NY 10009

index

158